Social Media Marketing
for Digital Photographers

Lawrence Chan

WILEY

John Wiley & Sons, Inc.

Social Media Marketing for Digital Photographers

Published by
John Wiley & Sons, Inc.
10475 Crosspoint Boulevard
Indianapolis, IN 46256

ISBN: 978-1-118-01412-7
Manufactured in the United States of America

10 9 8 7 6 5 4 3 2 1

For general information on our other products and services or to obtain technical support, please contact our Customer Care Department within the U.S. at (877) 762-2974, outside the U.S. at (317) 572-3993 or fax (317) 572-4002.

Wiley also publishes its books in a variety of electronic formats and by print-on-demand. Some content that appears in standard print versions of this book may not be available in other formats. For more information about Wiley products, visit us at www.wiley.com.

Library of Congress Control Number: 2011927307

#about the author

Lawrence Chan is a marketing strategist for smart photographers. He authors a blog, e-book, and a real book, and he has a propensity for eating and reading— sometimes reading about eating ... and eating while reading. These have been wonderful precursors for ideas in marketing. Lawrence also happens to be a somewhat edgy wedding photographer.

credits

Acquisitions Editor
Courtney Allen

Development Editor
Jenny Larner Brown

Project Editor
Matt Buchanan

Technical Editor
Alan Hess

Copy Editor
Matt Buchanan

Editorial Director
Robyn Siesky

Business Manager
Amy Knies

Senior Marketing Manager
Sandy Smith

Vice President and Executive Group
Publisher
Richard Swadley

Vice President and Executive Publisher
Barry Pruett

Book Designer
Erik Powers

#acknowledgments

This is the last thing I get to write in this book … therefore, my last little nugget of information shall be imparted with the following words:

In the making of this book, I want to say —

Courtney, thanks for taking a chance on me and filtering through my ten emails each day. Jenny, you are the best pen pal through a Word document (insert winky face). Alan, your fresh perspective is always priceless. Matt, if poor syntax was a crime, you would be its policeman. Erik, I know that marketing can be boring, but you make it beautiful. Thank you, team!

Kenny, Zach, Jody, Jasmine, Becker, Jerry, Catherine, Grace: Thank you for your friendship and valuable insight! Your contributions to this project opened wonderful new perspectives. Thank you.

Tofurious readers: Without everyone's support and participation, my words would have fallen on deaf ears. #GroupHug

 Thanks and enjoy!

Dedicated to Julie,
whose hand I never want to let go.

★★★★★

#table of contents

#introduction

Photographers are visual storytellers. Sometimes our stories are true, real-life depictions of what's before us. And sometimes they represent a version of reality that we want to convey. Not exactly *lies*, but … oh, c'mon. An artist must be free to interpret his/her world, right?

Well, there's a fine line, requiring careful balance, between entertaining storytelling and genuine transparency. Today's consumers are painfully savvy and their tolerance for trickery is scarce. But don't let this scare you.

In this book, we'll cover the importance of earning trust in your marketplace and how to handle the process of strategic planning. We'll also explore how to target and attract the right audience and develop content that engages and motivates them in ways that benefit your business.

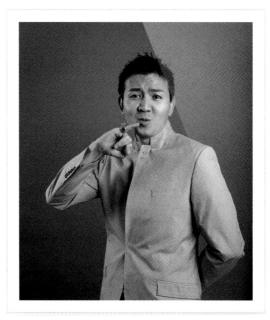

While photographers project their world, Austin Power's nemesis, Dr. Evil, tries to take over the world. A comedic self-portrait by Lawrence Chan taken at 50mm f/3.5 for 1/200 second.

Successful marketers have learned to play the high-stakes communications game with finesse and market insights. During my recent travels in Australia, for instance, I discovered Weis Bars in Gold Coast. They're fantastic. And I loved them even more after a local told me a story about how the bars came to be.

> *Grandfather Weis tried to coax his grandchildren to eat fruits. They refused. So Weis chopped up the fruits and froze the mixture into what looked like an ice cream bar, and he added a strip of cream in the center. The kids gobbled up the treat. And now, Weis Bars have become Aussies' most popular non-dairy, non-ice cream, ice cream-like bar.*

I learned later that the story is untrue, but it's catchy. And hidden within this story are proactive answers to possible concerns or objections consumers may have to the product. The creative and caring grandfather softens mistrust among consumers, whose typical default perception is that companies are more concerned with making high profits than providing a quality product.

The story also positions the snack as an alternative to ice cream … for lactose intolerant individuals and/or those with other health-related concerns. So while wholly untrue, the brand's story conveys important elements of Weis Bars, and it helped me bond with the product.

I bring up this important issue of storytelling, because one of the coolest things about social media, I think, is that this set of online tools are making it possible for small businesses to broadcast their stories and engage their marketplace in ways that've never been possible before. It no longer matters if your marketing budget is nil and your PR contact list doesn't exist. What matters most to a successful social media marketing program is your time and a genuine willingness to connect with your audience.

Throughout this book, we'll examine various social media tools and explore why they're worth the effort. We'll discover how much fun and rewarding social media marketing can be. We'll even talk about why it's really no longer even a serious option to not participate in the social media sphere. It's quickly becoming a cost of entry—the ante in a highly competitive photography market.

Long gone are the days when a photographer could make a living with just a camera, an eye for composition, and a flair for developing great

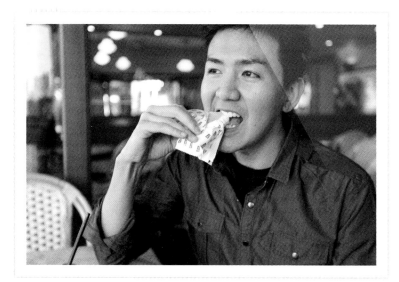

Weis Bar is known as the "no stick" fruit bar, which is particularly convenient for kids. Self-portrait photograph by Lawrence Chan enjoying a Weis Bar taken at 35mm f/2.8 for 1/100 second.

images. When Canon and Nikon launched digital cameras that *everyone* could use, good photography alone as a selling point became moot. Now, social media raises the bar again, and it goes far beyond staying connected with friends.

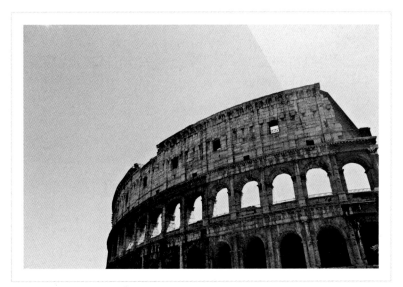

Participating in social media is just as important as visiting the Colosseum when in Rome. Photo taken by Lawrence Chan at 35mm f/2.8 for 1/100 second.

Online engagement tools (like Facebook, Twitter, Flickr, and YouTube) are making it easier than ever to find out what your audience wants and how they're responding to what you're putting out there. It's the communication platforms our fathers and grandfathers could only dream about. So don't let self-doubt intimidate you out of the game.

If you're thinking things like:

- Social media is too complicated.
- I can't keep up; social media keeps changing.
- Forget it. I don't know where to begin or what's even out there.
- What could I possibly say to interest an audience?
- I have a Facebook page and Twitter account, but have no idea what to do with them.

… then this book is for you.

Find out how to launch a social media marketing program, because there's just no way around it: people make decisions based on who and what they know. Hiring a familiar name/face/voice is simply a comfortable way to filter the options. It's an emotional market, so you need to ensure that yours—and not your competitor's—is the business people call when looking for a product or service you provide.

Unlike Amsterdam's Red Light District, serious photographers need to build substantial credibility. Photo taken by Lawrence Chan at 24mm f/1.4 for 1/100 second.

And when you're ready to take it even further, find out how and why to market your business as a social luxury and even how to earn brand evangelists, who will tout your brand messages voluntarily and with genuine gusto. Sounds exciting, right? It is!

Digital photographers who want to gain exposure and build credibility throughout a target niche … and sustain ownership of a desired market position over the long haul … need social media as part of their marketing program. But don't make the mistake of thinking that mind-blowing social media content can keep your photography business alive if you take terrible photographs. Ultimately you have to deliver.

In other words, at the core of your social media work, as with any other kind of marketing effort, is a quality product. Like with dating, looks attract and flirting engages. But it's the live, real-world behavior that makes 'em fall in love ... or vanish.

Got it? Well, let's get started. ✶✶✶✶✶

#chapter1

Remember posting flyers on telephone polls or on community boards at the library to get the word out about your services— or something you had for sale? Well, yes, these flyers are a type of media and they are a way to reach out to a community, so I suppose they're technically a form of social media. But this isn't what we're talking about here.

There are now much better ways to reach people who might be interested in what you've got. Ways that aren't limited to those who happen to walk by. And these new tools offer your audience a chance to reach back, so to speak, and interact with you and each other online and on demand. These are the tools we're referencing when we use the term *social media.*

I know it can get confusing, so allow me to explain the difference between the two types of communication we've mentioned so far. The term *media*, in a traditional sense, refers to relatively static, one-way modes of communication that broadcast information to a large population of people. We're talking about conventional marketing and PR tools like tv advertising, billboards, print ads, newspaper placement, and even the aforementioned flyers along with other formats that have been used for many generations to send out news and messaging.

But convention is changing. No longer are consumers paying attention to the self-serving proclamations of businesses with stuff to sell. It's so "last year" for companies to tell us what we need ... at their convenience. A new savvier marketplace is comprised of people who make purchase decisions based heavily on information they seek out, primarily on the Internet—on demand.

In this and other ways, social media represents a dramatic shift in how we, as both marketers and consumers, deliver and receive information. Digital tools are opening fantastic opportunities for highly engaged interaction among people—in real time. That is, social media participants can comment, share, bookmark, vote, and more on whatever topic is being addressed. Or they can begin a whole new line of discussion if interested enough.

This means that you can listen, discuss, and engage in relationship-building on the Internet, through sites that you can also use to provide news and updates about yourself and/or your business. It's like simultaneously being in many different places—coffee shops, conferences, networking events, etc.—and having conversations with all of your different communities.

And truly, this is a luxury that customers have come to expect now that so many companies are using online connectivity to reach and engage their markets. Customers insist on receiving information that actually matters to them, information that can help them make smart decisions. They expect to be able to reach back and have their questions and concerns addressed quickly.

Thus, the digital market interaction of social media allows and even encourages unrestricted discussion, an unstructured sharing of ideas and opinions. And this is the backbone of social media's evolution. It's alive and growing every single day.

The 2.0 Evolution

The web is constantly evolving without too much fanfare, but there was a significant shift at the turn of this century, when collaborative, social sharing and networking tools gradually emerged to allow for widespread user interaction, collaboration, and content development.

We refer to this shift as *Web 2.0*, which differs from Web 1.0—a more traditional communication platform that projected information to audiences without offering an opportunity to actively engage. Yet, instead of an actual technical upgrade, the term Web 2.0 describes how developers and users now approach and utilize the Internet.

During the web's infancy, its 1.0 phase, information was created by publishers and distributed to readers. It was essentially a read-only era. Well, Web 2.0 democratized the Internet, making it much more vibrant and valuable. I mean, think about some of today's most popular websites. Facebook would be a mere shell without its users and their updates. Wikipedia wouldn't be half the resource it is if no one added information to it.

Users dominate today's Internet. So savvy brand message-makers are moving away from the fluff and spin of yesteryear and trying instead to truly integrate messaging with the wants and needs of consumers to develop an effective public presence. At minimum, this requires authentic communications; meaningful information; and room for comments, a power to vote, or a place to make suggestions.

Yet, of course, conventional media is not obsolete. My girlfriend has a corkboard with coupon clippings, and it's updated constantly. Companies just need to learn how to incorporate social media platforms into their marketing mix. But it's just a matter of time before check-in programs (like FourSquare) will provide coupons right on a mobile phone when its user is nearby.

Dynamic Marketing

Social media is all about interaction—it's your dialogue with your network and their interaction with each other. The following three actions will help you use social media effectively:

Talk with your clients—not at them.

- **Listen** to what your audience is saying. What do they need, want, dislike?
- **Engage** with people through genuine conversation (not solicitation).
- **Evaluate** your efforts with analytic programs.

We'll dive deeper into these three actions later in the book. For now, just know that building relationships through social media—or anywhere for that matter—is increasingly important to the future of your business. But it's a two-way street. Business relationships require meaningful dialogue with your market, because promotional monologue feels like spam in most every format.

This is why the term *social media* can be confusing. By definition, *media*, a tool for communicating to large groups of people, is social—technically. But, as mentioned earlier, this word has traditionally referred to one-way blasts of information that are crafted for the masses. Good marketers are catching on quickly though. Consumers have a voice, too, and they want companies to hear what they're saying.

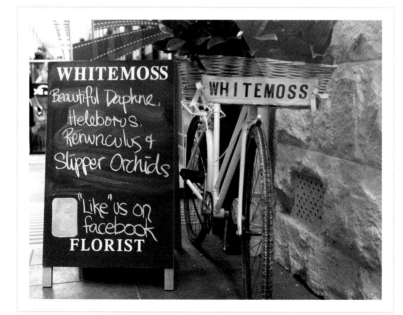

A common misconception is that asking clients to Like a Facebook page means automatic social engagement. In this particular situation, the display board for this boutique florist neither gives the URL for its page (or a QR code). It also fails to offer a reason to Like them in the first place. The request would be more appealing if it tried to engage with its potential audience by asking, for example, for people to "name their favorite flower." Or better, "submit a photo of your favorite flower" and have a chance at being immortalized on the walls of the shop.

Even televised commercials are getting on board. Many are no longer running with "Buy this!" Instead, the message is more like a request: "Tell us what you think at facebook. com/[company-name]!" or "Upload your video here! [link]"

An example of a successful social media marketing campaign is Canon's Project Imagin8ion, which asks people to submit their photographic inspirations via youtube.com/imagination. The program encourages viewers to visit Canon's YouTube Channel to interact and subscribe. This builds a relationship with users in a competitive environment. Who doesn't love a good contest?

As a company, Canon has adapted to a world with social media. Instead of just prompting people to buy a Canon product, this campaign asks people to explain how Canon inspires them—and ultimately Ron Howard. The answers come in as photos … ideally from a Canon camera. And if you don't own a Canon, maybe the inspiring photos in the competition will convince you to switch.

Project Imagin8ion: Here is a Ron Howard production based on eight submitted photos.

Use this strategy when creating your social media content. Focus less on "Hire me!" and more on "Tell me how I can help or inspire you." Encourage response! That can facilitate some very valuable relationships.

Also make it fun for your audience to converse among themselves. You can gain some very valuable insight to what they want and need from you as they explore a topic or debate an issue. Tune in to this and then deliver!

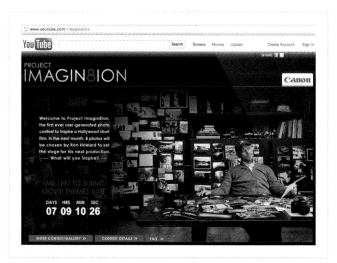

Project Imagin8ion: The contest is very interactive. Users may upload photos, vote for people, have conversations, critique or commend submissions, and ask questions about how certain shots were taken.

Earning Trust

Obviously, trust is a really big deal in business. No one hopes to get swindled. And since anyone can create a website or blog nowadays—for free and within minutes—how does a person know if the content they're reading is accurate, given the lack of filters and qualification checks on the Internet?

Indeed, earning online consumer trust can be difficult for some businesses. But it's a fairly straightforward process. Here's the secret: be truthful; don't intentionally mislead others. And ultimately, it helps to accept the fact that all you can do is provide good information and trust folks to make the right decisions for themselves.

Along those lines, when developing a social media program—or any communication campaign for that matter—it's important to realize that no matter how great the information is that you provide, the one entity consumers tend to trust most is *other consumers*. So let's take a peek at a company that has successfully harnessed this social paradigm: Amazon. Its customer rating and suggestion system demonstrates unprecedented trust in its customers.

That is, the Amazon site allows anyone to write and read honest reviews about every product it offers. It even suggests other titles one may enjoy based on a given search. Even more, Amazon provides information on its competitors who may be offering the same product at a cheaper price! If this isn't a display of genuine trust in the marketplace, I don't know what is.

And despite the perilous effect of a negative review in the old days of single-source expert-written book reviews in a magazine or newspaper, in today's online marketplace, truthful feedback by consumers generates a level of trust that couldn't have been bought for any price in the past. Amazon is genius. But try to think of a single other company that publicizes customer complaints or makes it so easy for you to make your purchase from a competitor. Exactly. Before the Internet was born, suggesting such a thing as serious business strategy could have earned you a pink slip.

After viewing a book, Amazon suggests books that other customers looked at as well.

Successful companies now provide more information than ever on their products and services. Those who don't understand this critical shift in consumer expectations or who appear to be hiding information are, at best, missing out on huge potential strides in earning trust among buyers.

Relevant Relationships

No matter how much you love it or hate it, social media is necessary for viable businesses. It's the Main Street of our times, where your customers are congregating, browsing, and making purchasing decisions. If you're not there; you virtually don't exist—at least in the minds of a sizable portion of your full potential market.

Yet developing and sustaining a valuable social media program takes time. And it requires a different kind of effort than a traditional media program, which basically takes a catchy message and adapts it to a ton of different platforms. Because social media allows a user to virtually be in many places at once, it's much more important to think about what you're putting out there (Does anyone care?), how often you post updates (Are you driving people nuts?), what platforms you're using (Is anyone even there?), and who you're reaching (Do you have the right audience?).

All of this matters a lot when creating your network—your community in the social media world. It's the basis of your *social currency*, your value to those in your network. So when you're building a social media program, you need to understand and remember that the promotional strategies on which social media operate are engagement and conversation—not straight selling.

We'll dive deeply into considerations for social media content in Chapter 4: The Power of Content. But for now, it's important to know that your content needs to be interesting and valuable to your network—or else they'll leave you. Sales are a potential byproduct of the relationships you build through social media, but simply pushing traditional marketing and sales messaging through this platform isn't going to work.

Consider Pepsi Co.'s decision to forego their advertising buy during the 2010 Super Bowl to instead invest $20 million in a social media program called Pepsi Refresh—a program that allows individuals and organizations to submit ideas for local-initiative grants ranging from $5,000 to $50,000. Since winners are selected by public vote, contestants are

encouraged to promote the heck out of the Pepsi Refresh program and, obviously, beg everyone they know to vote for their grant idea.

Cause-based marketing isn't new, but social media gives it a boost that can help companies leverage it in new and dramatic ways with public votes! Through its program, Pepsi has sponsored thousands of community projects—all while dramatically strengthening its relationships with communities throughout the US. The program shows that Pepsi understands something that many other large corporations still don't get: meaningful public interaction is more important to brand loyalty than entertaining tv spots.

The payoff for Pepsi is great. Instead of being known only as a mega-company that sells soft drinks, Pepsi is now revered as a generous benefactor for important community initiatives. We'll take a closer look at building your network and developing powerful content in Chapters 3 and 4, respectively.

Emergence of Social Platforms

So where did all this come from, you ask? Well, it's still pretty new. Web logs (or blogs) have been around for quite some time among the ultra-geeky set, but the social media phenomenon truly began when Facebook emerged in February 2004 and quickly replaced MySpace, which had been among the first well-known social networking sites available. Twitter followed two years later, and the whole social media thing roared to life. People were thrilled with these cool new ways to communicate and regarded social networking as a way to reconnect and stay in touch with friends through personal updates.

And this is pretty much why some people still resist using social media. The mundane updates get tiresome if you don't care. "I don't need to know when you're on the John," people complain. Or, "I don't care if you're eating at Olive Garden."

Yet those who see past the noise recognize that the opportunities for important interaction with social media are fantastic. For instance, while companies spend millions each year on market research surveys and focus groups to find out what customers are thinking, consumers are now *giving* away this valuable data—every day. Even more exciting, companies can engage in direct dialogue with customers to find out even more! And there are no honoraria fees to pay these respondents. Cha-ching.

But I don't blame the non-adapters. To be honest, I'm not too interested in knowing when my buddy is eating at Olive Garden either, unless I thought we were meeting someplace else! I am, however, very interested in things he likes/hates about a particular place or if something weird happens.

For example, say you ate so many breadsticks that the manager came out to check on you. Or that you, being lactose intolerant, had Zuppa Toscana without realizing it contains milk, which led to a disastrous dash to the men's room. This would be material for a good post.

Funny? *Oh yeah!* Embarrassing? *Quite.* More importantly, do you think your followers and friends would enjoy this information? *No doubt.* In fact, if they're like me, they'll laugh diabolically on the inside and send you a consoling note, even if it's just to show everyone else what an empathetic friend they are.

But what's truly amazing is how many variations of social media websites are now available. From a simple networking site designed for sending out personal updates, hundreds of different sites that serve a multitude of purposes have emerged. For instance, there are sites designed primarily for:

- **Communication:** blogs, social networking, advocacy, fundraising
- **Collaboration:** wikis, gaming, news, bookmarking
- **Sharing:** photographs, videos, music, presentations
- **Reviews:** movies, products, books, charities
- **Entertainment:** games, movies, books
- **Monitoring:** media hits, brand references, video clips

For photographers, the ability to post photos, videos, and text on various social media sites—and make this content sharable by those in your network—is something that just wasn't practical through previous forms of popular media. And it can be so gratifying and helpful to gather honest feedback on your work and ideas from other people. That's why, in this book, we'll focus on the tools that are designed mainly for communication and sharing. These powerful tools will not only help expand your market exposure; they can also help you grow as an artist and tune-in to your audience needs from the perspective of a business person.

Social Politics

Particularly for artists, an important element of social media is its power to provoke strong emotional responses. The public format and real-time presence of its content make social media a perfect tool for stirring support for causes and social movements.

Perhaps for the first time in history, individuals and groups who may or may not enjoy sufficient resources or adequate power to launch a traditional media campaign have the power of voice. And many are harnessing this power to create significant social movements worldwide.

Bypassing the filter of traditional media and other gatekeepers to public awareness, social media makes it possible for compelling content alone—from anyone willing to put it out there—to drive actions, whether that action is to buy, to hire, to donate … or to join, meet, and rebel.

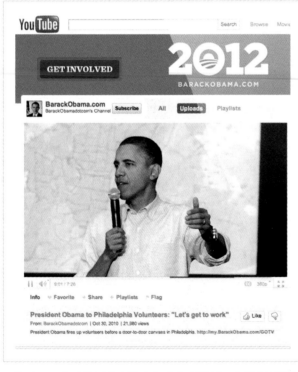

It was no coincidence that Obama rolled up his sleeves and omitted a tie when he rallied volunteers in Philadelphia, "Let's get to work!" His humility and approachability enchanted his supporters.

Two rather recent examples of how social media has moved the dial of public opinion and historical action include Obama's 2008 election and 2012 campaign and the downfall of Mubarak in Egypt.

Barack Obama Election/Campaign

Barack Obama was the first United States presidential candidate to recognize the value of mobilizing social networking as part of the political process. Instead of running a campaign that centered on the typical offline smear ads, Obama used social media to tell the world his personal story. He posted photos and videos of himself, and he encouraged people nationwide

to share their photos and stories online, too. He was thereby able to project himself as an authentic, forthright, and personable guy who really "gets it."

The comparison of socially networked campaigning and one centered on the negative, personal-attack ads that've dominated the US political election process in the recent past is something worthy of analysis. But I'll leave that to the pundits for now.

My point here is that social media has allowed Obama to present his positions on political issues in an intimate and engaging way to a wide variety of people. And by inspiring people to use social media platforms to create their own videos and blog posts about presidential messages, Obama jump started the democratic process, particularly for younger generations who've not experienced much participation in the politcal process. For the first time in a long, long time, like-minded—and unlike-minded people, too!—are conferring and debating online about our nation's political issues and governance.

Further, the speed of information transfer via social media allows people to act and react immediately. So, during Obama's 2008 campaign, updates about political gatherings were posted, and citizens rallied in local communities. Those who couldn't attend in person rallied online. Everyone who wanted a voice had one.

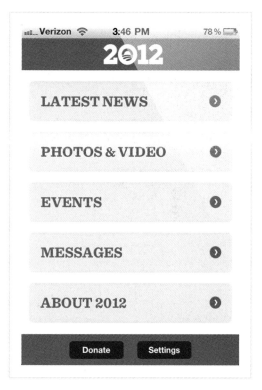

Obama's iPhone application keeps supporters informed on events and allows them to make donations with a click of a button.

This fostered an emotional wave of renewed trust in the US political process. And this phenomenon earned Obama enough voter loyalty and support to win the prize. I firmly believe that this campaign fundamentally changed national politics forever. Social media has activated democracy like never before in our nation's history!

But that's only half of the story! Aside from organizing the Obama movement, toppling

his opposition and mobilizing the youth to vote, social media continues to allow Obama to raise lots and lots of money. Ever notice that whether you're on his Facebook page, YouTube channel, iPhone application, or website, there is a donate button? He makes it as easy as possible to support him. So when a person becomes emotionally charged enough to make a difference, it can be done quite easily with a vote and credit card.

Egypt Mubarak

Another example of the potential power of social media is the resignation of former Egyptian President Hosni Mubarak in February 2011, following an 18-day uprising against his rule.

Despite the rules of martial law that banned Egypt's citizens from protesting, which had been in effect since 1967, organizers used Twitter and other social media to ignite the movement to remove Mubarak from office. Clearly, the sentiment of revolt had been present in the nation prior to the social media campaign, but the communication of logistics and the comfort of numbers gave citizens a clear call to action and knowledge that others would be there protesting, too.

The ruler was unable to curb the momentum of this movement. And the widespread dissemination of information about this uprising made it virtually impossible for the international community to look away.

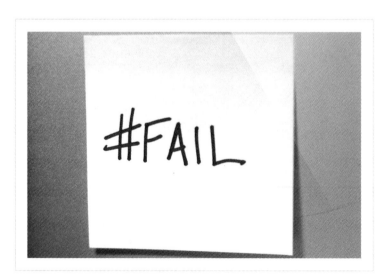

#FAIL is a common hashtag used on Twitter. It denotes "failure."

Of course there are protests, natural disasters, and other newsworthy events happening throughout the world on any given day, but this particular uprising used something special to organize the citizenry and claim the world's attention. Yep, it was social media.

Oh, and did you notice how terms that are commonly used on Twitter and Facebook were integrated into the actual protest signs? *#FAIL* is a term used on Twitter that denotes *failure*. The protest signs provided a way for others to follow the event as it progressed, and it demonstrates how integrated Egypt was with the world at the time of these protests. That is, Mubarak's association with the #FAIL hashtag became a widespread message that was understood by many opposed to something in Egyptian Arabic. Indeed, social media is a vernacular in itself.

As shown by these examples, social media can be quite powerful when used as part of a communications strategy. The real-time presence of social media content fosters an emotional trigger when content is compelling. And it can generate powerful response by traditional media outlets, too, which can reinforce and, in many ways, legitimize a position or story.

So I'll say it again: social media is one of many tools that can be used in your marketing mix. Deciding if it's the best platform at any given time is part of the process of strategic planning, which we'll cover in the next chapter. Developing a strategic plan is all about deciding what you're trying to accomplish and mapping out the executable steps for achieving the kind of business you envision. Let's get started. ✪✪✪✪✪

Socializing

An Interview with Kenny Kim, photographer

TWITTER: @kennykim
BLOG: blog.kennykim.com
WEBSITE: kennykim.com
FACEBOOK: facebook.com/kennykimphotography
INSTAGRAM: @kenny_kim
GOOGLE+: kennykimdotcom

Do photographers really need a blog?

It's funny that you ask me this. About a year ago, I simultaneously posed a question on my blog and Facebook: "I'm thinking of stopping my blog and migrating everything to Facebook. What do you (readers) think?"

Most replied by adamantly disagreeing with my thinking. They said it would be a mistake for me to give up posting on my blog. And, ironically, all the replies were coming from my Facebook account.

I did not stop writing my blog, and this experiment convinced me to focus more of my energy on other forms of media, mainly Facebook. It's important to maintain a conversation with readers, and these conversations need to happen amongst other readers. Right now, Facebook allows that to happen most conveniently. The blog brings it all together and provides a central staging point.

If you write a blog, what should it say?

If you are a photographer writing a blog, I believe your blog needs to convey your personal side in a professional way. If your clients are perusing through your website, you need to help them feel connected to you by showing your personality. But that does not mean you should write about anything and everything you're doing or thinking. There is a fine line between being professional and personal. The trick is to formulate content that reflects your professional side in a personal way. If you can do this, then your readers will get to know you as a person and as a photographer.

How do you use social media?

I currently use social media for many facets of my life. Professionally, I use it to connect with my clients and to share my images. Personally, I use it to keep up with the latest news and deals and to stalk some of my favorite celebrities. Ha.

If you have only one hour a day to devote to social media, how should you spend the Time?

Spend the time connecting with people on Facebook and sharing your images from recent shoots. Engage with people who start threads related to your interests.

Are you afraid of negative feedback via social media ruining your credibility?

Regardless of how any negative feeds come in, there's a lesson to be learned in each criticism. While getting negative feedback might not be the most pleasant experience, I welcome it and think it's great that someone cared enough to take the time to write something about my work. Beyond that, I try to see the perspective of the sender to figure out what I can learn from the feedback. Then, rather than worrying about a comment, I keep doing what I do, which is providing excellent services to my clients. Hopefully my actions can show who I am and what I prioritize.

If someone disagrees with something you say on social media, how do you handle it?

Sometimes agreeing to disagree is the best policy when it comes to this. Everyone is entitled to an opinion and to share it. A good way to handle this, in my experience, is to paint a bigger picture and try to be in the shoes of your audience to understand where a person is coming from. If the discussion goes out of control online, then it's sometimes best to resolve it through a private chat or personal discussion so you do not clutter other people's news feed.

#chapter2

Strategic planning is the process of defining how a business will compete in its marketplace. It's the roadmap, so to speak, of an organization that guides the team toward desired outcomes. A well-considered strategic plan makes it easier to establish priorities over time and use resources efficiently.

There are three basic components to a strategic plan. They are—in order of hierarchy—goals, strategies, and tactics.

Goals must be set before anything else takes shape; because without goals, we're aimless. Think about it in terms of driving with no sense of where you want to go. A lot of time and fuel can be wasted by meandering through neighborhoods and urban centers without getting anywhere. But with a clearly defined destination—a goal—the effort is validated and worthwhile.

So if your goal is a destination, then *strategies* lay out how you're going to get there. Strategies are the set of actions that function together to achieve the goal. It's the route in our road trip analogy.

Getting lost in Italy is not fun. Without a clear sense of direction, frustration and anger can quickly creep up. Photo taken by Lawrence Chan at 24mm f/1.4 for 1/320 second.

Finally, *tactics* are the details, the specific moves and turns that you take to achieve your strategy. Tactics must remain nimble and able to change as obstacles and opportunities present themselves in the real world of implementation.

But first things first. Before we can develop meaningful goals, we need to know where we stand right now. Where does the business currently fit into the market in relation to competitors and in the minds of consumers?

A popular exercise for making this assessment is known as a SWOT Analysis. So before we talk further about goals, let's look at the Strengths, Weaknesses, Opportunities, and Threats of your business.

SWOT Analysis

A SWOT Analysis can help you identify your internal and external circumstances, so you can decide which actions may be most advantageous—and perhaps even harmful or irrelevant—to your business. Here's what we're talking about:

- **Strengths** are attributes that give you an advantage over your competition.
- **Weaknesses** are characteristics that put you at a disadvantage in terms of your competition.
- **Opportunities** are circumstances that can help you maximize profits.
- **Threats** are challenges that could undermine your business.

By understanding the internal and external factors of your business, you can more easily determine what actions will yield the greatest profits and minimize risks. And knowing where your business is positioned in the market can help you sculpt relevant goals for the future.

Structural Goals

We've all been reminded at some point(s) in our lives to keep an eye on the prize—the goal! It's good advice, because your goals represent the end-game of your efforts; they're the purpose of your work. And I believe that every business, before developing any kind of financial goal or other short-term kind of business objective, needs to build the three-legged stool of structural goals.

Structural goals are:

- **Vision**
- **Mission**
- **Desired Market Position**

Let's explore these different goals to find out how they work together to define a company's purpose.

Vision

A company's vision statement is a long-range, potentially impossible aspiration. It articulates the ultimate goal—the dream—and communicates the company's primary values. A fundamental element of any business, a vision statement requires careful consideration, because it will ideally serve as a beacon of inspiration to guide leaders and employees through the choppy waters of days and years—perhaps for the entire lifespan of the business.

Sydney's Opera House is an architectural masterpiece. From 1957 to 1963, the design team went through a dozen designs before figuring out a way to create the shell ribs. HDR photo taken by Lawrence Chan at 16mm f/5.6.

A vision statement is not necessarily a goal that you share with clients or competitors. Of course you *can* share it publicly, and many companies do, but a vision statement is more of an internal compass that can help you define your professional priorities.

We'll talk more in this chapter about setting goals, and we'll determine that goals should typically be attainable; but part of the beauty of impossible goals is that they can motivate us to stretch our efforts. They inspire us to envision achievements that extend beyond our normal limits and thereby push us to exceed the boundaries of what we thought we could do.

Certain to Stretch

It's tough to argue that setting realistic goals is important, because achieving them and moving on to a new goal establishes momentum. Yet I fully believe in setting impossible goals, because they can stretch our capabilities and help us avoid complacency. Further, ambitious goals require us to make certain sacrifices, and this can lead to great rewards.

Let's look at Google's vision statement as an example. It's *Become the perfect search engine.* Even though the company has publicly recognized that search engine perfection is impossible—that "Search is a problem that will never be solved"—Google still challenges itself to work toward that goal. And the company continues to improve search functionality. (Amen!)

Mission Statement

A company's mission statement defines its purpose—what it intends to do. A well-crafted mission launches the journey toward the vision. It helps you prioritize the use of your resources and develop time-related milestones for your business.

So don't confuse a mission with operational or financial goals, as in, "If we photograph X number events at X price, then we will make X dollars per year." The two kinds of goals are quite different.

Let's use Google again as an example. The Google mission is *We organize the world's information and make it universally accessible and useful*. This is what Google does—not this week or this year, but always.

When developing your mission, also be careful to not confuse your personal aspirations and those of your business. It can be tough, especially for a professional artist. The mission is a statement that tells the world what you do.

Market Position

With a firm vision and a well-considered mission statement, it's time to figure out where your company best fits in the marketplace. Your market position goal centers on how you want the market—your potential clients and even your competitors—to perceive you in terms of your status and capability in the field of business.

The more specific you make your market position, the more influential you can become in your niche. Conversely, a broad and loosely defined market position means less control.

Think of it in terms of war. Would you rather be responsible for defending a large flat piece of land with miles of perimeter or sit alone on top of a tall hill where you stand apart and can see competitors coming from a mile away? Right, you're much safer at the top of the hill. It's easier to guard.

So while there will be times when you have new ideas or whims of inspiration, you'll need to be cautious and ask yourself whether these ideas align with your company's vision, mission, and desired market position—or not. For instance, after a wildly inspiring workshop on food photography, you'll need to decide whether or not offering food photography services would enhance your brand or confuse it.

The long view, indeed. Atop the Swiss Alps, one can see a great distance with clarity. Photo taken by Lawrence Chan at 16mm f/13 for 1/100 second.

It's not always easy to follow through with the structural goals you set for your business, because we naturally want to take any photography job that pays. But you'll have to say no sometimes and stick to work that supports your positioning; because in the long run, diversification will hurt your market position by confusing customers about who you are and what you do.

By committing to a niche, you must commit to not being everything else. Sacrificing sucks—at first. But it's the only way to define who you are. Here's a simple formula for crafting a market position goal:

1. Choose one word that defines you. You're selling a boutique service, so your personality is a huge asset.

2. Choose one word that defines your craft. What form of photography are you providing?

3. Choose one word that defines your target audience. We cover audience in Chapter 3. For now, just try to narrow it down to one word.

4. Add specificity by adding a location (optional). Where are you operating?

Here's an example. I am a(n)…

● **Edgy**
(defines *you*)

● **Edgy wedding photographer**
(defines *you + your craft*)

● **Edgy wedding photographer for stylish couples**
(defines *you + your craft + your target audience*)

● **Edgiest wedding photographer for stylish couples in Orange County**
(defines *you + your craft + your target audience + location*)

Niche
A well-defined niche requires minimal defending and yields maximum profits for any client looking for this combination.

WEDDING

EDGY STYLISH

PHOTOGRAPHER

The more you slice the market to define your position, the smaller your pool of potential clients gets—but the more market share you'll potentially own in that niche. Of course, how well you can deliver on your promise (in this case, to actually *be* an edgy photographer who creates images that stylish clients love) will ultimately determine your success, but that's a whole different issue.

Just keep in mind that most clients are unsure of what they really want. People do, however, tend to like someone who is confident in what (s)he does. For instance, most of us would prefer to have a brain surgeon remove, say, fluid from our brain versus a general practitioner. But why? Both doctors have a medical degree. Well, the thing for me is that only one specializes in brain procedures. There's comfort in that daily practice.

But don't let your market position dampen your creativity. It's not as though a specific and narrow market position needs to limit your range of work. Take a look at the image on the right. Without specificity, it could be described in a whole slew of ways. But by taking control of the image's description and using the words you desire, the image can easily support your market position.

Without prefacing the image, there could be a wide range of interpretations of the style of photography. Photo of Layla taken at Café Nuovo in Providence, Rhode Island, by Lawrence Chan at 50mm f/2.2 for 1/200 second.

So while some might describe it as *romantic*, I say it's edgy. And if your definition prefaces the image, viewer perception of it is more likely to align with yours.

So take another look. Does it matter if your niche is narrow? Does it hinder your creativity? I don't think so.

Just make sure that you stick with positive adjectives, like *stylish* couples. No one's going to say that they're not stylish. Seriously, whether people are wearing clothes as expensive as Gucci or stitching their own styles at home, they usually think they're rocking the look.

On that note, perception is very important in marketing. Especially if you have a lot of competitors providing photography products that look similar to yours, it's critical that you integrate your personality with messages that reinforce your boutique brand. This will go far in helping you stand apart. The more you're out there, portraying your unique voice, the less someone else is able to copy you.

Pick a Position

Using the example position we built with the formula earlier, let's say you want to be known as the edgiest wedding photographer for stylish couples in Orange County. If this is your ambition, you might wonder how to make sure that you are in fact the edgiest of them all.

To be making such a claim— the *edgiest!*—may sound far-fetched. But who says you're not? Art is subjective, so what you are is what you believe you are. Plus, there's no *edgy* police to monitor such claims anyway. You're unlikely to be approached with "Sir/ma'am, you do not meet the Edgy criteria by two points as set forth in Section 35C Code 77, so please rescind such title immediately." Snort.

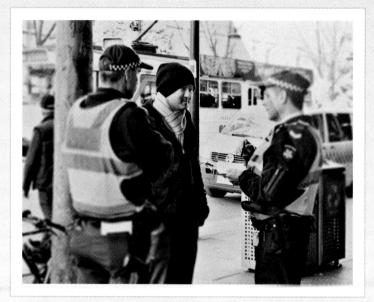

Photo of a citation in Melbourne, Australia, by Lawrence Chan taken at 35mm f/2.8 for 1/250 second.

You will encounter many distractions and many temptations to put your goal aside. ... But if you hang in there, always following your vision, I have no doubt you will succeed.

👍 *Larry Flynt, American publisher and president of Larry Flynt Publications (LFP)*

And, of course, you don't need to pursue the title of *edgiest*. Choose anything. You could be a *classical* photographer or a *vintage* photographer just as easily. But do take a position—even if you think it's ostentatious. Any position is better than no position. It offers clarity.

But notice that *Orange County* (a location) is included at the end of this sample position to give it even more focus. With this, you're not competing for such a title across a Tri-State area, nation, or world.

But even if you do claim such a region, so what? It's how your customers perceive you that matters most. This is especially true when it comes to word-of-mouth marketing, which is after all what social media is. So by constantly reinforcing your brand through social media, you can arm your advocates with a way to distinguish you from your competition.

Think: "I know a wedding photographer who is really good." *Eeh*. Or … "I know an edgy wedding photographer for stylish couples based right here in Orange County." *Mmm*.

The second example offers more visual substance for prospective clients. If they're looking for an *edgy wedding photographer*, here's the one! If they're not, oh well. Not every prospect is an ideal client. Remember that sacrificing bit we covered earlier. (I know, it hurts a little, right?)

We'll cover audience development and content strategy in the next few chapters. For now, just pick a position,

Action Goals

Now that your structural goals are set, you can begin developing shorter-term action goals that support your grander ambitions. These goals represent more specific operational objectives that are typically developed and assessed annually or perhaps on a five- or ten-year basis. They are the baby steps—the sub-goals—that move you closer to achieving your vision, mission, and market position.

To establish meaningful action goals, it helps to use the SMART formula. SMART is an acronym for Specific, Measurable, Achievable, Relevant, and Time-Bound. Let's take a closer look at what this means.

Specific

Understand the goal. Make it clear and distinct.

- What needs to be accomplished?
- Why has the goal been set?
- Who is involved with meeting the goal?
- Where is the goal located, if it's location-based?

Measurable

Set metrics to assess progress toward the goal.

- How many [shoots] will be completed per day/per week?
- How much [per shoot] will be charged?
- How will other elements of your aspirations be measured?

Achievable

Be realistic when setting a goal.

- Is the goal practical, within reach?
- Can the goal be segmented into stages to make it more attainable?

Relevant

Set meaningful goals that improve your business. Use the SWOT analysis for reference.

- What weaknesses can be addressed for better business performance?
- What opportunities best complement your current offerings and can be most easily secured?

Time-Bound

Set a deadline for achieving your goal.

- Set short- and long-term goals (e.g., one week, one year, five years).
- What will you do if your deadlines are missed?

Strategies Support Goals

Strategies represent the grand plan for accomplishing an aim. And, full disclosure here: Thinking about strategy is truly more energizing for me than guzzling espresso. I love playing strategy games. And one that took away years from my life … but made it worth living in some respects … was StarCraft.

StarCraft is a war-strategy game that, in my opinion, makes it very easy to understand the concepts of business strategy. So here we go.

The goal of StarCraft is to dominate territories by eliminating competition with military force. Having a strategy to win is key. Without a strategy, a player might just send waves of foot soldiers out to their deaths.

Strategy without tactics is the slowest route to victory. Tactics without strategy is the noise before defeat.

👍 *Sun Tzu in The Art of War*

Are you wondering what's wrong with that? I mean, if the goal is to win by plundering enemy forces, why doesn't it work to send out waves of foot soldiers to obliterate the opposition? Well, us geeks know that it's a terrible idea. Here's why.

The Arc de Triomphe is a monument in Paris that honors those who fought and died for France in the French Revolution and Napoleonic Wars. Photo taken by Lawrence Chan at 24mm f/9 at 1/125 second.

Remember, the goal is to overpower enemy territories—to win a decisive war. You can't just send out parachute soldiers without knowing where to deploy them. That's a death sentence.

Below are some strategies to consider.

- **Harvest Resources:** Find building materials to fund war machines.
- **Locate Enemy:** Send out scouts or use satellite technology to determine where an attack will cause the most damage.
- **Build Sufficient Defenses:** Make sure that if enemies attack, you won't be obliterated before reinforcements arrive.
- **Create Long-Range Fighters:** Attack from a distance, on the ground and in the air and sea, to minimize casualties and destroy frontline defenses. For example, USA might use B52 bombers, battle ships, tanks, cannons, and mortar teams.
- **Create Mobile Forces:** Use mobile foot soldiers to defend tanks and other long-range vehicles. And use cruiser ships to support the main carrier.

Similarly, it's important to develop solid business strategies to accomplish your goals. Strategies outline how you will compete successfully to win the business in your desired market. They represent operational decisions about how you will communicate with prospects and meet the needs of customers. They specify how you will gain and sustain advantage over your competitors, how you will find and handle new opportunities, address growth, and more.

The executable steps, the tactics, come next.

Tactics Support Strategies

This is what I consider to be the fun part of strategic planning. If you're not geeking out with me here, sorry. Stick with this though. It will help you use social media in a smart way to promote your work.

So, alright, social media overall is usually considered a strategy—as in, build long-term relationships with prospects and clients to establish and retain loyalty.

> *All men can see these tactics whereby I conquer, but what none can see is the strategy out of which victory is evolved.*
>
> 👍 *Sun Tzu in The Art of War*

Sample Strategic Plan

Goal

Be [known as] the Edgiest Wedding Photographer for Stylish Couples in Orange County

Strategy I

Develop an Edgy Online Image

Tactics

- Design a blog to reflect edgy and bold colors (hot pink, red, black, etc).
- Post edgy imagery on blog.
- Get your work featured on blogs that promote edgy culture.
- Share avant-garde inspirations in art, culture, and politics.
- Create photo essays that document the stylish/edgy side of Orange County.

Strategy II

Portray Edgy Personality

Tactics

- Dress in edgy clothes (e.g., smart with a hint of rebel).
- Participate in somewhat high-risk activities, like surfing, snowboarding, and skydiving.
- Advertise in bridal platforms that denounce tradition and embrace an unorthodox approach to weddings.

Portrait of creatively edgy artists taken by Lawrence Chan at 45mm f/2.8 for 1/200 second.

Strategy III

Reinforce Edgy Brand via Social Media

Tactics

- Filter for edgy brides by offering a field on your contact page that says, "Submit Edgy Wedding Date Here."
- Encourage your edgy brides to attract other Orange County edgy brides through online interactions and sharing.
- Define yourself as an edgy wedding photographer in all social media profiles.
- Share edgy content on Facebook.
- Include links related to Orange County and its stylish/edgy culture in your Twitter posts.

Beyond this description of a general course of action are various social media platforms, which are tools (*tactics*) for implementing it. In other words, tactics are the executable actions that support a strategy.

Another example: Let's pretend that one of your strategies is to establish yourself as an authority figure in your industry. This is a popular ambition, because people naturally gravitate toward experts, and expert advice is trusted. Well, tactics to support this strategy might include creating or sharing existing content regarding your craft and broadcasting it via social media. Indeed, over time, people would likely begin to perceive you as a knowledgeable authority figure on the topic you cover.

In business, everything you do should be executed with clear intent. If you're ever unsure about an action, ask yourself to name the strategy that the action supports. Maybe even push yourself to identify what part of your goal(s) the strategy fulfills.

Now, with a strong strategic plan—a clear vision, a meaningful mission, a well-defined market position, and action goals to push you ever closer to your vision—you're ready to further define your target audience. ✪✪✪✪✪

Homework

Create a desired market position. Try to formulate an identity that amplifies your company values. Be sure that you don't confuse personal ambitions with your company's goals.

Post the results of your draft market position in our forum http://www.tofurious.com/forum/. Feel free to peruse what others have posted and respond to existing threads. This will be a safe environment where others like you can help, share, and learn.

Proceed to the next section when ready.

Socializing

An Interview with Zach and Jody Gray

TWITTER: @ZachandJody
BLOG: zachandjody.com
FACEBOOK: facebook.com/ZachandJody

Why are goals necessary in a business?

We sat down in the fall of our first year in business and created a mission statement (to articulate what we wanted our business to be about) and set goals for where we wanted to be in five years. We knew that "without a plan, the people will perish," as the saying goes. A plan gives us something to reach for.

Our plan was to earn a six-figure income, have a business working for us—instead of us serving our business. Without those goals, we would have floundered. We would have kept doing what we were doing throughout the first six months of our business, which was running a very unprofitable company!

Financial adviser Dave Ramsey says, "Where you want to be in five years is dependent on two things: the books you read and the people you meet." Well, we know that our business went from making $500 for our first wedding to being in the top 10% of wage earners in the US in just one year. This is primarily a result of the business books we read and the influential people we met.

Goals are necessary, because they give direction to your efforts.

Do you think it's important to set unachievable goals or to pick only the low-hanging fruit?

Neither! We think you should set goals that are attainable, but represent a major stretch. As an example, when we set our financial goals for our first year in business (which was to make a six-figure income), I (Zach) had never made more than $12,000 in a single year of my life. I was 27 years old, had not graduated from high school, and had never run my own business. Six figures was a seriously high goal for me personally. But deep down, I knew it was possible if we worked hard enough.

If you set enough goals that never get realized, you can get discouraged. So it is good to break down goals into manageable steps that help you get there.

When we set our financial goals, we knew that in order to make six figures, we needed to decide how many weddings we wanted to shoot (our target was thirty for 2008). This meant we needed to make a profit of at least $3,300 for each wedding. To do this, we had to ensure that the package we wanted to sell most was highly enticing to potential clients.

We built a $3,000 package that contained *almost* what we knew people wanted, but it was missing some key things (like the disk of images, which most clients were getting at the time). So we also built a $4,500 package that contained exactly what most clients wanted. (It included the disk of images.) This second package gave us more profit than the $3,300 we needed per wedding. So our sales process centered on selling that package most of the time.

We knew we needed to book at least two to three weddings per month to hit our goal of thirty per year. To do this, we needed two to three wedding planners, photographers, and past clients referring us to engaged couples. We knew who we needed to ask for help, how to price ourselves, what we needed to sell, and when to hit our goals—and that is how we did it!

One of the newest goals of our business is to serve and aid other photographers in their businesses and help them reach their goals. Since photographers are avid about social media and love to get content delivered to them that way, we use these tools to reach our audience and deliver helpful content.

With 750 million people on Facebook and all those people looking for information there, we know this is one of the most important areas in our business. We use social media by giving our clients images and content—delivering first. When we shoot a wedding, we have images available for our Facebook and blog audiences within 24 hours of the event. Speed is key. Also, under-promising and over-delivering is a proven way to excite a client and get them talking about you after the transaction.

We always say that you should give a client a reason to talk about you (as in, you rocked it for them with great service) and then give them a tool to do it (like getting images of them on Facebook so they can share). The easier you can make it for someone to talk about and sell you, the more likely they are to, yep, talk about you and sell you. Social media is ideal for this.

#chapter 3

AUDIENCE MATTERS

You know how a pyramid network operates, right? One person tells two people, who each tell two more people, and so forth. Well, social media is very much like that; its gig is sharing, spreading, and cultivating ideas in an updated word-of-mouth kind of way. And it's quite effective at building an audience— quickly. But are you attracting the *right* audience to meet your business goals?

If you're not sure, you're not alone. Many business owners have trouble figuring out who their target audience should be. I mean, it's anyone who's willing to hire you and can pay, right? Well, no.

Identifying a target audience is similar—and just as critical to your success as a business owner—to building a strategic plan. It falls closest in line with the desired market position. Yet it's important to understand that your target audience contains more than clients and prospects. There are also colleagues, industry bloggers and other communicators, and even your suppliers. Your social media content must resonate with each of these groups in a specific, targeted way.

In Chapter 4: The Power of Content, we'll dig deeper into the fertile ground of content and go through some important elements of cultivating credibility and trust within your industry. This is where your interaction with and recognition by colleagues, industry thought-leaders, and suppliers come into play. These groups can help broaden your exposure and boost the public's perception of you as an expert in your niche.

For now, think about growing a social media program as your backyard garden in a drought. Given a limited water supply (read: public attention span), it's smarter to localize

Focus on the elements you want to grow instead of wasting resources on barren ground with little chance of rewarding your investment. Photo of small garden in Tyrol, Austria, taken by Lawrence Chan at 24mm f/1.6 for 1/640 second.

your effort and pour water directly on the flowers and vegetables you hope to grow than to spray indiscriminately, wasting the valuable resource on peripheral concrete and barren ground—areas that are unlikely to offer return or reward.

Zoom In

As mentioned, a photographer's audience potentially includes clients and prospective clients as well as colleagues, industry bloggers and other communicators, and even suppliers. And while your fellow photographers and industry influencers are probably scattered throughout the world, your clients and prospects are likely local.

In this respect and others, each group has a different kind of information need, so it's important that you recognize this and handle your content accordingly. Yet what they all share is a common interest in your business or industry. They are all interested in possibly hiring you for a shoot, collaborating on a project, learning about your work, and/or providing you with equipment.

In Chapter 5, we'll explore some social media platforms and identify those that are especially good for reaching certain groups, but it's important to craft your messages in a way that's meaningful for those you're trying to reach. And this has everything to do with your business goals, as we covered in Chapter 2: Strategic Planning. So let's take a closer look at who you want to pursue for business.

Ideal Customers

When you're considering who you want to attract as customers, refer back to your structural goals. What's your vision, your mission, and your desired market position? Not everyone with a heartbeat and a wallet is going to fit your criteria for an ideal client.

The low-hanging fruit, so to speak, are folks who have some interest in what you're selling. For instance, if you're a wedding photographer, then you're probably looking for engaged couples and soon-to-be brides—or maybe even mothers of engaged women. Food photographers would naturally be interested in connecting with restaurant owners, food bloggers, and publishers of food-related magazines.

Shared experiences and demographic attributes can help foster a productive business relationship. That is, a mom looking for someone to snap memorable photos of her new baby is very likely to hire a photographer who is also a mom. People simply tend to

trust and feel comfortable with those who are like them, those who share important life experiences. Plus, there just aren't too many single male photographers specializing in baby or maternity photos anyway.

Using the desired market position example that we developed in Chapter 2: Strategic Planning, if you aspire to be known as the *edgiest wedding photographer for stylish couples in Orange County*, then your target customers are stylish couples in Orange County who are looking for an edgy wedding photographer. They are the folks who are most likely to use your photography services and perpetuate your market position.

Here are some examples of how a target audience might be described for various types of photographers.

- **Wedding Photographer:** Engaged women in the greater New York metro area between the ages of 25 and 34 earning more than $50,000 annually.

Photo of Taryne and Nishan de Silva at Beverly Wilshire taken by Lawrence Chan at 135mm f/2.8 for 1/160 second.

- **Food Photographer:** Owners of non-franchised restaurants operating in the Pacific Northwest region of the US.

Photo of pesto chicken with angel hair pasta taken by Lawrence Chan at 35mm f/2.8 for 1/1000 second.

- **Portrait Photographer:** Families in Charleston, South Carolina, with a minimum annual household income of $100K.

Photo of Logan and parents taken by Lawrence Chan at 24mm f/6.3 for 1/60 second.

Photo of Florence, Italy, taken by Lawrence Chan at 35mm f/16 for 1/100 second.

- **Travel Photographer:** Editors for print and online travel magazines as well as producers of travel-based television programs.

Remember the spiel about sacrifice. Commit to your niche, because operating in the market with well-defined and targeted products and services helps you maintain consistent customer expectations—and deliver on them. This can cultivate a culture around you that attracts other people looking for the same results. Then, *voilà!* You've got yourself a known commodity within a secured niche, and this leads to successful business.

So where do you find your ideal clients? Well, the more you know about them, the easier it'll be to track them down and (joke alert) … shoot them.

Examine

To understand what kind of information and content your various audience groups might seek out and value—so you can provide it and eventually win their business—visualize everything about them. A common set of attributes that set a group of people apart from

the general population is known as *demographics*, and they can help you profile the components of your target audience. Ask yourself:

- Where do they live?
- How old are they?
- How do they dress?
- What cars do they drive?
- Where do they work?
- What holidays do they celebrate?
- Which charities do they likely support?

Be as specific as possible in your answers. When considering their clothes or cars, don't ignore brand names. And think about the background, personality, likes and dislikes of these people. Do they recycle, go to the farmers' market, wear fur coats? Are they more likely to vacation in a tent or a luxury hotel? Also consider where they get their inspiration. For example, we know that brides look through bridal magazines, but I know that many of my clients regularly read *Vogue*, *Marie Claire*, and other high-fashion publications. That's why I choose to focus on high-fashion poses. It's what my clients see most ... and want to emulate in many cases.

Listen

Whatever you can't visualize about your audience, you can find via social media. It's a sharing bonanza! Thoughts, pet peeves, questions, whatever. It's pretty much all online these days. So take advantage of the information that's so easily available.

For fun, do a search on Google for, "I'm scared about my boudoir session," or "Questions for my [wedding, senior, baby…] photographer." A lot of information comes up. And most results are honest opinions from real people in forums, blog posts, and tweets.

So listen and take in what people have to say. It'll go far in helping you get into the minds of your clients. And this insight can ensure that you have the information necessary to develop services they want, address their concerns, ease fears and so forth. You can become the custom-made photographer for the clients you want to serve.

> *The most basic of all human needs is the need to understand and be understood. The best way to understand people is to listen to them.*
>
> *Ralph Nichols, author*

Expose the Needs and Wants

Most of us learned the difference between needs and wants in elementary school. But it can be tough to differentiate sometimes, especially when we really, *really* want something. Like when we find that pair of jeans—on sale!—that fit perfectly.

It can really and truly feel like a full-blooded need. But technically, needs are the must-haves in our lives, the things we can't live without—like food and water. Wants are everything else; they're all the perks we'd *like* to have, like tickets to the Super Bowl or a Canon 70-200mm f/2.8 L IS II Telephoto Zoom. Ahhh …

So what is it that your audience needs … or thinks it needs? What experiences are they seeking?

Of course, newlyweds pretty much *need* photos of their wedding, but if resources are lean or no one really cares about fancy photos, some might just ask a friend with a nice compact or disposable camera to take photos. This is perfectly fine, but maybe you could be that friend with the *big* camera at the wedding getting paid (at a friendly rate) to take photos.

Similarly, the senior-care center with disability assistance dogs may need images of the animals to promote this special service. If the budget is low, an employee or friend may just take a snapshot to post on the center's website. That works, too.

And really, pretty much anyone can take nice photos nowadays. With digital cameras and affordable, easy-to-use photo editing software programs, it's not difficult. Technology has dramatically reduced the learning curve and made it pretty inexpensive to get ahold of decent images.

But if you're looking to create a profitable business through photographing weddings, animals, kids, food or any other subject type, then you really need to be charging a premium for your services—and stick to your standards.

For this to work, your ideal customers need to know what makes you so special. What are you offering that people need or want enough to hire you instead of doing it themselves? I don't know the answer, but you need to think about it, believe it, and make sure your audience gets the message.

Ultimately, your ideal customer must want nice, professional-grade photos of their event or offerings so much that they perceive a real need. Your passion for quality and your work should align closely with that of your clients. It's okay to walk away from a job because a client does not value and share your passion for what you do.

For example, let's take a look at why people choose Apple computers over alternatives. I mean, there are computers that are faster, cheaper, more robust ... and overall better. So why Apple?

Apple's 1997 Think Different campaign branded Apple users as "crazy enough to think they can change the world."

> Here's to the crazy ones. The misfits. The rebels. The troublemakers. The round pegs in the square holes. The ones who see things differently. They're not fond of rules. And they have no respect for the status quo. You can praise them, disagree with them, quote them, disbelieve them, glorify or vilify them. About the only thing you can't do is ignore them. Because they change things. They invent. They imagine. They heal. They explore. They create. They inspire. They push the human race forward. Maybe they have to be crazy. How else can you stare at an empty canvas and see a work of art? Or sit in silence and hear a song that's never been written? Or gaze at a red planet and see a laboratory on wheels? While some see them as the crazy ones, we see genius. Because the people who are crazy enough to think they can change the world, are the ones who do.

So, if you're freewheeling and liberated— a round peg in a square hole—then your ideology aligns with Apple's. You buy a PC to be standard and compute. You buy an Apple to create and make change. It was a highly engaging and emotionally charged campaign, and it sold a lot of computers. We'll explore this advocacy approach more in Chapter 9: Brand Evangelism.

Search "Apple Crazy Ones" on YouTube to find the 1997 black-and-white commercial.

Capture

In my experience, hitting your target with any kind of marketing program really comes down to two things: emotional connections and credibility. We'll explore some important emotional triggers for photographers using social media below. But the credibility piece, which also relates closely with trust, is covered in depth in the next chapter (Chapter 4: The Power of Content).

Let's get in touch with some emotion for a bit …

Emotional Triggers

Emotions represent the most basic element of our decision-making. Sometimes, emotions become so strong that they overpower logic. Jealousy, for example, might motivate a guy to punch another guy in the face—even though he's bigger and stronger. Doh! Doesn't take long to learn *that* lesson.

Positively Powerful

When it comes to your photography business, I recommend that you focus 100% on positive emotions, because people tend to naturally avoid negative feelings. I really love Facebook's approach to voting on posts. There is a Like button, and that's it. You're welcome to comment freely or ignore a post, but there isn't a Dislike button. This keeps things a bit more positive overall.

What are the emotions that will trigger your target audience to hire, promote, or collaborate with you? Five common triggers used by social media marketers to engage their target audiences and earn their loyalty are described below:

- **Belonging:** Social media has made it possible, in ways that've never before been available, for groups in various geographical locations to gather and interact based on a common interest. Successful social media marketers understand that giving people opportunity and incentive to vigorously discuss and debate on their site(s) puts them in the center of the action.

- **Trust:** As an approach for attracting customer attention, trust is catching like wildfire, and I'd say that's a pretty good thing. Social media has encouraged companies to cut back on the fluff and spin and get more honest about their business offerings.

- **Value:** Similar to trust, social media marketers are offering greater value to their audience than traditional outlets could allow. Through instructional videos and other kinds of free information, businesses know that valuable industry insight sells. It keeps people coming back for more.

- **Quality Time:** People today are highly protective of their time. Experiences need to be enjoyable, valuable and/or exceptionally fulfilling. To attract and retain hard-to-capture audience groups, make sure that your social media sites are fun, engaging, and chock full of interesting content.

- **Trendy:** Many social media users are quite interested in being cool or trendy, so posting content on your site(s) that enables users to easily pass along interesting information, videos, images, etc. to their networks can earn you a strong following. The social media set responds well to concepts and content that support their perception of being tuned in.

Through social media marketing, especially as an artist, triggering these emotional cues will probably come naturally. Just stay focused on what you're doing, why you're doing it, and with whom. Let your goals be your guide.

Roadblocks

Ultimately, social media marketing, like all kinds of marketing, is about reaching and motivating buyers. But you're not the only juggler in the circus. So it can be very helpful to understand what hesitations your desired clients might harbor that could prevent them from actually hiring you.

To start, this information gives you an opportunity to offer solutions before desired clients can even fully think of objections they may have. People tend to value information sources that answer questions they hadn't thought to ask. It builds trust.

And people absolutely need to trust you—to do a good job, to not embarrass them, to be fair, etc. What comes up when you Google search your name or business name? Ideally, a search engine query will reveal your thoughtful contributions to forums, wikis, other blogs, and your own sites, too, of course. So definitely get out there and share your expertise.

But don't be too sterile. Pretend that a perfect-fit client is sitting across from you at a coffee shop. What questions might (s)he ask? How would you respond?

It's a crazy world. Everyone has an act. How will you stand out?
Photo taken by Lawrence Chan at 45mm f/2.8 for 1/160 second.

The goal of this exercise is to understand the thinking patterns of your ideal clients. By doing so, you can hone in on your personal characteristics and attributes that resonate most with these people.

So what are some roadblocks for closing the deal? Don't be bashful. Put yourself in the shoes of your target clients. Pretend that you're looking to hire a photographer and you know nothing about the craft. What are some of your concerns or objections? Here's what may be the most common one: You're too expensive. (Sigh.)

I handle this one during the initial photography consultation with my prospects by treating the conversation as an interview going both ways. This is important, because I need to know if they really want what I'm offering.

So if I start hearing requests for shortcuts and deals—like a session that's half my minimum hours, no prints, and all digital negatives on a DVD—I typically decline the

opportunity. This is not my target client. In fact, this situation could become seriously problematic due to the non-alignment of our values related to photography.

Some other objections, ones that may come up for a destination wedding photographer, might include:

- You could miss your flight and thus miss the wedding!
- It costs so much to fly you to the destination.
- You do not understand the native culture or language of the destination.

Of course, there are other potential concerns, but I hope you get the idea. And the thing is, to a professional photographer, these concerns seem ridiculous. Obviously, you'd fly out days before the wedding. But to a stressed out couple that's trying to plan a destination wedding, it's not so obvious. That's why it's smart to proactively explain that

you need to be there ahead of time to test lighting and positioning and other aspects of the location to prepare for the shoot, and that you'd never propose saving money by flying out on the day of the wedding.

In the case of a boudoir session, the following concerns might bother some prospects.

- I need to lose more weight.
- I don't know how to pose to look sexy.
- I feel nervous and uncomfortable.
- I don't know what to wear.

Earn client trust by preemptively responding to common concerns. Using the destination wedding example above, let's explore two ways of answering these objections before they see the light of day.

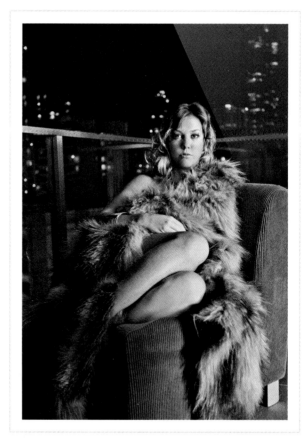

Not all women are models. Making a subject feel comfortable is important. Boudoir photo taken in Gold Coast, Australia, by Lawrence Chan at 35mm f/2.8 for 1/160 second.

Consider creating an FAQ document to address every standard concern. Just remember to change the presumptuous statements into questions.

- What precautions do you take to ensure that you arrive at the destination in time for my wedding?

 Understanding how unpredictable tropical storms are, I always fly to destination weddings a few days prior to the event in order to avoid any potential interruption in travel that's caused by nature or other unforeseeable situations.

- Can you pay for your own ticket, or share the cost with us, to shoot my destination wedding?

 Moments like your wedding happen only once. Make sure you have someone you trust to capture the special union.

 Basically, cost shouldn't be a factor.

- How will you manage in the destination if you do not understand the native culture or language?

 Fortunately, most resorts throughout the world have service staff members who speak English and cater to American standards.

Preemptive Comfort Example
Swivel Vacuum

Using infomercial style, get ahead of the worry curve by explaining your service in terms of possible hesitations that could stop buyers from accepting your offer. In the case of my fictitious swivel vacuum cleaner, I'd say, "It works on thick carpet and won't scratch hardwood floors. And when you're done, use one click to fold it into a tiny two-inch contraption that fits between your wall and refrigerator."

This pitch addresses several possible roadblocks:

- Does it have enough power for thick carpet?
- Does it scratch hardwood floors?
- Will it be an eyesore that takes up lots of space?

As a buyer, I might be so wowed with the first two attributes that the third one simply enhances the vacuum to best gizmo ever.

Another approach is to subtly integrate the proactive solutions into a blog or Facebook post, as shown in the fictitious blog post (next page), which was written after a destination wedding.

Sample Preemptive Blog Post: Livin La Vida!

Okay. Note to self: I have to convince my husband to move to Cancun … permanently. I am having such a great time. So sad my four-day trip is coming to an end. Has it already been four days? Man, time really does fly.

Guess I better hurry to order another one of these coconut cocktails. They just don't make 'em like this back home. I do so love destination weddings. Four days of total bliss. Acclimation and preparation requirements for the shoot are the best perks of my job!

Seriously, tropical storms are as unpredictable as my five-year old's mood, so I always fly out a few days before any wedding. Can't let *that* Mother affect my flight schedule! Can you imagine missing a wedding cause of a storm? Ugh, that's every bride and photographer's nightmare! No way that's ever happening for one of my projects.

Anyway, you want to know something kinda surprising (but cool for me!) about most resort-style living? Everyone speaks English. Awesome! In your face, Ms. Spanish-teacher-from-high-school! I'm kidding. I'm super thankful for my four years in Spanish class. "Uno mas …uh, coconut drink por favor!"

See you all at home … too soon!

Photo of Helen and Matt taken at Ocho Rios, Jamaica, by Lawrence Chan at 45mm f/2.8 for 1/200 second.

Of course, you could also address objections in person. Just keep in mind that whatever you can do to put your clients at ease, the better off you'll all be. So my recommendation is to use a multi-pronged approach to this. Create an FAQ and post it to your Investments page (prior to your pricing information), and integrate proactive solutions into everything you write.

An example of an organization that's doing this well is Zappos!, an online company that sells a wide array of products, but is best known for shoes. What are some concerns with buying [shoes] online? I personally had tons—until I really checked out Zappos! They've literally addressed all objections. You can't lose.

- 365-day return policy
- Free shipping both ways (if you return)
- Free returns (no restocking fee)
- 24/7 customer service available by phone

Now tell me why you wouldn't give this a try?

Photo of Lawrence Chan next to Zappos's fashion text analysis display board at the company's Las Vegas headquarters.

Evaluate

To monitor the progress of your audience acquisition and retention goals, social media metrics should eventually come into play. And it's probably safe to say that you'll need to go beyond the standard freebies of most platforms, which focus more on participant volume and activity than the quality of your audience and business outcomes. We'll cover the available metrics for various social media platforms in Chapter 5: Social Media Channels, but for now think about how you will know if you've accomplished your audience-recruitment goals.

- From where is your traffic coming?
- Who is interacting with you and your other fans and followers?
- How interesting are your audience comments and contributions?

Assuming that your participation in social media is to engage actual potential customers—as well as your fellow photographers, industry thought leaders, and suppliers—and to foster meaningful dialogue with these groups, be sure to track related metrics to check your progress.

I suggest looking at audience engagement numbers, trending topics, and participation by industry influencers. But ultimately, you want to make sure that your social media efforts are producing new clients, keeping existing clients happy, and fueling the green machine of your business. ✪✪✪✪✪

Homework

Think about your target client. Pretend that (s)he is sitting in front of you right now. Use a separate sheet of paper and answer these questions.

1. Tell me about this person in extensive detail. Feel free to even give him/her a name.
2. What are his or her frustrations with photographers? You can even describe a bad experience that a friend had.
3. What are your prospect's top fears regarding photography?
4. What are the prospect's top desires ... beyond nice photos?
5. What products or services do you offer that your prospect may not know about?
6. What common interests do you have with this person?

Socializing

An Interview with Jerry Ghionis

WEBSITE: jerryghionisphotography.com

How do you use social media for your business?

In the photography world, people know who I am. In public, few know me. So when couples are searching for a wedding photographer, they come to know me through social networking, and the articles and blogs that surround my work. In that sense, social media has helped my business quite a bit.

Why do you have videos on your website?

The videos that show me working give folks a way to properly get acquainted with me. I didn't want to be too "in your face" by having a photo of me or a video of me saying, "Hi. I want to shoot your wedding. Look at how great I am..." I'm not that kind of person. The videos are a softer, more modest version of that.

Have clients pointed out how helpful it is to see you working on video?

Absolutely. That has been a real big plus for me, because people feel like they already know me when we meet. They're used to my jokes and antics.

The videos give a heartbeat to the person and the logo. You know what I mean? Clients see a name, but they have no idea who that person is. So, the video shows that, apart from getting great images, clients can have some fun, too. They've worked wonders for me.

What is your suggestion for a website design?

Your website is your most powerful marketing tool. No doubt it is the window to your world. I want people to browse my website. And to make this happen, you can say I upgraded my website by downgrading it. In other words, I created this whiz-bang website a few years ago. It cost me $20,000 and it was different from anything else anybody had. But it had more star than substance. It was flashy and a bit too opulent. This made the website more powerful than the images.

So I changed to a simple website. I want a simple user experience—no more than two clicks to find anything. And since I made that change, the inquiries have been coming in faster. I really think it's because of the simpler website design. The more basic website made my work look more appealing.

In fact, I gauge the performance of the website based on use of the contact form. If it's within reach, people will use it. In the past, people went out of their way to email me directly instead of using my contact form. Maybe this is because the website was too elaborate or a bit too busy. Now, we get about two inquiries a day through the contact form. Before, we'd get one every couple of weeks.

What would you recommend other photographers do to build a strong online presence?

The big thing I do is post wedding albums. I promise that if you go to 100 photographers' websites, you'll barely find three people who do complete wedding albums online. No wonder photographers are selling only JPEGs. So few of us are planting a seed in the minds of clients to buy a full wedding album. But this is a great approach, I think.

#chapter 4

There is *a lot* of information in our lives … on a daily basis. In fact, there's so much data persistently coming at us—from our smart phones, car radios, and televisions to the billboards we pass and the books and magazines we pick up—that it's nearly impossible to appropriately filter what's important.

But with a good action plan (a content strategy) for your social media program, you can help the people in your target audience cut back on thousands of extra bytes they are likely to consume while searching for information about your craft. Becoming their one-stop shop for, say, newborn photography in Savannah or gourmet pastry photography on Long Island can reward you handsomely in readership and loyalty.

> *Content is important. Good content tells the world who you are as an artist. And that's what people are investing in.*

 👍 *Jasmine Star*

TWITTER: @jasminestar
BLOG: jasminestarblog.com
WEBSITE: jasmine-star.com/
FACEBOOK: facebook.com/JasmineStarPage

Action Plan

It's all about the fans, right? Well, there's no way around it. You've got to deliver the goods to earn the love. If you don't, it's fairly certain that someone else will—or already is. No one has the time or tolerance for irrelevant posts.

In other words, if you insist on posting frivolous information, like how terrible your day is, people

There is an information overload in our modern society. Offer focus and quality content and you will be rewarded with loyal readership. Photo taken by Lawrence Chan at 50mm f/16 for 1/320 second.

> *It takes a lot of work to create good content. So every Sunday I sit down and schedule what I'm blogging for the week. It really helps to have a map on how to approach that week. Without it, I might not maintain the frequency I need to stay visible.*

 Jasmine Star

are unlikely to engage with you … at least on that update. And if you continuously convey such self-focused information, expect your audience to dwindle. Few care about that kind of stuff.

So think about what interests your audience. And develop an action plan to keep people engaged in your posts. I recommend a healthy dose of content strategy along with some personal humor.

By *content strategy,* I mean a framework of what you'll put out there to reinforce your brand's market position. Having a strategy will likely improve the cohesiveness of your content. Without this plan, your updates might leave your audience perplexed. You could talk about how to entertain cats one day, why you really love using a zoom lens on another, and how reality television has affected the movie industry on a third day.

But if, from the very beginning of your social media work, you have a strategy to focus on pets—because you're a pet photographer!—then you'd include the animal angle in all of your posts. I mean, you want cats playing in the frame when photographing the family

Effective delivery is just as important as quality content. For example, Gabby looking for a midnight snack is a humorous approach to display pet photography. Photo taken by Lawrence Chan at 27mm f/4 for 1/200 second.

pets, right? Similarly, a zoom lens allows you to snap a close-up of that cute pet boa constrictor from a safe distance. And, duh, you'll definitely want to tell your fans about your upcoming shoot with Paris Hilton's dog for the movie promo.

Whatever your actual tactic, just make sure your content is consistent with your strategy. In my case, I am a total foodie. So many of my updates contain food-related photos, even though I'm a wedding photographer. In fact, my topical consistency has actually reached a point where my audience anticipates the subject of my photos before they even see my posts.

Set up a certain level of expectation for your readers. With some consistency, you can train your audience to read your tweets in certain intervals, open your emails on specific days, and respond to posts, knowing that they'll get a response. It's content that people await, because they know, essentially, what to expect.

The goal is to stay in the minds of your audience.

Know Thyself ... and Stick with It

At this point, we've developed structural goals for your business and profiled your target audience, which contains ideal clients as well as professional colleagues and those who influence opinion in your industry. And we determined that the best way to capture the attention of this audience is to consistently create content worth reading, seeing, and sharing.

> It's almost impossible to fail being yourself.
>
> It's almost impossible to succeed being someone else.

But this is often easier said than done. It can be tempting to embellish stories of your experiences or to feign knowledge in areas you think might make you sound a bit cooler than you actually are. Don't do it though! No matter how creative you can be or how well you can pretend, it's just not possible to fake an expertise or persona for long. People can sense a load of BS pretty quickly. Basically because it'll start to really stink.

So instead of trying to trick people, produce content that is authentic. Create and share information based on what you really do know. And speak in a language that your audience will understand. Honestly, pretend that your audience groups are gathered around a table. Write as you would speak to them. Even if that means separating them into different groups and scheduling one-on-one time to talk about specific topics. In other words, talk to *people*. Be natural, and segment your communications if that's most appropriate.

This also means that you shouldn't shy away from talking about personal stuff. You don't need to limit yourself to being a photographer. But, of course, show restraint. Don't share more through your social media content than you would when talking to a stranger at a cocktail party or on an airplane. You've got to protect your brand. And while sharing photos of your night out in Vegas might amuse some of your followers, it can create confusion about who you are. Ultimately, this can hurt your business, especially if your target audience consists of a rather conservative bunch, who may not like the drinking and gambling sort.

Be Personable

It's true that most of us respond best to those we like and trust. When you share interesting information about yourself and your work, and give people free helpful advice, relationships grow—both ways. That is, as you interact over time, your audience learns more about who you are, and you learn more about them.

> My rule of thumb is what I call "The Man on the Airplane Rule." I broadcast on social media no more than what I'd feel comfortable telling a person sitting next to me on an airplane. When you use that as a barometer for yourself, it's fairly safe to say you'll stay within the boundary of appropriateness.
>
> Jasmine Star

Armed with insight to your audience's fears, wants, objections, and so forth, you can more easily create and share content that's valuable to them. This keeps 'em coming back for more and (hopefully) motivates them to share your content with friends. It's a productive cycle, because the more you put out there, the harder it is for others to imitate you. So be personable, establish yourself as a familiar and trusted voice, and get to know your audience.

This may seem like common sense, but believe me … it's not commonly practiced. Building relationships takes time, and not everyone is wired to take the long view. A far more impulsive approach is to focus content on reminding people that you're an expert at what you do professionally. But it can be equally important, sometimes even *more* important, to share the personal stuff about yourself. Think along the lines of sharing information like you love dogs; your favorite evenings are spent preparing a gourmet dinner; you're a mom to a child who's deaf; and/or you have a passion for competitive bicycling.

And don't be afraid to reveal your imperfections. Vulnerability conveys authenticity and helps to build trust. We tend to envy, fear, and sometimes even despise those who are so sure of themselves that confidence turns to conceit. It's just not comforting to be

Whether you compete locally or internationally, share your experiences. Photo of 2009 Tour de France at French Riviera taken by Lawrence Chan at 50mm f/7.1 for 1/100 second.

constantly reminded that the person you're talking to is smarter, prettier, stronger. Yet we admire those who are capable and know what they're doing/saying. So try to walk the thin line between confident and conceited to make yourself approachable through your social media work.

This will go far to personify your brand, because people want to relate to the product and services they use. It's that belonging thing we covered in Chapter 3: Audience Matters. When folks see a face with which they relate or a message that resonates, they can become emotionally triggered. And this brings them closer to you.

Think about how some popular brands use this approach. One of my favorite examples is Dos Equis' The Most Interesting Man in the World campaign. You've seen the tv spots and YouTube videos. In a sophisticated Latin accent, the "most interesting man in the world" explains, "I don't always drink beer. But when I do, I prefer Dos Equis."

He's a fictitious spokesman for the Dos Equis brand, and he advocates a life lived interestingly. The campaign is a spoof featuring over-the-top glamour and adventure, profiling the guy we all want to be … or the one we'd all like to know.

> He once had an awkward moment, just to see how it feels.
> He can speak French, in Russian.
> The police often question him, just because they find him interesting.

Hilarious. And the company even invites its audience to compete online to join the League of the Most Interesting. By winning preselected challenges in the categories of Vitality, Dedication, Intellect, Charisma, Accuracy, Nerve, and Synchronicity, participants can collect medals and attempt to qualify for a spot among the top 100 competitors, who advance to the semifinals in Mexico to compete for the distinction of supreme candidate in each of the seven categories.

And of course, there's an app for this contest, because "a true Exemplar is never tied down." Brilliant.

Similarly, Subway's "Subway Diet" campaign, which launched on January 1, 2000, and featured Jared Fogel—an Indiana guy who lost 245 pounds in one year by switching from a lifestyle of fast food meals and little to no exercise—awakened millions to the appeal of the chain's low-fat offerings. Putting a face, and a real experience, with the Subway

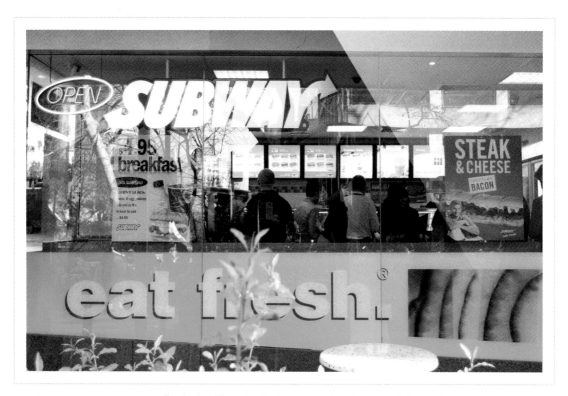

Subway restaurant focuses on eating fresh, which indirectly demonizes unhealthy pre-made foods. Photo of Subway restaurant taken in Sydney, Australia, by Lawrence Chan at 25mm f/2.8 for 1/160 second.

Show Yourself!

Don't hide behind your photography results in your online profiles. Instead, use a flattering picture of yourself. And dress slightly above your audience, but do not go overboard. Remember, you want them to relate with you. If you're too fancy or appear unkempt, you separate yourself, which can hurt your appeal.

brand helped the company secure a market position as a healthy alternative to fast food. The campaign made dramatic weight loss feel within reach to people hoping to slim down.

Subway strengthens this market position through a national sponsorship in healthful events, such as American Heart Association Heart Walks, local triathlons, and children's sports teams. The company also launched a social media component, called the Slim Down Challenge, which gives people an online forum to monitor weight loss.

The face of this masked avenger, V (from V for Vendetta), was a comic made into a movie in 2006 and has become an icon for freedom fighters against an oppressive society. Some protestors even adapted this motif as a symbol for rebellion (reference: http://en.wikipedia.org/wiki/V_for_Vendetta). Every brand needs a relatable face. The topic is explored in Chapter 9: Brand Evangelism.

Photo of spray-painted motif on a Paris dumpster was taken by Lawrence Chan at 24mm f/4.5 for 1/100 second.

Emotional Triggers

As mentioned in the previous chapter on audience development, successful organizations understand the value of knowing the emotional triggers of their target audience. It's no secret that the power of emotions can create desire, close sales, create advocates, and influence other types of outcomes.

A good example is Oreo's use of love to promote its brand: See http://www.youtube.com/watch?v=q2TGEm-PzYE. Objectively, Oreo is just a cookie. But in this presentation, Oreo is a way to connect a family and to celebrate Mother's Day.

As a social media marketer, it's helpful to remember that emotions are contagious. Ever watch Oprah, Extreme Makeover, or America's Got Talent and hear an inspirational story? I know I can't help but feel emotionally charged by this stuff. And the funny thing is that

I find myself talking with other people about these stories, and they're interested! Yet we don't have any real connection to the people on television.

If you don't know what I'm talking about, go on YouTube and search for the eight-minute video called, "Korea's Got Talent Homeless Boy Sung-Bong Choi." You'll see what I mean!

Your photography can have the same effect if you focus on creating images that trigger emotion. No doubt, when people see a photograph of a bride's father crying, they will relate to it and feel something meaningful.

So take a cue from companies who are getting this right. Think about Disney. You go to Six Flags for the rides, but Disneyland for the memories and experience. Consider Subaru. You buy a car for transportation, but you invest in a Subaru to ensure your kids are safe. Clearly, your business goal is to sell photography. But you can be more by offering a positive experience or feeling.

Just remember that emotions are also quite resilient. That is, our emotional response to certain images and people tend to stick. So when you help someone selflessly, they generally think of you over time as a generous person. But if you're rude to someone because you're in a hurry or having a tough day, they'll probably always think of you as an ass. It's tough to shake these initial emotional perceptions, so try to make the ones about you and your work positive.

A great example of trigger power is Purple*feather*'s video (http://www.youtube.com/watch?v=Hzgzim5m7oU) about how the right words can change the impact of a message. In the video, a woman helps a blind homeless man harness emotion to get the donations he needed from passersby.

The homeless man had a sign that read, "I'm blind. Please help." Some people spared a bit of change when they passed him. When a certain woman passed by, she changed the words on the sign to "It's a beautiful day and I CAN'T see it." People began emptying their pockets. It clicked.

The same information was provided, but the message was different enough to make people understand the guy's predicament. The woman helped the man connect emotionally with passersby. People *sympathized* and took a minute to consider what it meant to be without the basic function of sight.

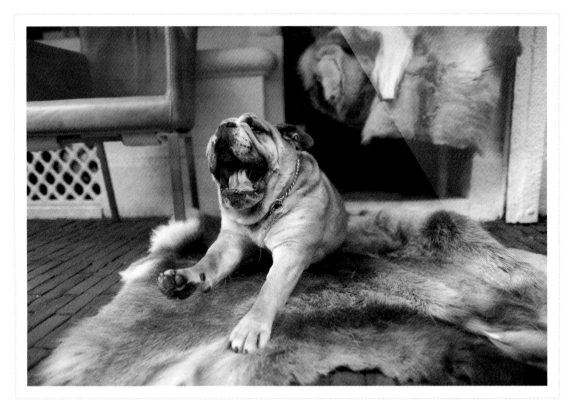

I always find this picture of a dog yawning to be funny, because it's an animal personifying human traits. I took this photo in front of an Amsterdam rug store at 24mm f/1.4 for 1/500 second.

How can you use emotions to motivate your audience to take certain actions? Below are some options for triggering audience emotion:

- **Surprise:** You know the feeling you get when presented with an unexpected gift? Well, give that same emotion to your readers by presenting little treats and extra value. For instance, consider offering a free wallpaper image (with your copyright and contact info on it) on a random day that you're feeling generous.

- **Curiosity:** Teasers from photo shoots are always fun. It leaves readers eager to see and learn more.

- **Hope:** Even *symbols* of hope trigger an emotional response (like the Statue of Liberty). So share photos that convey human kindness and resiliency whenever the opportunity presents itself.

- **Secrets:** Information privy to only a select few is delicious. Did you know that many restaurants have secret entrees not listed on the menu? Learning the inside scoop is fun and exciting, and it reinforces the satisfaction of belonging.

A glacial lake and other naturally beautiful landscapes often evoke feelings of peaceful bewilderment.
HDR photo of Alaskan glacial waters by Lawrence Chan, photographed at 24mm f/7.1.

- **Awe:** Photos of majestic scenes are always inspiring. Share photos of dramatic landscapes or the hands and feet of a newborn baby to trigger feelings of reverence and wonder.

Amplify Your Message

When developing content for your social media audiences, do not muddy your message by trying to cater to all forms of photography or to address everyone who may be interested in *some* kind of photography service. Focus only on creating content for your niche and reinforcing the market position you've decided to pursue (as covered in Chapter 2: Strategic Planning).

A lack of focus hinders your ability to speak with authority and build equity in your brand. It confuses clients about who you are and what you do. And this is particularly harmful for your business in terms of your potential for word-of-mouth marketing, which is really what social media is all about, right?

For example, Bobby Flay is all about barbeques and grills. I won't get that mixed up with Duff Goldman from *Ace of Cakes*. So if I'm talking with someone who loves baking, I definitely refer them to Duff's show. Similarly, you want to make it simple for your audience to categorize you. This makes it more likely that your readers will refer folks interested in your niche to your blog and social media pages.

And honestly, it's just weird for someone to go out to the world saying (s)he specializes in weddings, portraits, family, children, food, *and* seniors. Sure, (s)he's perfect—for anyone with skin. Well, we all know that a jack of all trades is a master of none. It's better to be highly proficient in a narrow niche than to sorta kinda be able to do a lot of things.

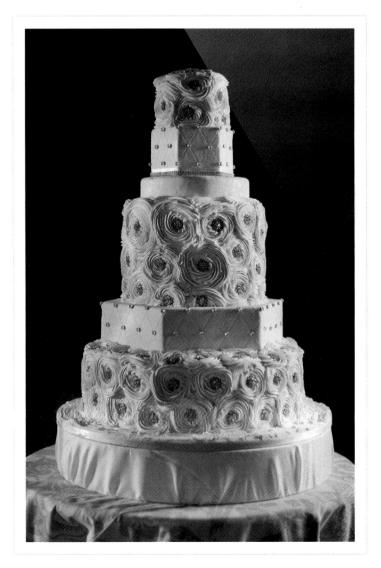

This ivory butter cream wedding cake with rosettes was photographed by Lawrence Chan at 50mm f/1.6 for 1/200 second for *Wedding Style Magazine* 2011 editorial shoot.

Think about A1 Sauce. What kind of meat comes to mind? I think most Americans would say steak. Few would confuse A1 as a sauce for pasta or pork. This is because the brand has done a good job of securing its niche ... for almost 200 years! A1 dominates the North American steak sauce market.

Of course, selling outside of your niche may give your business a temporary boost in sales, but an unfocused brand cannot sustain market share in our increasingly competitive marketplace. Successful businesses know this.

Consider Arm & Hammer, a brand of baking soda. Despite the fact that baking soda can be used to bake cakes, clean ovens, and even clean teeth, the company focuses on one niche: deodorization. It's become a no brainer to put a box of baking soda in the fridge to keep things smelling fresh, and cat owners seem to like the company's kitty litter, too.

Delivery Persona

When broadcasting your focused and valuable content, consistency in your delivery can be important. And authenticity also matters here a lot. Again, you want to use a persona that suits your personality and comes natural to you. It's okay to wear different hats on different occasions, but definitely choose a primary role for delivery.

Some examples of delivery personas are educator, motivator, comedian, and even some kind of unique combination of these or other roles that fit your personality. Let's take a closer look at what this means.

Educator

Educators teach us things and make us smarter. Educational content improves people's lives. So, as an educator, be sure that your content is helping folks learn something new. The goal here is to become a likable authority figure in your niche, because people trust authority figures.

One way to do this is to make your content too valuable to throw away. That is, make it print worthy. Receiving content from you will feel like getting a new issue of a magazine or sitting in a very interesting class with a terrific teacher.

Just keep in mind that your educational content does not always need to contain information on how to take better photographs. You can talk about hair grooming for dogs (if you're a pet photographer). But be sure to include your beautiful photos of dogs.

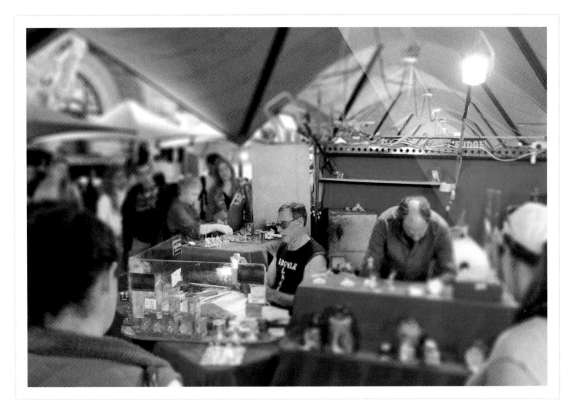

Normally, glass trinkets might not be too interesting, but a glass blower demonstrating how they're made interested shoppers who hovered around to watch and learn. Photo taken in Sydney, Australia, by Lawrence Chan at 25mm f/2.8 for 1/100 second.

Or you can provide a step-by-step recipe for, say, Fragrant Orange Chicken with Scallion Mashed Potatoes and, of course, include the scrumptious photos you snapped of your own preparation process. This is a way to promote your photography work while offering helpful information to your clients and other audience groups.

It's important to find new ways of doing this, because constant selling gets frustrating. For example, my friend recently bought an Infiniti. And for months after the purchase, she continued to receive emails about why she should buy an Infiniti! *Unsubscribe*!

If the company was smarter, it could have strengthened its relationship with her by sending emails with ideas on what she could do with the car, like suggestions for road trips along the coast of California (where she lives) or for drive-in theaters nearby, where she can put the top down and have a romantic evening with her boyfriend. Wasted opportunity.

This HDR photo of a drive-in theater in Los Angeles shows a venue waiting to be filled with patrons. Image taken by Lawrence Chan at 24mm f/10.

Motivator

Motivators make people feel good emotionally and thereby inspire them to do good things for themselves and others. Depending on your goals for using social media, your intentions to motivate certain actions will vary. Maybe you want to inspire your readers to share their own stories of personal triumph or to reinforce the status of especially loyal readers. If it's the latter, you might give them special access to certain content or referral gifts. This is likely to motivate them to share the rewards you bestow with their own networks, if you allow it.

You can also motivate your audience by acting as a conduit for a charity or cause. For example, in observance of Blood Donor Awareness month in January, you could offer a free 5x7 print to any of your past, current, or future clients who can show proof of a blood donation in January. Or put together a team of clients and/or colleagues to participate in a walk or run event to support the Leukemia & Lymphoma Society

(http://www.teamintraining.org/). This kind of activity can build awareness for causes you care about while motivating your audience to team up with you to effect positive change.

Just remember to remain authentic in your efforts to motivate. People are quick to spot a gimmick to earn their loyalty, and being insincere here can cost you dearly. But using appropriate motivators for social media marketing can earn you a following of brand advocates who will eagerly spread your "good news." See more on building market allegiance in Chapter 9: Brand Evangelism.

A last bit of advice on the role of motivator: be humble. Avoid any pretentiousness or condensation. If anything, take a position of self-deprecation. And focus on positive things. Be hopeful and make even the most difficult tasks seem possible.

Comedian

Humor can go a very long way in boosting your social media appeal. Truly funny content is pretty much universally enjoyed. C'mon, *no one* hates The Most Interesting Man in the World.

But being funny to the audience you're engaging begins with listening to them. As covered in Chapter 3: Audience Matters, listening to your audience is a fundamental element of success in social media. It's the primary benefit of using these tools in the first place, right?

Social media is the only marketing platform that allows your audience to respond back to you, and this can give you loads of insight to how they think and what they want. They'll basically tell you what they think is funny, which can help you avoid the deadpan silence every comic fears. So make sure you pay attention and use what you hear from your audience to develop your material.

Don't try to monopolize the interaction though. When you really know your audience, it gets easier to converse naturally with them in the open forums of social media. In this format, you basically want to volley conversations to keep them going.

Stay away!

For heaven's sake, be sure to stay far, far away from sensitive topics like politics and religion. That stuff might humor a few, but it is just not good judgment to offend anyone on that level.

For example, say a guy posts something about being very nervous about what his bride is going to look like in the crazy feather veil she decided to sew herself after watching a documentary on unique headpieces. What can you say? Lighten things up by replying with some truly horrific bride images (that were not taken by you, of course) and asking your readers for caption ideas. It can't get *this* bad, right?

Just don't overdo it. If you're basically a funny person, that'll come through. As you relate to

What caption fits best? Go. This photo of an art piece at the Museum of Contemporary Art in Sydney, Australia, was taken by Lawrence Chan at 16mm f/2.8 for 1/100 second.

current events and popular topics, go ahead and use all those bad puns and clever play on words. Just don't force this approach. Know when to close down the laugh factory and talk straight. Seriously, we all know *that guy* who doesn't know when to stop, right? (Groan.) Don't be annoying.

In fact, humor can be especially effective when it's unexpected. Take Ford's new social media campaign that features a "spokespuppet" named Doug—an obnoxious personality who provokes trouble with presumably stuffy auto execs. The campaign is

Skittles
If you drop Skittles on the floor, you should abide by the 3 million-second rule.
July 10 at 9:00am via The Rainbow · Unlike · Comment · Share

You and 17,781 others like this.

View all 1,319 comments

Write a comment...

Skittles plays on popular themes in society to populate its social media updates, and the company creates clever jokes that circle on its brand.

being developed in the popular mockumentary style by comedic A-listers behind some of the most successful shows ever, including *The Simpsons*, *The Office*, and *Curb Your Enthusiasm*. Its purpose is to attract attention to the new 2012 Ford Focus. Funny by Ford will be discussed, no doubt.

Say What?

So all that authentic and delivery approach stuff is well and good, but what does your audience really want from you? Despite your terrific listening skills, I doubt they could order it ... even if you asked and they tried. It's hard for anyone to accurately define what (s)he wants. Most people simply do not know what they want—either due to a natural aversion to loss (picking one thing at the potential cost of missing out on better alternatives) or a basic unfamiliarity with the options.

For instance, say you're shopping for a computer and aren't familiar enough with the technical components to make an educated decision. A salesperson may approach you and ask, "What type of computer are you looking for?" A normal response might be, "Something for my office" or "Something good enough for games."

Did you notice that these responses define user benefits and not technical specifications? Right! Let's think about this more.

Emphasize User Benefit

No matter how excited you are to tell the world about your fantastic new camera bag or to show off the amazing photos you shot on Thursday, be careful to avoid coming across as self-indulgent. If you want people to care about your posts, figure out how your news benefits your audience, and emphasize that information.

> *What do clients gain by your news?*
> *How are you contributing to the improvement of photography in your field?*
> *Who's doing great work that you admire?*
> *What's happening in your industry that's interesting/motivating/controversial?*

Truly, very few people will bother reading the specifics about your business. So while it is probably super cool that you just bought a new Canon EF 100mm f/2.8L Macro IS USM, this is unlikely to interest your clients. Instead, these people want to find out how your

While it might be sufficient to describe the entrée as "snails," it might sound more appetizing if described as "escargot bourguignon baked in traditionally seasoned parsley-garlic butter." Photo taken in Paris, France, by Lawrence Chan at 24mm f/1.4 for 1/160 second.

equipment and skills can help them. So don't get nerdy about your gear when you're talking with clients and prospects; instead, make sure your audience knows that your photos can be crispy clear—even as large canvas prints.

That said, other photographers are often interested in the opinions of industry leaders when it comes to gear. So anyone looking carefully at the new Fujix100 camera as a potential new addition to his/her equipment bag will be looking for opinions. Zack Arias loves it; Scott Kelby doesn't. And both photographers have written about the camera on Facebook and Twitter. To me, this made for interesting reading, but I'm a photographer and love some good gear drama. So, again, what's important is that you're writing for the audience you're trying to reach.

No Silver Bullets

Only make claims you can deliver. That's how you build and hold onto your audience's trust. So don't get crazy and try to offer your audience silver bullets. Rather, focus your

content on easy, actionable tactics that can help your readers make better decisions about photography. Explain, for instance, that shooting in the early morning or late afternoon is best, because the sunlight is softer and warmer.

That's good advice for those who don't already know about the Golden Hour, and it's a good reminder for those who do. Whether they use you or not, they'll know that the photographic results will be better if a shoot is scheduled for early morning or late afternoon. Thanks! What else you got?

Tell Stories

Storytelling is a proven method for conveying information. It's been used since the beginning of language, because … well, it works. People listen to stories and they usually keep listening until the story ends. This is important, because especially in today's ADHD culture, it is rare and remarkable to capture attention.

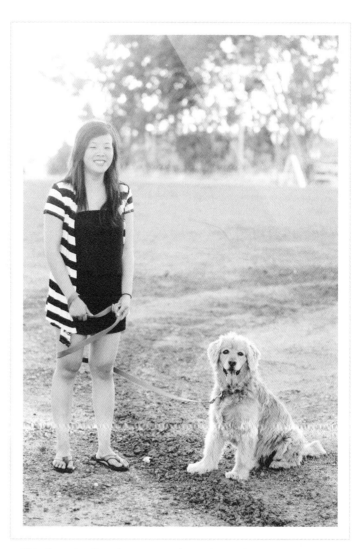

This photo of a girl and her dog was taken in the late afternoon Golden Hour by Lawrence Chan at 70mm f/2.8 for 1/400 second.

I recently overheard someone say, "Facts tell, stories sell." And it might be the most powerful statement I've heard in a while! Fine, it's true that I haven't been getting out much. But there's no denying that a good story gets a certain hold on people. It fuels our cultural addiction to entertainment. And it's probably one of the reasons that social media is so popular. Stories are everywhere.

Only Helen can make her usually serious husband laugh and wrinkle his nose.
Photo taken by Lawrence Chan at 45mm f/2.8 for 1/1600 second.

So whether you're writing about your clients, yourself, or an event, use stories to convey your ideas. It's a natural way to put people at ease and open their senses to what you're saying. And remember that images tell stories, too. Share pictures that show climactic moments of interaction.

Become the Authority

A common goal for using social media to market your business is to be the first photographer people think of when looking for the type of services you provide. With good, reliable content, you can dominate your niche and be first to mind when your target clients are considering a purchase or just looking for accurate information about the kind of work you do.

Remember, not everyone who reads your social media posts will be a future client. But they could easily refer clients to you or share your material with someone who's in

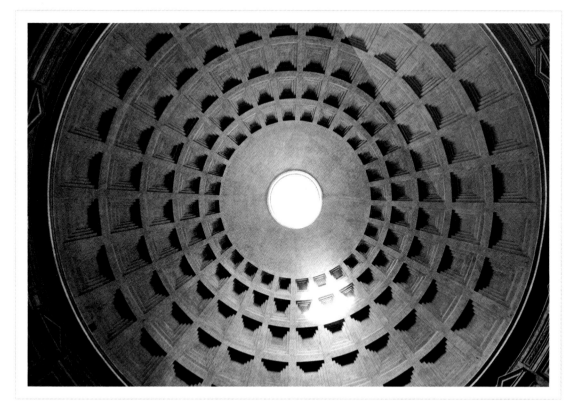

Even though someone may never have been to the Pantheon in Rome, Italy, (s)he might recommend it to a travel or history junkie as a must see. Photo taken by Lawrence Chan at 16mm f/3.5 for 1/60 second.

the market to buy what you're offering. So keep in mind that social media marketing is about creating conversations with customers to project and solidify your position in the marketplace. Dominate your market with interesting and informative information.

Teach people about your trade, and thereby become an authority figure. But take a moment to reflect on the authority figures in your own life. Think about your professors and bosses. That's right. Being an authority figure can put you in a position of high regard … or crippling disdain. So remember to practice humility. A little self-deprecation can go a long way. The goal is to be a *likable* authority figure, right?

Is there someone in any niche industry that you love and respect as an authority figure? As I've mentioned, for me it's Bobby Flay from the Food Network. My food-related decisions are always swayed, at least a little, by his influence.

Flay has a number of shows, but I like to watch *Grill It!*, in which he shares ways to grill foods. And if there's a specific barbeque sauce, for example, that he likes, it's definitely the one I'm most likely to buy. He's a proven authority in all things barbeque, so I trust him.

But realistically, I have no idea if his foods taste good. I don't ever actually try cooking his recipes. So there could easily be someone better at barbequing than Flay. But he shares so willingly and the Food Network validates him, so I trust him. Plus, there isn't anyone else (that I know of anyway) who has claimed that niche. And those who do not share will never be known as authority figures. But I won't trust Flay with butter; that's Paula Deen's department.

So, just as Flay demonstrates how to cook, you can demonstrate how to create a certain kind of photograph.

Some coffee companies host free workshops to educate consumers on how to properly brew espressos and differentiate quality beans, including theirs. In addition to exposing people to their superior beans, the complimentary education creates an affinity for the company. Even if a hobbyist learns how to brew espresso at home, I doubt that (s)he would stop buying coffee while at work. Photo of Blue Stone Café in Sydney CBD, taken by Lawrence Chan at 35mm f/2.8 for 1/80 second.

Okay, I hear you. I knew it'd come up. If you're thinking, "If I show people how to photograph like a pro, why would they hire me to do it for them?" So here's the thing: Even though Emeril Lagasse shares his cooking secrets on television and in his cookbooks, I still go to his restaurants to eat. Please, a casual hobbyist isn't going to produce the quality of a practiced professional.

So when someone has a baby, she may use some of what she's learned online and in photography books about how to take cool photos of babies. But eventually, if she really cares about capturing the baby's milestones in photographs, she's going to hire a pro. And who do you think she'll want to hire? A random person who has an ad in the local newspaper or the authority she's been following, learning from, and engaging? Even if her authority figure is a bit more costly than the anonymous advertiser, I'll bet she'll sway toward her information source. It's a matter of trust.

Validation

In Chapter 1: What Is Social Media?, we looked briefly at the importance of trust in today's online business world. And we noted that proof of your expertise can be the most important type of content you share. Well, the most convincing kind of proof comes from other consumers and personal experience. This proof validates that you can do what you say you can do. After all, it's always better—more believable anyway—for someone else to say that you're an awesome photographer than for you to say so yourself.

Let's explore the two forms of proof, or *validation*: social and real.

Social Proof

Social proof is a psychological phenomenon whereby trust is created based on the validations of outside entities. Trust emerges through an assumption that the source of proof possesses more knowledge about the situation than the one seeking proof.

If you're scratching you head, imagine that you're driving on an unfamiliar highway and you take an unfamiliar exit. You're mildly hungry. On the left is a restaurant with two cars in its parking lot. On the right is a restaurant with forty cars in its lot. Most other considerations being essentially equal, which restaurant will you visit?

Based on the social proof of this situation, we can probably assume that the restaurant on the right has more business, because it's better. So that's where to go. Yet we're

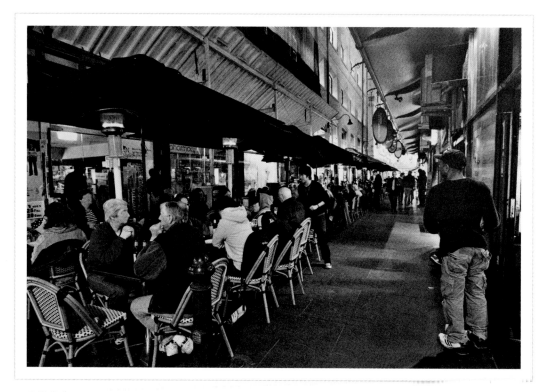

This photo of packed restaurants on Degraves Street in Melbourne, Australia, was taken by Lawrence Chan at 16mm f/2.8 for 1/80 second.

making this decision without any actual knowledge of the two restaurants. Maybe the owner of the more-popular-looking restaurant is having a milestone birthday, so everyone from the nearby town came to surprise him, including the folks who work at the restaurant across the street. Who knows?

Social proof is validation by people who are regarded as knowledgeable about a certain topic. Social validation is far more powerful than anything you can say about your own work. You can't buy the power of endorsements.

Just look at Timothy Ferris, author of 4 Hour Workweek and 4 Hour Body. He uses lots of testimonials for his crazy claims. Because really? Someone can work for just four hours a week and get amazing results? Hmm …

Even though I don't know the people giving the testimonials, the overwhelming support for Ferris' program coaxes me into believing that it's possible. The testimonials soften my disbelief and make the claims seem attainable.

Chan's Six Trust Rules

1. **You cannot sell directly to someone else**, because you have an ulterior motive. Clients will always ask, "What's in it for me?" and "What's in it for you?" This is why cold calls do not work. So don't try to earn business by emailing or otherwise contacting prospects directly with a sales pitch. Get them to come to you.

2. **...unless it is tied to a selfless cause.** Ever been approached by a Girl Scout selling cookies? Well, I bet you bought, because her motive for selling to you is not to get rich. She just wants to go camping and earn merit badges. It's easy to support her with a purchase.

3. **A friend can sell to you**, because for the most part, friends do not have ulterior motives. They try to help you. And this is what makes word-of-mouth marketing so effective. So focus on creating strong relationships with clients. Ideally, they'll sing your praises. (More on this in Chapter 9: Brand Evangelism.)

4. **Authority figures can sell to you**, because these are experts. For example, if Rachel Ray from the Food Network suggests a specific spatula for cooking eggs, that's the one I'm going to buy when I need a new spatula ... unless it's priced far out of my range for cooking accessories.

5. **Endorsements can sell to you**. When trying to choose, say, a restaurant, most people choose the one with more high ratings. So ask your happy clients to support you on popular sites with ratings. A high number of endorsements can change people's minds. Really.

6. **You can sell to yourself ...** or convince yourself that something is good, especially if it's something you've used or experienced before. I mean, we all know a Starbucks addict who bought a $4 beverage yesterday. Why wouldn't (s)he buy another one today? It becomes a costly habit, but it doesn't feel too expensive each day, even though there's free coffee at the office. It's all about anticipation and repetition. So let people try what you've got.

This photo of girls passing out free Monster energy drinks to passersby at SXSW (South by Southwest) conference in Austin, Texas, was taken by Lawrence Chan at 50mm f/2.8 for 1/1000 second.

Real Proof

Real proof is actual, physical, hands-on "I know it to be so" validation that the darn thing works. So, in the case of photography, this means proving that you really know how to shoot great pictures.

An example of this kind of proof being helpful, if not required, is when a new mother wants pro photos of her infant but fears that her baby won't be comfortable around a photographer—a stranger. To ease this concern, you could post a video of you acting super silly (but gently!) around a baby and making him laugh and play. In a private moment, you could also explain that you're using natural or still light, because babies are often sensitive to the flickering of strobes. Then, reveal the stunning baby photos from the session. This makes a darn good package of real proof that you can do the job (hopefully better than others) and keep the baby comfortable.

GE demonstrated its solar charged batteries by powering a carousel at SXSW in Austin, Texas. Photo taken by Lawrence Chan at 50mm f/13 for 1/5 second.

A great example of a guy who does this well is Jerry Ghionis, a wedding photographer who includes videos on his website that show him working on the job. See http://www.jerryghionisphotography.com/#/Movies/ to find out more.

Industry credentials and awards can also help prove your expertise, so pursue accolades that reinforce your strongest attributes.

Brand Association

Aligning your brand with another to elevate your social status or sculpt a specific perception of you is typically a good marketing strategy. For instance, if a guy pulls up in a Lamborghini and has designer shades on, it's safe to predict that he has something good going for him. His association with luxury labels elevates his social status.

Similarly, we figure that a guy driving a Prius is either concerned about the environment or saving money on gas. Even if none of it is true, association to certain brands helps us

Who Are You?

What's the first question strangers usually ask you when at a party? I'd say it's, "What do you do for a living?"

But why is that ever important? Well, it serves dual purposes. First, people are curious. They want to compare themselves with you. (Who makes more money?) Secondly, people are interested in assessing whether your association to your job can benefit them. For example, a juggler might not interest a doctor unless (s)he is interested in learning how to juggle and often treats broken facial bones.

Bottom line is that associations help define you. You are what you wear, eat, do. You're influenced by the people you hang out with. Of course, this may not hold true in all situations, but mental shortcuts are a reality.

This is why understanding your target audience is so important. Creating relationships through common associations to certain brands can make you more appealing. Still, don't fake it. Be yourself.

Brand associations include which hotel you book. Someone who stays at Aria Hotel might give off a different perception than someone who stays at Circus Circus. This HDR photo of Las Vegas was taken by Lawrence Chan from Aria Hotel at 16mm f/5.6.

Wedding Style Magazine has an online badge for photographers who are featured by the publication.

make this type of mental shortcut about people based on the cars they drive, the clothes they wear, and the stuff they do.

So you can solidify your position of authority by aligning your company with brands that enhance your desired market position. It's also helpful to be part of professional organizations and recognized by industry press, such as *Wedding Style Magazine's* Platinum List, which represents the best of the best wedding photographers.

The bottom line on social media content is this: If your posts are interesting to people and convenient to share, your audience will likely pass them on, increasing your exposure. And when they do, respond with a "Thanks!" Seriously, unless you're a celebrity, it's not likely that you're going to have so much social media action that you cannot acknowledge everyone supporting you. Remember, social media is all about two-way communication! ✪✪✪✪

#chapter5

With a solid communications strategy in hand for your social media program, now's the time to select the appropriate channel(s) to mobilize your thoughts. So we'll use this chapter to explore a number of social media platforms that are especially helpful for photographers.

Of course, we're only scratching the surface of possible platforms. There are thousands of different social media sites. From interactive gaming to social networks and sharing sites, there is a social media outlet for everyone. No two channels are the same. Each has its own features and limitations. So finding the right social media tool(s) can seem to be quite the task.

To help make sense of it all, this overview profiles some popular channels based on the following four categories:

- **social networks**
- **social sharing**
- **social news**
- **social bookmarking**

Try as many different options as you can and see what fits best for you. Just keep in mind that platforms change. Remember MySpace and Friendster? Well, it's quite possible that today's popular sites will face a similar fate. So stay flexible and keep your eye on the ball. That is, remember *why* you're engaging social media and what you're trying to accomplish.

Keep your tactics nimble enough to adjust to the realities of implementation. Fortunately, social networks can help with this, because the audience you build with these sites can move with you if and when you decide to try out a different platform. But I'm getting ahead of myself. Let's find some social media hotspots.

Social Networks

Web-based social networks offer users a way to connect with groups and people who share interests. As social beings, we're drawn to this type of connection. We're naturally curious about relationships among people we know. So social networking makes it very easy for others to discover you and your work.

A social network is different from other types of social media, because it is a platform that strictly connects individuals together based on common interests. A networking site allows for content sharing, but it's designed specifically to connect people and provide a place online for them to interact.

Usually, a social networking site launches to a user's profile page and includes a list of social contacts. These sites also typically include some sharing mechanisms, like instant messaging, email, and feeds that show posts made by the user's contacts.

One of the most popular social networking sites (right now anyway) is Facebook.

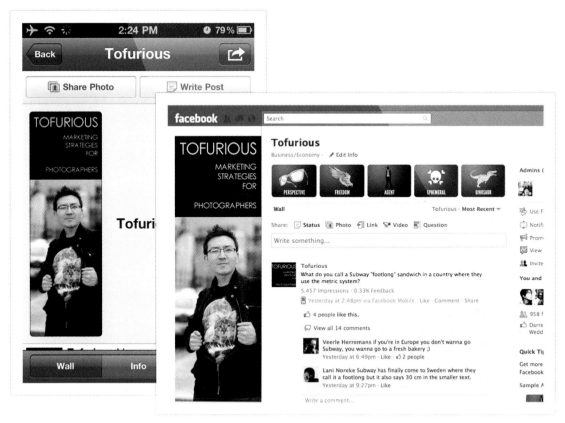

Facebook

Mobile | Web | SEO

Oh Facebook, how it's changed the world. What began casually in the fall of 2003 in a Harvard dorm room as a comparison game to rate female students on "hotness," Facebook officially launched in February 2004 and quickly grew to become today's global behemoth that rivals Internet powerhouse Google.

Even though Facebook creator Mark Zuckerberg, along with his roommates and computer science peers, initially developed the site for only Harvard students, the site expanded in 2006 to include everyone aged 13 and older with a valid email address.

Today, everyone and (literally) their grandmothers are Facebooking—yep, it's a verb. There are more than 750 million Facebook users right now. And according to Facebook's own statistics, half of the site's users log in on any given day, and 70% of the user population lives outside of the US. The global reach with this channel is significant. Of course, by the

time you read this, the number and demographics of people participating on Facebook will have likely changed significantly, so check https://www.facebook.com/press/info.php?statistics for updates.

What can I say that you don't already know about the Facebook story? There was an Oscar-winning blockbuster movie about Facebook, *The Social Network.* And most of us already have Facebook accounts (at least personal ones) and spend hours on the site. It's a near-endless abyss of free information. Here's how it works.

After creating an account, users create a personal profile. This profile usually includes a photograph and basic information, like hometown, college attended, employer and birthday. Then it's time to add Friends to your network. Find them by importing from your email account or searching with queries related to your school, workplaces, or other affiliations. You can also join a group of other users with a common interest or affiliation (e.g., college graduating class, former or current workplace, photography groups). And then begin the sharing!

Facebook makes it very easy to post and share images, which makes it a terrific format for photographers. We'll cover this functionality in more detail in the next chapter. For now, just know that users can upload individual images or import albums, or *galleries*, and even identify (or *tag*) the people in the photos, as long as they are in the photographer's network.

So wedding photographers, for instance, can post photos from a wedding or engagement shoot. (I suggest doing this with client permission.) And by tagging the people in the album, the couple's networks will see the photos, too, and they can access and share the images with *their* friends. Aha! Suddenly the images are circulating to the friends of the friends of clients without the photographer actually doing anything beyond initially posting and tagging.

When sharing images in this way and others online, I recommend that you put a small copyright or logo on your photographs. Also be sure to add a URL at the bottom of the image that links to a full gallery. See an example at http://www.facebook.com/photo.php?fbid=10150198840472566.

When the photos appear in your client's feed, his and her friends are likely to Like them and make pleasant comments. This places the images on your client's friends' pages,

further pushing your images throughout new networks. So remember to add a URL in the caption of your photos, so people can find you to learn more about your work. Ahh … networking!

Personal Facebook pages cannot be used to promote your business, but no one says you can't be friends with clients!

Yet Facebook is always evolving, so today's features may not be available tomorrow, and new functions will appear without warning. So to avoid offering outdated details on how to use Facebook, I've posted up-to-date user information on my website at http://www.tofurious.com. You can also check out Mari Smith's site at http://www.marismith.com. She is a Facebook guru.

One thing to definitely know about Facebook is that there are two different kinds of accounts available: one for a personal page and another for a business (or Like) page. Personal pages are used for personal updates—not business promotion. And Facebook takes this seriously. If your personal page is being used for business purposes, Facebook has the right to delete your account.

There's no reason to not have both kinds of accounts. I do!

See the special section (Business or Pleasure?) to dig into the differences between the two account types.

Business or Pleasure?

Here's a quick look at the differences in the two types of Facebook accounts.

Facebook Account Features	Personal Page	Business Page/Like Page
Number of Friends	5,000 (Max)	Unlimited
Login Required	Yes	No
Customizable	No	Yes
Search Engine Friendly	No	Yes
Analytics/Metrics	No	Yes
"Liking" Pages/Brands	Yes	Yes
Able to Befriend People	Yes	No
Able to Tag People	Yes	Yes*
Able to Join Groups	Yes	No

** only in conjunction with personal page*

Max Number of Friends

Personal pages on Facebook allow you to befriend other private users. For privacy purposes, users must approve friendships before profiles and other information are revealed. The maximum number of friends you can acquire on a personal page is 5,000. Business pages do not have a limit on the number of fans it can have.

Login

Fans can subscribe to a business page without user approval. By removing the approval barrier, it's much easier for people to start engaging with you and your company, which is great! You don't want to waste time approving—one click at a time—the (hopefully) many thousands of people who will come in droves to your page. I imagine you'd rather be shooting photos or creating engaging content for your page than approving access for adoring fans.

Customizable

While the shell of the Facebook design must remain intact, business pages allow users to adjust fields and content in many ways. This means content on your business page can look and function in a specialized way, based on your settings in iFrames. For instance, users can create a custom landing page with iFrames, so fans go someplace special and not the standard Wall page.

Custom tabs can also be developed on business pages. You can install existing applications on personal pages that might look like customized apps, but custom tabs with custom iFrames are only available for business pages. It's very popular for companies to use custom tabs to host contests, offer special promotions, and allow for custom games through this feature.

I also like the custom URL feature, which sends a company's website traffic to its Facebook business page. Watch for more information on this in the next chapter! A tutorial for iFrames is available online at http://facebook.com/TofuriousPage. Personal pages cannot be customized in these ways.

Searchable

We'll cover search engine optimization (or SEO) later in this chapter. For now, just know that search engines will read Facebook business pages but not personal ones (due to privacy). This means that your business page comments, notes, photos, and links can potentially show up on searches that use related keywords.

Analytics and Metrics

What's the point of all of your efforts if you cannot measuret their effectiveness? Fortunately, Facebook has integrated a metric system called "Insights," and it allows you to view the number of users subscribing

to your page, the number of interactions your page is generating per day, and the percentage increase or decrease of the number of Fans. There's also an on-page analytics table that shows the number of impressions per post and its percentage of interaction. All very handy stuff!

Here's a glimpse of Facebook Insights.

Liking Pages and Befriending People

While personal pages can Like business pages and befriend people, business pages can only Like other business pages. You cannot befriend people through your business page. This is why I recommend that you create a personal page in addition to a business page if you own a boutique photography business. You'll want to establish a business friendship with your clients to convey a deeper level of trust and intimacy than what can be established purely on a business page. Plus, befriending clients will enable you to tag them in photographs.

Tags

As mentioned earlier, business pages can only Like other business pages. Therefore, business pages are not able to tag individuals in photos per se. However, it's possible to post photos of clients on your business page and tag them with your personal page. The two accounts work hand in hand nicely in this way.

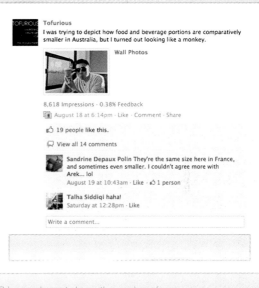
This sample post shows the number of impressions and percent of feedback.

Groups

Facebook Groups are wonderful places to have discussion with groups of people on specific interests (e.g., Black and White Photography Group). You can create your own Groups and even add password protection through your personal page. Conversely, business pages can neither join Groups nor create Groups.

Overall, Facebook offers some great features, including:

- **High Engagement:** There is significant opportunity for interaction with fans via Wall posts, notes, photos, polls, etc. Facebook also has a notification system that lets you know when someone has subscribed to your page or replies to any post that you've created or participated in.

- **Mobile Friendly:** Facebook has an application for major smart phones that allows you to stay current on all activities.

- **Searchable:** Business pages and notes can be found by search engines.

- **Visual Appeal:** There is high value in Facebook's online visual real estate. The site allows you to enhance your brand through photos and custom looks. Additionally, when you add a photo, gallery, video, or hyperlink, Facebook takes an excerpt image from the source to make it easier to view and share.

- **Photo-Oriented Design:** Facebook allows users to organize photos into galleries and create a "theater effect" for easier viewing. Facebook's theater effect is an attempt to put more emphasis on photographs by creating white negative space.

- **Local Filter:** Facebook allows you to broadcast to certain audiences based on location to avoid creating unnecessary noise for non-relevant readers. For example, I could make an update for only those who speak a certain language and/or live in a certain country, state, and/or city.

You can customize an update for everyone to see or for only certain audiences that fit your criteria.

But, like everything else, Facebook isn't perfect. Some things to consider when using this site:

- **Audience:** Just because you build a business page, it won't necessarily attract an audience. No one will automatically come. You must tell people about your page through other social media efforts, such as a blog, and incorporate the various platforms.

Facebook Filters

Some users follow many friends and business pages (sometimes in the thousands). Therefore, it's nearly impossible to keep up with all of the updates. Facebook created a Top News filter, which shows those that a user interacts with most. If Facebook feels that a user has no interaction with your page, it won't show up unless (s)he hits the Most Recent newsfeed.

News Feed Top News · Most Recent 2

Share: ☐ Status 📷 Photo 🔗 Link 📹 Video ☰ Question

Facebook filters updates that are deemed irrelevant and displays how many posts are in queue in the Most Recent tab of my newsfeed.

- **Updates:** Content needs to be updated frequently and consistently to be considered as Top News for subscribers.
- **Change:** Facebook seems to be constantly changing its layout to improve user experience. So be prepared to adapt.

Twitter
Mobile | Web | SEO

Twitter is a free social networking microblog that distinguishes itself by limiting user posts, known as *tweets*, to 140 characters. Because of the excerpt format, users can scroll past lots of topics and read whichever compels them. Participating on Twitter is basically online texting.

Like Facebook, Twitter is considered a social network, because users are allowed to be followed and to follow others. If your Twitter account is set to "private," then you must approve people as followers. And when you follow someone, anything that (s)he posts on

✈ 📶 ❄ 2:25 PM 🔋 79% ▭

More **My Profile** Edit

Lawrence Chan
@tofurious
#16,611,249

I am a photographer and professional dinosaur trainer. I may blog about photography marketing strategies, but I tweet about food and traveling. Hello!

location **Los Angeles, CA** ›

web **www.tofurious.com/ab...** ›

141	6,830
following	tweets
7,178	108
followers	favorites

Twitter will come into your *feeds*—a term that refers to the area that aggregates all announcements of those you follow.

Twitter offers some real benefits to photographers hoping to use social media to market a photography business. Despite the primarily text format, it is possible to share images on this channel. Through third-party programs, like TwitPic, users can post photos and videos to Twitter from the program's site, a mobile phone, or email.

Until recently, TwitPic was the service of choice for many photographers, because the company officially (per its Terms of Service) allows users to retain the copyright for their content. But in 2010, photographer Daniel Morel's now-iconic image of the Haiti earthquake was lifted from the TwitPic site by a news organization without his permission, and a legal battle ensued. Visual artists have since drifted to other photo-sharing sites, including yfrog.

For more information on the Morel photograph battle, see http://www.petapixel.com/2011/05/10/twitpic-updates-tos-to-reassure-users-of-photo-copyright-ownership/.

On June 1, 2011, Twitter announced new functionality that will allow users to post photos directly from the Twitter site. But it's important to understand that retaining control of your images once they are posted online is problematic. So think about this carefully before sharing your images digitally through any channel.

Twitter also allows users to:

- **Follow** anyone's tweets as long as they're not registered as "private."
- **Connect** into a large community of users. (This community reached the 200 million mark in March 2011.)

- **Share** and obtain information on real-time events and trends.
- **Track** the effectiveness of your social media efforts with metrics.
- **Track** your competitors' activities through Twitter searches.
- **Monitor** what people are saying about you through Twitter searches.
- **Drive** traffic to your blog or newsletter signup.
- **Aggregate** search engine results based on real-time queries.
- **Obtain** feedback for your photography.

Some challenges to consider when using Twitter are:

- **Noise:** Without management on who to follow, Twitter can be a place for a lot of useless information.
- **Narcissism:** It's easier to tweet than to listen.
- **Brevity:** Providing content (in 140 characters!) that's valuable enough for people to follow you is challenging.
- **Timeliness:** Twitter is probably not the right format for finding clients or photo agencies who need your services due to its real-time nature. Tweets are short-lived; they become overshadowed by newer news.
- **Appeal:** Twitter is not photo-oriented, so it's more difficult to attract attention, especially as a photographer, in an ocean of text.

A very important tool for use with Twitter is the link shortener, which consolidates URLs that direct your followers to sites. Since Twitter allows for only 140 characters in a post, a long link would dominate too much of the allocated space. Just know that some scammers hide malicious links behind shorteners, so be wary of what you click.

Popular link shorteners are Bit.ly (http://bit.ly) and Goo.gl (http://goo.gl). Both allow users to see the number of clicks they get for each link and at what times. I rely heavily on this feature to measure the effectiveness of tweets.

All in all, Twitter is rich in information if you're following the right people. Perhaps more importantly, it's a place for wonderfully engaging casual conversation. And since conversations are public, users are able to reach all of their followers immediately and simultaneously.

Tweeter's Toolbox

Other tools for Twitter include **Tweetdeck** and **HootSuite**, which help users better manage their Twitter activity.

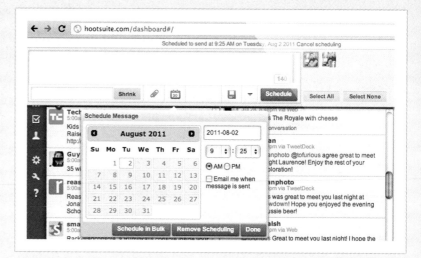

Tweetdeck was important when Twitter first launched, because the Twitter website was not very versatile. It was tough, for instance, to tweet from a mobile phone. But Twitter's newest HTML5 version is pretty slick; it acts like an app itself.

Tweetdeck also integrates various social media channels, like Facebook (among others). So if you post (or tweet) on Tweetdeck, it'll send your content to Twitter and Facebook at once. But Facebook has apps now that draw the RSS from Twitter automatically, making the Tweetdeck service no longer unique. Tweetdeck's distinguishing feature now is that users can maintain different columns of newsfeeds (like one for a family list, a friends list, a celebrity list, competitor list, etc.) without having to load each one.

Hootsuite is another good tool for Twitter, because it allows you to schedule tweets (like when you're away). However, this action is frowned upon, because social media is supposed to be direct access to people—not a program. And it's tough to have any type of back and forth with your followers if your tweets are all preprogrammed.

Since Twitter is free, many kinds of users can hop on board. And this is good in a lot of ways. But Twitter's lack of barriers creates a lot of noise. So it's important to filter through the spam, negativity, and irrelevant information that won't help you grow. The noise has also desensitized people, which means you have to work extra hard to win attention on this channel.

Be vigilant in providing interesting and beneficial information—regularly. And speak only when you have something of value to contribute. Because it all boils down to the question: Why should I follow you?

And then, you need to know if you are, in fact, attracting an audience. Fortunately, Twitter offers some basic metrics to gauge your performance. In the upper right hand corner of the home screen are data on your number of followers and the number of people you're following.

Some sites that can help you gather more information about your Twitter impact include Twitterholic (which ranks your account with others in your region), Retweetrank (which reveals how many retweets you're getting compared to other users), and Twitalyzer (a site that scores your account activity based on the categories of influence, signal-to-noise ratio, generosity, velocity, and clout). Klout is another player in this field; it monitors your data from Twitter as well as Facebook, Foursquare, and LinkedIn to gauge your social media reach and level of influence.

Twitter Jargon

- **Profile**

 Your *profile* or *Twitter handle* is the name you use when participating on Twitter. If you've ever seen an (@) sign in front of a name, without it being followed by a (.com) or something to that effect, then it's probably referencing a Twitter profile. To view the web version of a profile (versus the application link), simply add "twitter.com/" in front of the handle. Example: The web version of the "@tofurious" Twitter feed is http://twitter.com/tofurious.

- **Tweet**

 A *tweet* is a user's post that's broadcast through Twitter. When I share text, a link, or an image, all the people following me receive it in their feeds.

- **Feed**

 This is the area of Twitter that shows information from those you follow, such as notifications, images, video, and broadcasts.

- **@reply**

 Respond to anyone's post, and they will be notified immediately. This is an effective way to start conversations or let people know your thoughts on their broadcasts. Usually, recipients of @replies view the profiles of those who are interacting with them. So it's a nice way to say "hello" and let someone know that you exist.

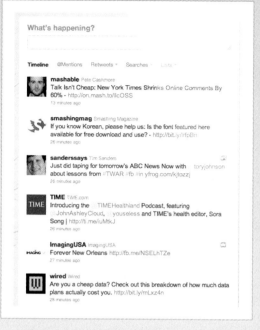

 Note that @replies show up only in feeds for users who are following both entities. So if I reply to Google's tweet with "@google – love the new app!" and you follow me and @google, then you would see my reply. But if you don't follow @google AND me, then this @reply won't show in your feed. This feature helps reduce noise and irrelevant information for Twitter users.

- **DM** (Direct Message)

 Direct messages, commonly called *DMs*, are private messages sent directly from one user to another. It's like an email, except that DMs follow the same rules for a tweet—a max of 140 characters. After building a relationship with someone online, users might DM information, like phone numbers or addresses, to each other. This is more private than a feed post. But you can only send DMs to those who are following you.

- **RT** (ReTweet)

 When you *retweet* a tweet, you're quoting someone else. Generally speaking, if you don't add your own comment to a retweet, it's considered an endorsement. That's a good thing. But it's also common for users to retweet and refute, as in: This idea stinks! RT @name: whatever they initially tweeted.

- **# (Hashtag)**

 Hashtags are clickable links in Twitter that represent common thoughts or topics. For example, if you click on a hashtag (#) for *Canon*, you'll see thoughts on Canon cameras, equipment, and other topics that've been broadcast by others, including users you are not following. Common hashtags for photographers are #tog, #togs, #photog, #photogs, #photographer, #photographers, and #photography.

- **Twitter Search**

 Search all tweets on Twitter by using the link http://search.twitter.com. Twitter search is awesome if you want to find real-time information on events, certain people, or companies. Some businesses use it to track what people are saying about them and what's going on with competitors. And it's really fun to see what global topics are trending. But Twitter moves really fast, so items are considered very old after more than a few hours.

LinkedIn
Mobile | Web | SEO

LinkedIn is a business-focused social networking site that targets what it describes as "an affluent and influential membership." The site currently boasts more than 100 million users, who use LinkedIn to get in touch or stay connected to colleagues, references, and acquaintances in order to find work and otherwise remain in the minds of people they know professionally. It's more of a platform for outlining your professional credentials than keeping folks updated on your thoughts and interests.

Users build their LinkedIn network by inviting contacts to *connect*. Those who accept an

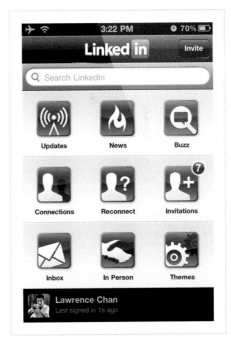

LinkedIn's mobile application has convenient buttons to commonly used tools.

invitation are referred to as the user's *direct connections*. And the direct connections of the user's connections are known as *second-degree connections*. Make sense? There are also third-degree connections, which are the direct connections of a user's second-degree connections.

I know, it's worse than trying to figure out how you're related to your grandpa's youngest brother's wife, right?

And just like *that* connection, your LinkedIn network can be used to gain access to someone you need to know … for a job, to better understand a business opportunity or industry development, or to get the scoop on a prospective hire. Users can even now follow companies that interest them—like yours. In fact, LinkedIn allows businesses to list products and services on company profile pages. And users can write reviews for your offerings.

Like Facebook, this site also allows users to join groups. LinkedIn has a number of different photography-related groups, including Adobe Photoshop Group, Portrait Photographers, and Hasselblad. So take a look and find out if LinkedIn might be a good format to grow your business.

Tumblr
Mobile | Web | SEO

Tumblr is a microblog with a social network, which means that you can use the site to follow certain bloggers and vice versa. One nice feature of Tumblr is that you can repost

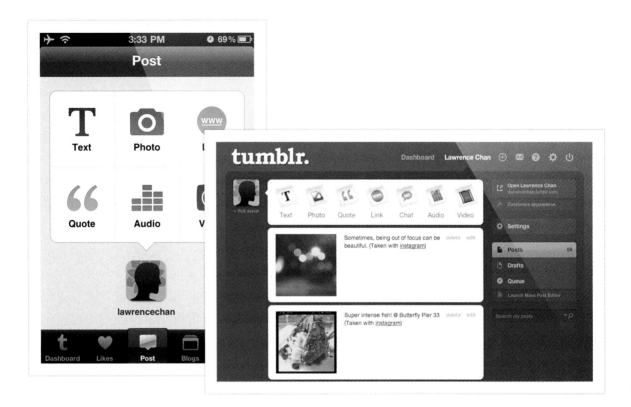

someone else's content if you find it interesting … without having to copy and paste.

To reblog, just pull the entire post into your Tumblr feed. It only takes a few clicks. You can add your own thoughts as well to further enhance the sharing experience.

A word of caution though: Unfortunately, the reposting feature of Tumblr has opened the door for people to use this site to steal content from photographers and post it as their own, or simply without permission. Because of the rampant image theft on Tumblr sites, be careful about what you share on this channel.

In this screenshot of Tumblr, notice buttons for "Love," "Reblog," and "Unfollow" in the upper-right corner.

Social Sharing

Photo-sharing websites, like Flickr, Instagram, and 500px are increasingly popular and highly visible on search engines. These sites make it easy to circulate your images, especially among those who are members of the site community.

Similar to other social networks, most photo-sharing websites also allow users to follow other users. This helps keep everyone updated on changes within their communities.

Depending on the complexity of the website's design, there are a whole slew of options, including geotagging (place-based tagging), folksonomy (tags and classifications), and taxonomy (galleries). These tools help classify photos for easier searching. And features that are consistent with other social media channels are also included, such as commenting and some form of "liking."

In this section, we'll look at Flickr, Instagram, and 500px as well as YouTube and Google+. For an elaborated list of photo-sharing websites, please visit the following link: http://en.wikipedia.org/wiki/List_of_photo_sharing_websites.

Flickr
Mobile | Web | SEO

Flickr is a free online image-management and sharing site that makes it easy to post photos, create image groups, and allow viewers to comfortably navigate through them. Users can upload images as a single photo or as part of a set, and an individual's *photostream* (or collection of images) can be labeled for viewers with tags that describe the scene. Search functions also pick up the metadata info for posted images.

Note that Flickr does not currently offer any photo-editing tools. Also, the free account limits your viewable photostream to 200 images. You can upload as many images as you want, but only 200 will be visible through the free account. Professional photographers who are interested in posting a higher volume of

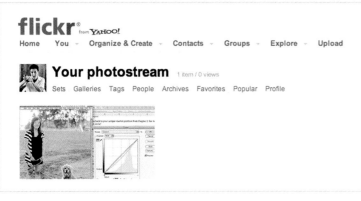

This is a glimpse into a user's photostream. From this page, you can navigate to various galleries, tags, archives, and more. Additionally, Flickr has a simple metric program that shows number of items and number of views.

images can purchase an upgraded account, which offers more viewable-file capacity and an added feature that allows you to share videos.

Photographs on Flickr are viewable as a slideshow. And users can comment on the images posted by other people. In fact, the site rewards members who, in addition to posting their own photos, make a point to interact with other users through comments. Active users benefit by more traffic to their profile and website and thereby greater exposure for their services.

When setting up a Flickr account, be sure to use a recognizable username for your account, so that your clients and followers from other social channels can find you easily. You'll also need to create a profile to describe your work and reinforce your market niche. Oh, and when posting your photos, be sure to adjust your privacy settings to manage your different audiences. I mean, while your college friends may love those crazy bachelor party photos, that set of images may not show the side of you that your clients will most appreciate.

Another great feature of Flickr is the ability to create a Contacts group of other users. Posts by those in your Contacts group will appear on a Friends page, and this can help you stay up-to-date on what your colleagues are doing. Find Flickr users for your group by searching name, keywords, or city. Also search the site's wide array of groups. Browse what's there and join a few. If one for your city isn't there, create one!

Note that you do not need permission to add someone to your Contacts on Flickr. And when adding contacts, you can specify whether they're a friend or family member via check box. This allows them to view photos that might have some level of privacy.

All in all, Flickr isn't wildly popular among photographers for nuthin'! The site is a great platform for sharing images and congregating virtually with other photographers—amateurs to superstars—and perhaps even prospective clients.

Instagram
Mobile | Web

Instagram is a tiny free application that's designed for taking photos, editing them with filter effects, and sharing them via social media sites, like Facebook, Twitter, Tumblr, and Flickr (all described earlier in this chapter).

Compatible only with Apple iOS devices, like the iPhone and iPad, Instagram effects resemble the look of old Polaroid pictures. Images edited with this app are even formatted from the standard 4x6 size to the hallmark square design of a Polaroid.

But Instagram is much more than another photo-filter-based app for Apple devices.

Instagram is also a simple social networking tool containing updates in the form of, yep, instant photos posted by the people in your network. Users can interact by commenting on photos in his/her network and can, in utter Facebook style, Like them.

Instagram is very easy to use, which is one of the reasons it's gaining ground so quickly as a valuable social media tool. As of May 2011, the app had reached four million users.

Burberry Loves Instagram

One luxury company that is using Instagram quite effectively is Burberry. Notice how I did not say that Burberry is using the site to *promote* or *sell*? That's right, Burberry is simply *sharing* behind-the-scenes images for fashion events and new designs. The intention is to keep the company's products first in customers' minds and provide followers with interesting perspective on the Burberry brand.

So, in the event that a consumer is at a tipping point (props to Malcolm Gladwell for that concept) and wants to make a luxury purchase, (s)he might think, "Oh yeah. Burberry has this gorgeous…" And a high number of Likes and comments on a particular photo is social validation for the concept being shown. As we explained in Chapter 4: The Power of Content, this kind of proof can be quite convincing.

I believe in sovereign thinking and all that, but the numbers are staggering. It starts to make you think. If so many other people like something, maybe I should like it, too. If I think the fashion is hideous, there must be something I'm not seeing, right? Accepted exposure usually makes us question ourselves and our knowledge of a product, at least a little bit. Interesting phenomenon, right?

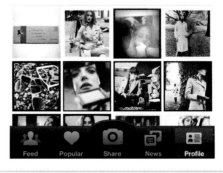

Burberry is constantly sharing photos to its 35,000+ followers.

Burberry received 443 Likes and 17 comments on a single photo.

When using Instagram, you can share photos with various social media platforms simultaneously. Clicking on a photo or link in the social media update will lead to the Instagram website. From there, users can see your profile and photos you've posted. The more you share, the quicker it will be to generate an audience.

500px
Web | SEO

One of the newest social sharing tools for photography is 500px, which defines itself as a "photographic community." The site is targeted more for serious amateur and professional photographers who want to share their work in a forum more upscale than Picasa or Flickr. 500px is also a great channel for photographers to interact.

The site allows users to upload images into sleek portfolios and browse the work of others. Users can also discuss photography-related topics, comment and vote on images, and solicit reviews for their photographs.

@tofurious
Lawrence Chan

Since everyone else is doing it. I know, I'm a sheep.
http://instagr.am/p/HAJJe/

Instagram Flag this media

4 Jul via Instagram
☆ Favorite ↩ Reply 🗑 Delete

I opted to share my Instagram photo on Twitter. A link appeared (http://instagr.am/p/HAJJe/), so users can click to see the enlarged image. When doing so, my profile appears next to the image and a link becomes visible that allows users to download Instagram and follow my progress.

500px allows anyone to access the site's content. But to post photographs and comment on images, you must register for a free account. Fortunately registration is easy, requiring only a username, password, and valid email address. The free account is a great way to explore the site's functionality, but it's limited to one album and a maximum of 20 image uploads per week.

For $50 per year, a premium account offers unlimited photo uploads along with higher-level portfolio options, additional customization tools, and an ability to link your portfolio to your website or other domains.

As a social media platform, 500px integrates some of the most popular features of superstar sites to validate its *community* claim. Users can build a network of followers and friends; and like Facebook, a Wall page aggregates the posts of people in a certain network, and users can comment on these posts and even Like or Dislike individual photos. The 500px site also allows users to share images via other social sites, like Facebook and Twitter. But what's really cool is that 500px users get a free blog—a terrific

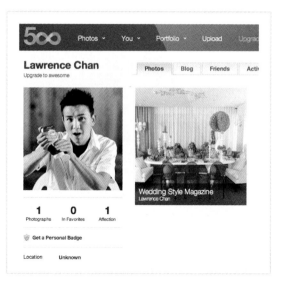

tool to relay details about their approach to photography, explain certain concepts and theories, and otherwise communicate with their audience. (More on blogs in Chapter 7.)

Anyone looking for a new channel to broadcast your photography work or to check out what other shooters are doing, this is definitely the place to be.

YouTube
Mobile | Web | SEO

It's nearly impossible to talk seriously about social sharing without covering YouTube, right? I mean, this is the known standard for posting video footage. And why wouldn't it be? It's free and compatible with all browsers and smart phones. But an alternative, Vimeo, is creeping behind for those wanting more customization features and to connect with more serious filmmakers.

But maybe you're wondering how YouTube serves the needs of photographers … cause YouTube hosts *videos*!

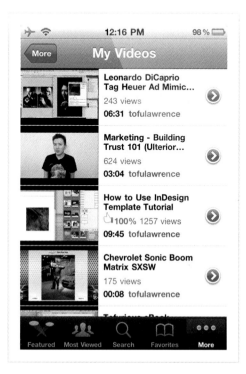

Well why not? Most photographers already know how to frame a shot and own the lenses needed to create stunning visuals, so video is a form of media that can be used to supplement business. Think: *fusion movies*, which are a combination of movie clips and still images.

A YouTube Channel is a comprehensive landing page, where users may view videos, comment, follow, Like, and perform other actions.

The inception of Canon's 5D Mark II, which has 24p, 30p, and 60p video settings, has allowed photographers to become professional cinematographers virtually overnight—without requiring a separate piece of equipment. Here are some reasons to use video as part of your social media program.

- **Show Personality:** Consider using video footage to show the person behind the camera. Or, if you prefer to stay on the other side, film some behind-the-scenes clips to show the setup for a shoot. You can also use YouTube to offer training sessions, which can support your effort to become known as an authority figure in your niche.

- **Expand Your Audience:** The potential for exposure on YouTube is significant. In May 2011, YouTube reached three billion views a day. People are watching! And for some extra help, you can pay to advertise your video and thereby get higher search results.

- **Circulate Slideshows:** Create and post a slideshow collection of your best images in video format. And to make it more special, add a voice-over to narrate the story.

But there are some challenges to consider when using YouTube. For example, anyone can create a video and compete with yours. The amount of noise on YouTube is extremely high. This means that you need to work hard to stand out. Also, video time is limited to 15

The "p" after the frames-per-second number stands for *progressive scan*, while "i" (not mentioned) stands for *interlaced scan*, which represents two fields per frame.

minutes. Videos that are longer will need to be divided into a series.

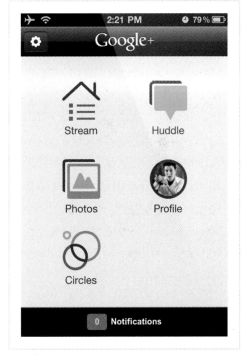

But what's exciting is that virtually every mobile media device now offers video capability, and video can easily become viral. I mean, a home video of a cat playing an electronic keyboard has just as much of a shot at attracting several million hits as a Lady Gaga music video. It just depends on what your audience wants.

As a social media channel, YouTube allows users to comment on your posts and even Like or Dislike a video. People can also subscribe to video channels (such as yours!), so they can stay up-to-date on what you're putting out there. The site even has built-in metrics to help you gauge your performance and monitor traffic to your content.

Google+
Mobile | Web | SEO

Google has successfully maintained an omnipresence in many sectors of technology, except for social networking. (Remember Buzz?) Well, Google+ is the company's answer to Facebook.

The moment you logon to Google+, you'll notice that it's very much like Facebook's News Feed, allowing users to share photos, videos, links, and location. Below are some of the channel's most appealing features:

- **Navigation Bar:** All Google+ accounts have a sleek black navigation bar at the top of the browser. This is where users find notifications, profile information, and content sharing options.

Google+ has a nifty mobile application that allows users to utilize the main functions of its social network. What's particularly fun about this application is its Photos button, which streams only a collage of photos in your network (no text).

- **Google+ Stream:**
 The Google+ Stream is similar to Facebook's News Feed. Users are allowed to share new content here and view content shared by their friends.

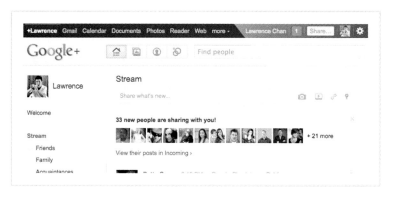

- **Google+ Circles:**
 This is similar to Facebook's Friends list or Twitter's List, but Google+ uses an HTML5 system that allows users to drag and drop friends in different social circles. Circles can be titled *friends, family, photographers,* or any other custom group. Users can drag friends out of groups just as easily as drag them in.

 Google+ Circles allows users to share targeted content for specific groups. For example, if I want to post a photo for my family social circle only, then I need to only select that group. Unlike Facebook or Twitter, Google+ is not set up to share only with a mass group of people, but it can do that, too.

- **Google+ Photos:** Google+ Photos has made managing multimedia much simpler than any tool currently available. The photo tab lets you see all of the photos you have shared as well as photos you're tagged in and photos from your circles. In the mobile application, there's a folder for photos from your phone. Also, Google+ includes an image editor, called "Picnik," with Instagram-type effects that can be used only for your profile image (for now).

- **Google+ Hangouts:** This is a group video chat feature that is pretty neat. Anyone can "start a hangout," and a message will go out to his/her social circles to alert them that the user is online. People usually join pretty quickly. Hangout allows up to ten people to participate at a time. And the main video screen changes to whomever is talking.

- **Google+ Sparks:** Google+ Sparks is a recommendation tool that enables users to share interesting topics. It relies on what is being shared at the moment and +1 buttons. So you can share content and find related content all in one place.

While Google+ has some great features, ultimately, a social network is only as strong as its user base. Since its launch just several months ago, Google+ has already amassed more than 20 million users. The site's current tools seem to be thoughtfully installed, and

there will no doubt be more rolling out.

Google+ does not allow businesses to create profiles yet, but I'm confident that this will change eventually. Overall, I believe that Google+ will be a platform to reckon with, because user interaction through +1 buttons will heavily influence search results (SEO).

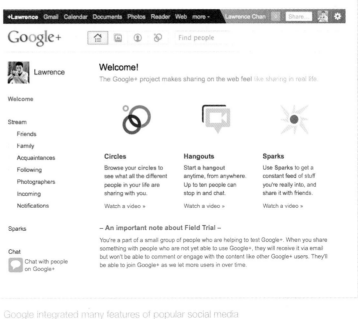

Google integrated many features of popular social media platforms to create Google+, but this new tool offers even more functionality than what's currently available on other platforms.

Social News

As important as it is to reach out to clients, it is equally important to stay abreast of current events in the photography industry. There are many great resources available, but I especially like the following three aggregators. Just know that most of these sites won't help you much with marketing. Rather, they're good for information.

Digg
Mobile | Web | SEO

Digg is among the most popular social news sites available. It features blog posts and web pages that Digg members post for sharing. So users can *digg* (or submit) URLs for pages they like. The person posting a URL will also categorize the link and provide a short description to help others figure out if it interests them. Users reading posts can vote on a URL by selecting "digg" (good) or "bury" (bad).

This is a glimpse of Digg's Top News stream.

The Digg site offers a bit of networking in the form of Friends, who share and comment on suggested content in a small-group kind of way. This helps users target their content instead of going out fresh every visit, hoping to find stuff that interests them.

And while it's possible for Digg to drive traffic to your blog, it's very tough to earn the recognition needed to land on the home page of the site. While you work on achieving that kind of exposure, use this as a resource for following trends in your industry.

Mashable
Mobile | Web | SEO

Mashable began as Pete Cashmore's blog about social media and technology. It's now "the largest independent news source dedicated to covering digital culture, social media and technology," according to the Mashable website.

With the popularity of photography, especially since almost everybody has a mobile device that can capture and share images, you can bet that Mashable is always covering photography-related news. And since photos are used in a plethora of ways in social media, Mashable is a great resource for keeping photographers up-to-date with what's happening in the industry.

AllTop
Mobile | Web | SEO

AllTop is a website that lists the top news in various industries, including health, sports, and so forth. AllTop even has a dedicated section for photographers (http://photography.alltop.com/).

You can create an AllTop account for free and follow various RSS feeds that are provided by AllTop. But not just any website can be part

RSS stands for *Really Simple Syndication*, which is a web format that's used to push information to a reader whenever updates are made.

of this list. AllTop has a staff that filters submissions before they appear on this website. This cuts down on the noise.

So whether you're looking for news on gear, remote lighting, marketing and/or other aspects of photography, you can customize your dashboard to notify you whenever any updates are made.

Since the content you get is filtered by AllTop, you can, for the most part, trust that the content you get has substance.

Social Bookmarking

Social Bookmarking is a fancy way of describing an online tool that allows people to save access to their favorite places on the Internet and manage these links. Bookmarking also helps people find resources online that apply to their interests.

And because users simply reference links to resources, and don't share actual files or save content to their computers, social bookmarking is different from file sharing. Yet this kind of site has evolved over time to include features that come standard on other kinds of social media sites, including comments and ratings.

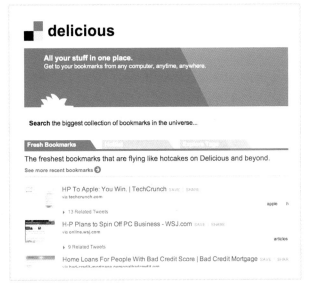

Delicious aggregates fresh bookmarks made by users and offers other ways to explore bookmark-worthy sites.

Let's look at some of the most popular social bookmarking sites.

Delicious
Mobile | Web | SEO

Originally called del.icio.us, this social bookmarking site uses tags (folksonomy) rather than a hierarchy-classification system. As a result, popular tags move to the forefront of the website, making it easy to track trending topics.

The site has a very strong following and a very simple interface. While Delicious doesn't offer some of the tools and features that other sites do, it's easy to use and beats other bookmarking sites on volume and quality of content by a mile.

Although this may not be a medium for photographers to market themselves, it is a great site to see what other people are bookmarking based on tags.

StumbleUpon
Mobile | Web | SEO

StumbleUpon calls itself a "discovery engine," and I think this description is quite accurate. This is a social bookmarking website that allows users to discover new sites based on search queries. Results are based on user recommendations. In other words, people "stumble" a site and it feeds into a database of similar topics. Users click "stumble" and a website appears. You can then click again and again until you find something you like. And then, you got it, you're free to Stumble some more. It's good in terms of finding out what others are doing outside your immediate sphere of resources.

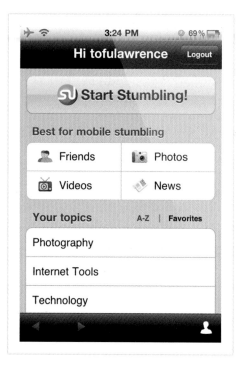

StumbleUpon makes Stumbling quite easy and fun ... especially on the go with its mobile application.

Users may submit their own websites, too, supposedly only if it's a personal, non-commercial site. So, I wouldn't recommend submitting a business website. However, StumbleUpon does not stop others from "liking" a business site—your site.

The moment a site is Liked, it is automatically submitted into the system. If the user who Liked it does not offer a review (such as tags), StumbleUpon will take the meta information from the website and create its own profile.

In addition to search results, this site allows users to build a network of followers, share bookmarks, and use Like and Dislike tags. StumbleUpon is a great tool for finding inspiration for your work and news related to photography or other interests.

StumbleUpon's dashboard allows you to tweak your interests, view old sites you liked, and more.

Whether you primarily use Facebook, Twitter, YouTube, or another current or future channel for your social media program—or, ideally, a combination of platforms—remember that interaction with your target audience is the fundamental strategy. So share content that resonates with your audience, and use a platform that best conveys your messages. Then, make sure that your content is optimized for maximum search-engine friendliness, because this is a very important element to successful social media marketing. Let's take a look at what this means.

Homework

Sign up for a Twitter account (http://www.twitter.com) and a Facebook business page (http://www.facebook.com/pages/create.php). These accounts will be helpful in the near future.

If you'd like to share your profiles and to follow other photographers for inspiration, visit http://www.tofurious.com/forum. My profiles are below. Say hello!

Twitter: http://www.twitter.com/tofurious

Facebook: http://www.facebook.com/TofuriousPage

Search Engine Optimization (SEO)

We've used the term *search engine friendly* in previous chapters of this book and even earlier in this chapter. And we may have even slipped in references to *search engine optimization*, or SEO. Here, we're going to dive deeper into what these terms mean, because knowing how to work with search engines is a vital element of successful social media marketing. Frankly, it's pretty important to any kind of online communication effort.

SEO is a combination of coding and keyword selection that strengthens online content, so it appears higher in search results by engines like Google, YouTube, Yahoo, and Bing.

Google +1 Buttons

Google +1 buttons sound very much like the social networking site Google+, but they are slightly different. You don't need a Google+ account to use +1 buttons; you just need a Google account.

According to Google, +1 buttons are "your public stamp for approval." It's sort of like a Facebook Like button. These buttons appear in Google search results and on websites if installed by the owner.

There are so many ways to make a gourmet burger. But if your friend(s) approve one certain recipe, then it's got to be good. Photo of a MT Brewery gourmet burger taken (and eaten) by Lawrence Chan at 16mm f/2.8 for 1/320 second.

The goal is to help searchers make better decisions through the validations made by those in your Google network. For example, if you were looking for a recipe for gourmet burgers, many sites will appear in your search query. However, let's imagine that one of your friends +1'ed a specific site. The +1 action means that it was approved by said friend, which incites you to read that site first ... or only that site.

Ultimately, the goal is to encourage your readers to +1 your site. This acts as powerful social proof to help people make better decisions, like hiring you. You can install the button rather easily. If you're on a WordPress blog, there are already numerous plugins available.

To find out more information about Google's +1 buttons, visit http://www.youtube.com/watch?v=OAyUNl3_V2c for a video introduction.

Organic search results are based on content's relevance to keywords instead of paid placement, or advertisements.

Being found organically through search results obviously increases your content's exposure, and it's a form of *inbound marketing*.

Inbound marketing is more effective than paid placement, because clients come to you seeking information about your goods and services instead of you blasting out messages that your audience may or may not want to hear or see. Alternatively, as the name implies, *outbound marketing* is often mistrusted. People put up a guard when receiving outbound marketing messages, because the information is riddled with pitch to sway them to buy.

SEO is a huge aspect of inbound online marketing, because it puts your content in front of people who used *your* keywords to search for information on the Internet. This is how SEO helps you attract an audience. A well-thought-out SEO strategy can make the difference between virtual obscurity and having your site show up on the first page of search engine results. Yet SEO is not some mysterious phantom science; rather, it's a series of practices aimed at improving your online visibility. The key is to stick with it and test different tactics until you find one that works for you.

For starters, make sure you are familiar with the keywords that your target audience is using to find information about your industry. Google Insights and the Google Adwords Keyword Tool can help you find keywords that can drive traffic to your content. Find more on keywords in Chapter 6: Launch a Social Media Program.

All the social media sites we've covered in this chapter are SEO friendly, except Instagram. But to what extent certain kinds of content, such as links, affect search results is unknown. For example, at one time, Facebook Likes were super powerful. But they probably mean less now that +1 buttons were integrated by Google. It's likely that Google search results will give preferential treatment to Google+. Nevertheless, interaction influences results some way, somehow.

And that's the gist of it. But remember that SEO and other social media elements are constantly changing, so try to check in occasionally with tech sites (like http://www.mashable.com) for updates to your social media tools.

All right, now let's find out how to get a social media program launched! ✦✦✦✦✦

#chapter6

There is no silver bullet to creating a killer social media program, because every photography industry is different. So, before we even start talking about how to get a social media program started, I need to make it clear that you'll want to customize any suggestions and information you receive here to meet the specific needs of your business.

In this chapter, we'll cover how to get started using three of the most popular social media channels—Facebook, Twitter, and YouTube. Blogs are examined in great detail in Chapter 7: Blogs and Websites. Of course there are many other great communities and networks out there, so definitely check out your other options and find the platform that works best for you.

Just make sure to consult Chapter 2: Strategic Planning to ensure that the route you choose can get you to your desired destination. A solid social media program is built on clear goals, a niche audience, deliberate actions, and relevant metrics.

Let's take a closer look at getting started with Facebook. This happens to be the social media platform that many people use first.

Facebook

Facebook is a wildly popular social networking platform that's perfect for interacting with … well, everyone. And its photo-friendly system makes this a great tool for photographers to share their work and build relationships with clients, prospects, colleagues, and thought-leaders in their niche.

To begin using Facebook:

1. Create a personal Facebook page.

Open a new Facebook account by entering your name, email and password, gender, and birthday. Your birthday verifies that you are at least 13 years old, the minimum age to open a Facebook account.

With an open account, you can create a personal profile. This usually includes a photograph and basic information, like hometown, college attended, employer, and birthday. Then, you can add Friends to your personal network. Find them by importing from your email account or searching with queries related to your school, workplaces, or other affiliation. Maybe even join a group of other users with a common interest or affiliation (e.g., college graduating class, former or current workplace, photography groups). And then begin the sharing!

It's very important to understand that you cannot use a personal page to promote a business. This violates Facebook's terms and conditions, and Facebook has the right to disable your account if they believe you are not in compliance with these terms and conditions.

Check In is an action that users take to let people know they're at a specific location—like your studio! Hopefully, curiosity prompts these friends to click on your business page link and/or inquire about your services.

2. Create a business page.

To stay compliant with Facebook's rules about personal pages, create a business page at http://www.facebook.com/pages/create.php. When naming your page, be sure to include your specific photography craft for better Facebook search results, as in Lawrence Chan | Wedding Photography. Just like the title of a website, this section is SEO-friendly.

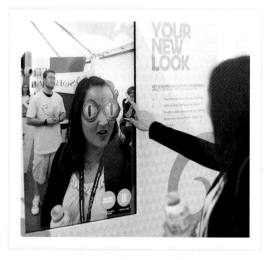

Here are some options for choosing which type of business page you'd like to be.

And when selecting your identity, I suggest choosing Local Business if you have a storefront for your studio. This will allow people to Check In at your studio. Otherwise, the option Company is a good choice.

The Facebook business page is one of the most powerful platforms for creating relationships with clients and vice versa. Your business page is publicly viewable and anyone may Like it to subscribe for updates.

Oh, and be sure to Like your own page, so your Friends will be notified of your new page and your business.

3. Add a profile image.

In most cases, an image of you smiling is perfect for your Facebook profile. Unfortunately, many businesses instead use a logo or a photo of a subject—

Could you relate to Julie if she looked like this?

an image of a dog or flower—for their business page. But most clients don't relate as closely with a dog's face as they do with the actual photographer.

For maximum visual impact on your Facebook page, use an image that's formatted as 180x540 pixels. And make sure to leave an 180x180 pixels square area around your logo or face to be cropped for the avatar.

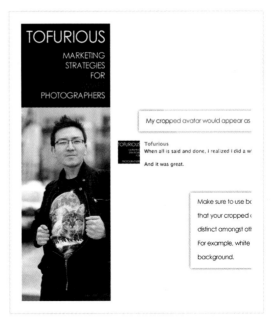

Here's a Facebook profile with a sample cropped avatar showing how the image will appear in feeds.

4. **Invite Fans.**

Send Friend requests to your actual friends as well as to your family, colleagues, neighbors, and, yes, even casual acquaintances. Ask them to Like your business page through your personal Facebook network (if you have one). Also use your email list and other social media communities. Remember, personal profiles cannot be accessed without your approval, but anyone can Like and receive updates from your business page.

But here's the thing: It's very difficult to initially generate an audience for a Facebook business page. But it's one of the best ways to *grow* a fan base once one is created.

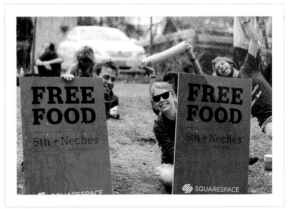

During SXSW's 2011 convention, to encourage people to visit specific venues, some companies offered free food, ice cream, beverages, and other goodies.

So connect with everyone you know and tell them about your interest in photography. Notice that I did not advise you to tell everyone you know about your *business*. Try to remove that ulterior motive. If people like you and your images, they're sure to inquire.

5. Create a Vanity URL.

Because a link like http://www.facebook.com/pages/VictoriasSecret/108243659268171 is pretty cumbersome, a vanity URL can boost its appeal. You can configure a URL to be something simpler, like http://www.facebook.com/VictoriasSecret. Make this adjustment in the Basic Settings tab of the Admin area.

Your Settings			
Manage Permissions	Category:	Websites & Blogs ⬍	Business/Economy ⬍ [?]
Basic Information			
Profile Picture	Username:	You can now direct people to www.facebook.com/TofuriousPage.	Learn more.
Featured			

Create a custom URL for your Facebook page, so it's easy to share with others.

Custom Landing Page

Another great way to make your Facebook business page more appealing to your fans is to develop a custom landing page. This allows you to introduce yourself as an artist and familiarize people with your work.

The standard view for users visiting your Facebook business page is your *Wall.* This is where you and other people post photos, links, and general updates. So without a landing page that introduces people to your basic vibe, the visitor experience is something like walking into a party with no idea why people are gathering. It can be unsettling. To help guests ease into the action, a welcoming landing page can help them figure out if and how they might fit in.

In fact, some companies have actually opted out of using their own homepage. Instead, they use a custom Facebook landing page to feature certain products or promotions, offer coupons, or otherwise greet visitors in a way that's

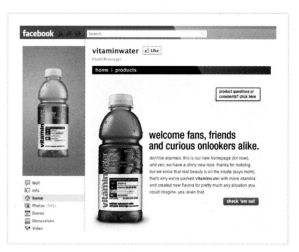

Vitamin Water Facebook Landing Page: If you visit http://www.vitaminwater.com, you will be redirected to the company's Facebook business page at http://www.facebook.com/vitaminwater.

more personable and fun than the Wall view. You can also reward loyal visitors by offering occasional free tutorials, workshops, and other giveaways. These random acts of kindness will keep users wanting to check back—hopefully very often.

To change the default landing page on your Facebook business page, select your preferred destination under Default Landing Tab. You'll need to create an HTML tab in order to designate a landing page. Given the rapid pace of change in social media processes, I've posted instructions on how to create a custom tab on my Facebook page (http://www.facebook.com/TofuriousPage). See the Custom Tabs Tutorial for up-to-date information.

Photo Galleries

It really couldn't be easier to post and share images on Facebook, whether you're using a personal or business page. But there are different terms used for the various types of image content. You've got Wall photos, mobile uploads, and photo galleries.

- **Wall photos** are images that you upload from your desktop computer or laptop. They go into a folder called Wall Photos.

- **Mobile uploads** are images that you shoot with a mobile device and post to your Facebook account. These are usually casual shots that capture an interesting scene or record things that happen in your life. Mobile uploads also go into your Wall Photos folder.

- **Photo galleries,** however, are separate folders that contain a collection of images. You create, title, and describe photo galleries. Facebook photo galleries are useful for separating a specific collection of pictures from all others.

Depending on how many images you shoot at a given event, think about creating a different folder for each event (by date) or type of photography (by subject). This makes it easy for your visitors to click from one photo to the next. See, if all photos are separated into small specific folders, then viewers must leave a gallery, find the next gallery,

All of the wedding photos are organized in this gallery by year, so clients can view all images at once—minimal navigation.

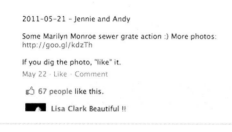

2011-05-21 - Jennie and Andy

Some Marilyn Monroe sewer grate action :) More photos:
http://goo.gl/kdzTh

If you dig the photo, "like" it.
May 22 · Like · Comment

67 people like this.

Lisa Clark Beautiful !!

For a 2011 wedding, I posted only a handful of photos from
the entire day. If viewers want to see more, they can click
on the blog link. Here, more extensive galleries are available
along with opportunities to schedule a shoot with me or get
more information on my photography services.

Red Bull has a strong call to action. In this case, it's to click Like.

and then resume browsing. You'll lose some of your audience every time you require navigation. The current limit on images for a single gallery on Facebook is 200 photos.

Just remember to add a descriptive photo caption to each of your images. And whenever possible, include a link to a corresponding blog post that features a specific photo shoot that your readers can access by clicking on an enlarged photo. When you upload the photo gallery, include something along the lines of, "To see the full gallery, please visit my blog at [link]." We'll cover blogs in the next chapter, but it's helpful to know that blog posts allow you to write more elaborately about your images.

Also try to add a call to action, which is a request for a viewer to do something. For example, a call to action for an image you've posted to your Facebook account may be to hit the Like button. And when someone Likes something on Facebook, it automatically pushes a notification to his or her network, thus creating a chain reaction of additional possible interest.

Another effective way to use photo galleries is to create a *photo strip*, which is a series of five photos that runs across the top of your Facebook Wall. A custom photo strip is a wonderful way to strengthen visual interest on a page. Each image in the photo strip can be clicked on with a new call to action. Treat them like buttons for a website.

For special emphasis on a certain type of photography, a recent event, or shoot, you can focus on specific galleries for your strip. For example, H&M, Abercrombie & Fitch, Victoria's Secret, and other clothing chains use photo strips to highlight new fashions.

For a tutorial on how to create a snazzy custom photo strip, please visit my Facebook page at http://www.facebook.com/TofuriousPage.

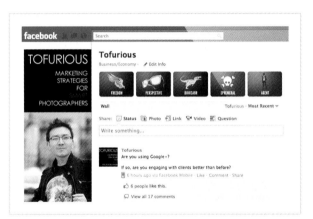

A photo strip provides a nice visual element to your Facebook page.

Facebook Content Tips

When creating your content strategy for Facebook, consider these proven habits for social media marketing:

- **Identify customer interest.**

 As suggested in Chapter 3: Audience Matters, find out what void you might fill in the online social lives of your potential audience. Otherwise, there's little to no reason for them to listen and engage with you.

H&M at http://www.facebook.com/hm uses the photo strip feature to emphasize new fashion lines.

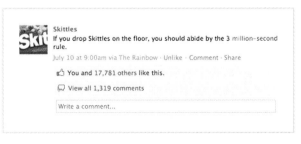

The Skittles brand uses comedy to emphasize attributes of the candy. Notice how Skittles uses text as its content versus, let's say, a funny photo.

- **Relate with humor.**

 As important as it is to show readers that you are an expert in camera settings, angling, and lighting, your personality is a powerful tool for creating connections. Comedy seems to be a universally accepted approach.

- **Be authentic.**

 When you try to be someone you're not, you'll fail. So emphasize your true attributes and be a superstar.

- **Stay current.**

 Facebook content that references real-time events is usually very effective. For example, random photos of donuts might need explanation. But posting photos of doughnuts on National Doughnut Day is clever. And for extra points, a photo-based tutorial on how to make a doughnut castle might be fun!

- **Share existing content.**

 Creating raw content all the time can be exhausting. So don't be afraid to share useful links that may not necessarily show your own work. That is, post useful links and quotes of others that will interest your audience. For example, if you're a baby photographer, links to cute baby boutique clothes will surely be welcomed.

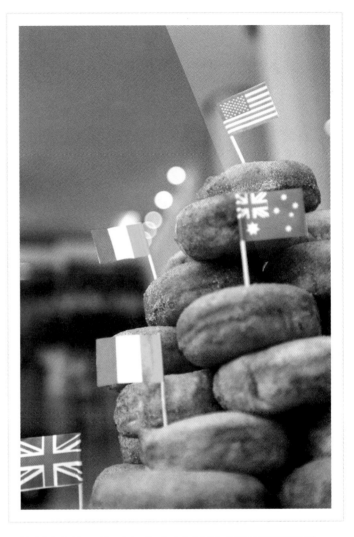

Unable to finish a plate of doughnuts, I decided to create an international doughnut castle. Photo taken at 35mm f/2.8 for 1/1250 second.

- **Listen!**

 Once your network is created, it's natural to want to promote the heck out of your services. But that would be rude. Social media etiquette prescribes that users promote their services in a post only after providing valuable, general information in ten. In other words, you should offer ten valuable posts, expecting no return, before running a promotional campaign for your business.

But whether you run ten or twenty … or five … value posts before posting a promo for yourself, what's important is that you've demonstrated genuine interest in what others have to say. Their posts will likely reveal where they travel, what they like to eat, their likes and dislikes, and so forth. For years, companies have paid millions to discover this kind of stuff. And now it's all right there for free, so pay attention. And use your insight to develop content that interests your network, so they'll engage with you.

SEO

As mentioned earlier, Facebook *business* pages are search engine friendly, which means that anything you post to a Facebook business page is searchable, including your posts and notes. So this content can be found by online search engines (like Google and Bing).

Do keep in mind though that personal pages are private, so search engines cannot pull information from them. Also Google and other search engines are competing with Facebook for visitor time spent on their sites. User time is important to search engines, because the longer you stay on their sites, the more time you're exposed to their ads. And this means they can charge advertisers more for online space. All this boils down to the fact that search engines are not necessarily interested in promoting user visits to Facebook.

So, as of right now, the only thing that really matters regarding SEO and your Facebook business page is the name of your page. That's the only item that will really show up on Google. Everything else requires a verbatim search—right now. This could change at any time. It's possible that Google will take a liking to Facebook in the future, but I doubt it.

That said, still be sure to *optimize* all of your business page content—write it in search-engine-friendly terms—because Google still comes up in the Facebook Insights metrics. You don't want to miss out on free exposure because you were slacking off.

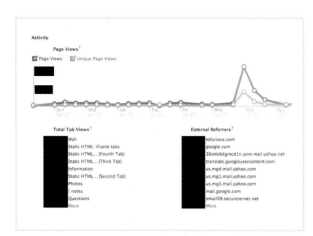

On the bottom right column, Google is listed as a source for incoming traffic.

Metrics

As mentioned, Facebook Insights provides metrics to help users gauge the effectiveness of pages. This tool can help you monitor if/how your Facebook work is building and strengthening your client relationships. This is important, because after all is said and done, you need to know if you're progressing toward your goals. Traffic data can help you figure out which activities are working well and which ones may need a bit more consideration.

Insight to Insights
From Facebook's Help Center*

What is Insights?

Facebook Insights provides Facebook Page owners and Facebook Platform developers with metrics around their content. By understanding and analyzing trends within user growth and demographics, consumption of content, and creation of content, Page owners and Platform developers are better equipped to improve their business with Facebook.

To see metrics on your Facebook Page or Platform application, go to the *Insights Dashboard*. Only Page administrators, application owners, and domain administrators can view Insights data for the properties they own or administer. To view comprehensive Insights on your specific Page, Platform application or website, click on the corresponding item on the left navigation bar.

Insights is a free service for all Facebook Pages and Facebook Platform application and websites. In addition to the Insights Dashboard, data is also available through the Graph API. To learn more about the Facebook Platform and Graph API, visit the *Platform and Developer Support* help pages.

How do I see Insights for my website?

To see Insights for your website, you must first claim your domain by associating it with a Facebook page or application that you manage, or with your Facebook account. To do this, click on the green "Insights for your Domain" link from the *Insights Dashboard*. The window that appears will provide a meta tag that must be added to the root of your web page. Once that is done, type in your domain address into the text box and select the account to link it with. Once checked, your claimed domain will appear on the left side navigation bar under the "domains" section.

*These questions and answers are available on the Facebook website's Help Center at http://www.facebook.com/help/search/?q=insights.

Facebook Insights reveals the number of users subscribing to your page, the number of interactions your page is generating per day, and the percentage increase or decrease of the number of Fans you have. Facebook Insights can be found on your business page either under *Edit Page* or near *Notifications.*

A glimpse of Facebook Insights. This line graph shows the interaction ratio of Likes to comments for posts on a business page.

Facebook also has an on-page analytics table that shows the number of impressions you're getting per post and its percentage of total interaction. Use this information to determine which posts engaged your Fans most and which ones did not. What type(s) of photos work best? Which words trigger the most response? And what time of day do you generate the most engagement? Repeat the tactics that are working, tweak those that aren't, and continue to measure the results.

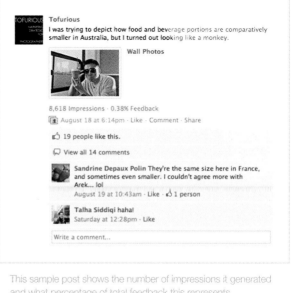

This sample post shows the number of impressions it generated and what percentage of total feedback this represents.

EdgeRank

Another tool for assessing the value of your Facebook business page is its EdgeRank score. EdgeRank is Facebook's system for ranking posts. The system filters posts for users on three criteria, so feeds don't get too cluttered. Pages with a low EdgeRank score might not appear on an individual's feed. If your updates have high scores, they're more widely circulated among your network.

EdgeRank uses three criteria to assess a post. They are:

- **Affinity:**

 Facebook assesses the relationship (or the *affinity*) between a user and the post's creator. So if you're constantly interacting with a certain person, you'll have a higher affinity score with that user than with someone you rarely contact.

- **Weight:**

 Facebook grades the usefulness of a particular post based on how many interactions the post generates in terms of comments, likes, tags, etc. A post with a lot of activity has more weight and will appear higher in feeds.

- **Time:**

 As posts get older, they become less relevant. Therefore, the likelihood of the post showing up on a user's Wall gets slimmer as time passes.

So, to improve your EdgeRank scores, always engage with your users. Reply to everyone. More importantly, ask questions. So instead of saying, "I'm at Olive Garden," ask you network, "What's your favorite entrée at Olive Garden? I can never decide." People love to dole out advice.

Twitter

This microblogging site is perfect for touching base with a busy audience. The 140-character limit forces users to be brief and to get to the point. So tweets are typically combined with other social media platforms via links to photos, blog posts, Facebook articles, YouTube videos, and so forth. But we'll get deeper into social media audience-engagement habits later in this chapter. Let's get tweeting.

Cross Reference with Tweets

Example: Instead of rice, have you ever seen chestnuts thrown at a bride?

http://goo.gl/anqfv #weddings

To begin using Twitter, follow the steps below:

1. **Register.**

 Open a Twitter account at http://www.twitter.com. Make sure to create a username that reflects your brand. Twitter handles are just as hot as a dot com; so if you must, stop right now and go register one now. A nice Twitter handle might be your first and last name. Grab it quick if it's still available.

2. Customize your profile.

Be sure that your Twitter profile positively represents your brand. Start by uploading a photo of you, smiling. Then add your full name, location, and website URL. I suggest linking to your About page. (More on this in Chapter 7: Blogs and Websites.)

Your bio is limited to 160 characters, so be creative, humble, descriptive, and clear.

Finally, add a custom background. If you want to commission design work, the following two websites do it inexpensively and, I think, well:

http://www.socialidentities.com/

http://twitpaper.com/

3. Find tweeters to follow.

Start following photographer friends. I like to use Twitter to connect with other photographers (instead of interact with clients). I think Facebook is a better platform for client relationships, because it's more photo-oriented and less time-sensitive than Twitter.

Once you get a core group of people to follow, take a look at who these people are following. A lot of times, people use lists to categorize their following. For example, I might follow web designers, wedding

A lot of Brisbane, Australia's top photographers meet every Thursday morning for coffee. Despite being competitors, this tradition continues ... after eight years. Photo taken by Lawrence Chan at 16mm f/2.8 at 1/100 second.

Friendly Competition

Colleague relationships—or, depending on how you look at it, being friendly with your competition—can be quite beneficial. If you do a good job pursuing and maintaining these relationships, other photographers might refer jobs to you or hire you as a second shooter. Plus, it's just good form to be a cordial professional among others in your industry. So get connected and interact with your photographer community. Social media tools can help.

photographers, and commercial photographers. If that was the case, I could create a list for each; so if I want to see only the tweets for a specific group, I would select it. Doing this would mean that the others would not show up in my feed.

To find people's lists, add "lists" to the end of their Twitter handle's URL. For instance, if my normal Twitter handle URL is http://www.twitter.com/tofurious, then my lists URL will be http://www.twitter.com/tofurious/lists.

In this scenario, I have two lists: one for designers and one for photographers. Despite being competitors, this is a way to organize all of the tweets I see every day. Just click on any of the lists to see who I follow.

And if you want to use Twitter for interacting with different audiences—say, clients and colleagues—seriously consider opening two different accounts. One could be for communicating with other photographers; the other would be used to engage with clients. You probably don't want clients to see a retweet on pricing your services or how to up-sell prints.

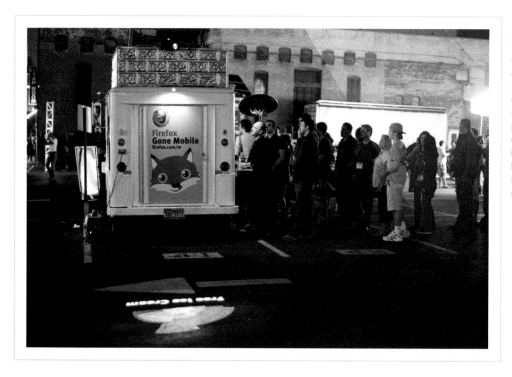

Rather than saying, "Download the new Firefox mobile application" at SXSW 2011, the company offered free ice cream and stickers that guide people to literature on its new service. Photo was taken by Lawrence Chan at 50mm f/1.4 for 1/100 second.

4. Listen … and then speak.

Shh … take in what others are putting out there for awhile. Pay attention to what you like and what you don't like about their style. And then decide how you'll present yourself and to whom you'll target your posts. Just keep in mind that not every tweet needs to be profound. You are, after all, human. So be human. If you think cupcakes solve all problems, tweet it! "When in doubt, eat a cupcake."

You can also use Twitter searches to track your competitors' activities and monitor what people are saying about you.

5. Engage.

When posting updates, remember to share lots before you promote. Build enough brand equity to earn the clout to promote your own services. I mean, imagine walking into a meeting and shouting, "Hire me!" No one would take you seriously. Why should they? But if you first prove your worth by helping others and then mention that you are for hire, your chances for serious consideration are much better. A suggested ratio for helpful links to self-promotion is 10:1.

Photo Galleries

While Twitter is definitely more text-oriented than some other social media channels, it is possible to share photos through tweets.

- Post a photo to launch a fun topic for discussion. The more you put out there, the better others will know you. No need to talk shop 24/7. Posts don't always have to be photo related to be fascinating.

 http://twitter.com/#!/tofurious/status/105450163476250624

 http://twitter.com/#!/tofurious/status/93397298633113600

 http://twitter.com/#!/tofurious/status/95174845716897792

- Reply to others with photos.

 http://twitter.com/#!/tofurious/status/96760721337098240

- Self-promote with humor.

 http://twitter.com/#!/tofurious/status/72749164949286912

Twitter Content Tips

Twitter is a great place to ask questions. Aside from posting new content, you can also participate on Twitter by replying to posts and retweeting interesting articles. *Retweeting* is a way to spread some love for others. And, believe me, reciprocity is important in the world of social media and online marketing.

In fact, one of the best ways to increase your number of followers is to have your tweets retweeted. It exposes you to your retweeter's network. So make your tweets roughly 100 characters long (versus using the limit of 140 characters) to give people room to add a message of their own to your tweet. Make it as easy as possible for others to retweet your messages … along with their own two cents.

jimgoldstein Jim Goldstein
A very good read RT @tofurious: Some Things Are Just Worth Dying For - http://bit.ly/h2zQ5w - story about a cockroach and a firefly :)
6 Apr

Jim Goldstein had enough space to retweet my article and add his own thoughts to it. Even better, his retweet is an unofficial endorsement of what I had to say. Eeeexcellent …

Just remember to keep things interesting and relevant to your followers. By creating and passing on meaningful content

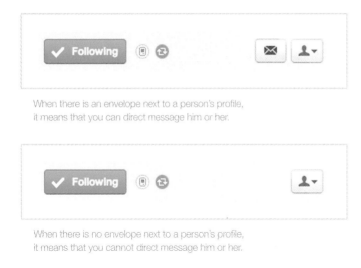

When there is an envelope next to a person's profile, it means that you can direct message him or her.

When there is no envelope next to a person's profile, it means that you cannot direct message him or her.

about your work, you can establish yourself as a likeable expert in your field. People naturally gravitate to and follow those who are authority figures in a specific field. And it's a good habit to share helpful information with folks. So find industry thought leaders and interact with them. Perhaps you'll score a retweet from a heavy hitter, so to speak. This can give you a boost of clout.

And to retain this trust among your followers, be sure to use Twitter's direct message feature when you need to explore a topic that may not have value to the majority of your audience. Direct messages are like emails, except they're confined to the 140-character-per-tweet rule. Just keep in mind that you can only direct message a person if (s)he is following you.

Speaking of followers, don't be afraid to be selective about who you follow. Pick only tweeters that you like. You're not obligated to follow someone just because they follow you. In fact, some refer to the ratio of following to followers on Twitter as an indicator of one's online influence. In other words, if you follow 1000 people and only have 10 followers, it appears as though you have little to nothing to offer. Be selective.

Time for Tweeting

In my experience, the best time to tweet is from 11am to 4pm. Obviously, your best time depends on your audience, but I've found this period to generate the most attention from my audience of photographers.

Metrics

All in all, it's important to measure your progress with any work toward a goal. Cause who knows? Twitter might not be a medium that fits your needs.

The following list of metrics can help you monitor your tweeting efforts. And while there are premium programs available that can track your every social media action (e.g., Radian6 at http://www.radian6.com/), the following free data points should suffice for keeping tabs on a basic Twitter campaign.

Note that Twitter itself doesn't currently offer many metrics. (Although, the site is converting all links to t.co/ which means it's gathering data.) So you'll need to combine third-party programs to monitor your Twitter work.

- **Followers:** Number of new followers over time at specific intervals. Check out http://www.tweeteffect.com/ to see how many followers were gained or lost during the past x-number of tweets.

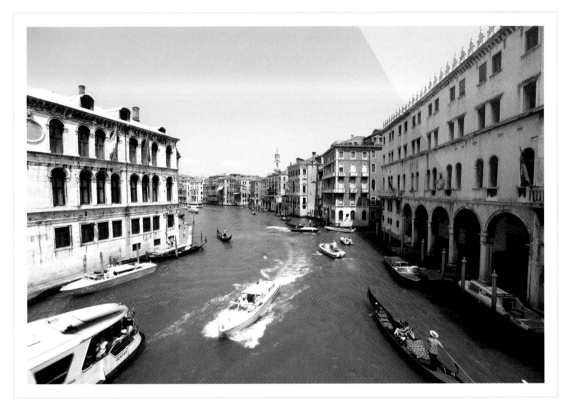

While traffic to your social media sources is probably getting better, boat traffic in Venice, Italy, is not. Photo taken by Lawrence Chan at 16mm f/5.6 for 1/200 second.

- **Listed:** Number of places you are "listed"—as, say, a photographer, inspiration figure, thought leader, etc. This information is on Twitter, right next to the tally of followers.
- **Traffic:** Volume of overall traffic to your website via Google Analytics.
- **Retweets:** Frequency of your tweets being retweeted. Just check the home page of Twitter under "Your Tweets, retweeted."
- **Click-Throughs:** Volume of click-throughs on the links in your tweets. Two popular URL shorteners are http://www.bit.ly and http://goo.gl. These sites tell you how many times a link was clicked by the hour.

Short Links

There is a growing number of URL shortening service sites available, and most are fairly straightforward to use. Just paste a URL and click "shorten." Once a shorter URL is generated, you can share and track its use. Luckily, many of these sites also offer some information on how many people click your link.

The image on the right illustrates the details for a clicked link using goo.gl. You can customize your report to show information based on pre-determined timeframes. Use two hours, one day, one week, one month, or all time. Since tweets (and Facebook updates, too) are short-lived, just don't expect much activity on a post after a few days.

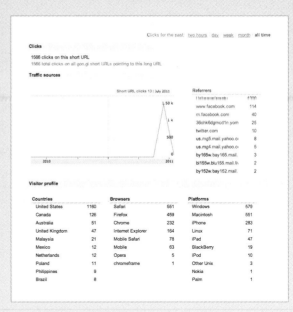

This screenshot shows various metrics—traffic source, countries, browsers, and platforms—for a shortened link created with http://goo.gl. I'm always especially interested in the sources of traffic. It's cool to see where people find my content.

Be careful though when clicking on a shortened link, or any link for that matter. Spammers are rampant. Only click links you trust. Don't risk it if something seems a little funky.

A good source for some all-around Twitter metrics is http://twittercounter.com/. This site shows a line graph of one's growth on Twitter with fields for number of followers, number following, number of Tweets, and a mixed graph.

Of course, these metrics do not necessarily tell you how effective your Twitter activity is. That is, a high number of followers does not mean that your audience can be rallied for action. Similarly, being listed on a high number of accounts does not mean that you're necessarily influential among your followers. And the number of retweets or replies varies because of the many channels we use to broadcast our messages. Audience interaction is split among Facebook, Twitter, blogs, Instagram, Google+, etc.

For example, http://twitter.com/#!/tofurious/status/93397298633113600 has zero replies, comments, and retweets on Twitter, but it has 50 Likes on Facebook.

Metrics are subjective. It's important to create your own measures based on your specific goals and strategies, and then monitor which methods work best for your program.

YouTube

YouTube hosts videos. You knew that, right? Well, as mentioned in Chapter 5: Social Media Channels, YouTube is a social sharing site, and it's a good platform for photographers because it's search engine friendly; it's a great format for showing off your personality and working style; and it has a huge audience. Plus, it's free and easy to use!

To begin using YouTube, follow these steps:

Your YouTube channel is a landing page where all of your videos will reside. During registration, you will be asked to create an account name. That account name will be the address for your channel, as in http://www.youtube.com/ [account name]. So name wisely!

1. **Register.**

 You can open a new account at the YouTube site (http://www.youtube.com/create_account) or use a Google account to register. Just be sure to create a username that reflects your business. That username will become the shortcut for your channel.

2. Design.

Stylize your YouTube channel by adjusting colors for text, links, and backgrounds. Make other tweaks by going through the advanced setup options.

3. Reveal.

Begin posting!

Keep in mind that YouTube offers slideshow capability for still images. And for maximum exposure, choose "public" when selecting your settings.

This is my YouTube channel. In the menu is a button for "Themes and Colors." Customize with hexadecimal color codes and by selecting images for backgrounds. Images can be stock images or a photographer's own work.

YouTube Content Tips

Uh, hmm … alright, you may be saying. So what the heck do you post on YouTube that's not going to make you look silly? Well, I suggest that you take a moment to fully consider the fact that clients and prospective clients are not-so-secretly concerned about things aside from how pretty your photos are.

They want to make sure, for example, that you won't embarrass them in front of their guests at the wedding or that you'll treat pets as family during a pet shoot. It may seem obvious, but it's not; I've seen wedding photographers in cargo pants. I've watched family photographers get impatient to the point of being scary and rude with children.

So a photographer's persona is very important. We reflect the people with whom we're working. Therefore, a video of you in action can be very assuring. It can show how you interact with the subject(s) and handle various real-shoot situations.

Try combining humor and personality to show how fun a photo shoot can be. Since most people are not entirely comfortable in front of a camera, this can help ease their fears. Of course, the situation is different if you're shooting food or another inanimate subject. Carrots, obviously, aren't camera-shy. But a restaurant owner who's needing images for a new menu will probably want to make sure you know how to work with her chef to style a plate without offending anyone's artistic vision.

This video screen capture of a bridal photo shoot in Paris, France, was taken by Lawrence Chan.

In your video, feature topics that underscore likely shared interests. It could be anything—tacos, shopping, craft beer, Marvel comics, dSLR cameras, anything. Just be sure to share details about yourself and your peripheral interests on YouTube. Include footage of your vacations and pets!

But you really can't go wrong with a good ole behind-the-scenes look. No question, it feels good to access something that's available only to a few. So bring an extra video camera to photo shoots. It can be as easy as putting the spare camera on the side and creating a time-lapse video that's synced with music. Show your audience how you operate.

Don't be Afraid

There are a lot of photographers and other artists who are afraid to put themselves out there too much. They fear that competitors will steal their ideas. Well, I say that the more you're out there, the more recognized you become as an authority—and the more difficult it is to copy your work without being "caught."

For example, John Michael Cooper was the first person who burned a bride's dress as part of a Trash the Dress session. Now, even if a hundred other people did that, only Cooper will be credited for the idea. Everyone else is a copycat. Plus, you know what they say: Imitation is the highest form of flattery.

And remember that your audience probably extends beyond clients, prospects, and even competitors. This group almost certainly contains people who've just taken a liking to you and may refer their friends to your business. Indeed, non-clients are important, too. Pay attention to them.

Whatever you do, be sure to include a call to action in the video. This will offer your viewers a way to engage. For example, write: "If you like this video, hit the Like button and comment your thoughts!"

And since YouTube is a social network, remember to nicely respond to people who take the time to post comments, subscribe to your feed, and Like or Dislike your videos.

YouTube allows users to customize information regarding their video(s) for better search visibility.

SEO

To maximize your search engine exposure on YouTube, be sure to use related keywords when describing your content. Since YouTube records a user's activities and suggests videos based on his or her recently watched content, your video on how to photograph dogs might come up in the suggestion system for a user who just watched a video on how to walk dogs—but only if you used effective keywords that relate to canines.

Engagement Habits

The entire point of using social media to market your business is to engage your audience and earn their loyalty, right? So how do you do it? What's it take to engage your clients, prospects, colleagues, and other followers with social media tools? Well, the number of tactics is nearly endless, but some key activities are described below. These actions can help you develop good social media habits—no matter what platform you're using.

Recognize Users

Don't you love it when you're publicly and positively acknowledged at school, work, or home? Most people get the warm and fuzzies when someone else recognizes them for something good. And that's a nice feeling to offer your friends and fans. So mention specific Fans and Friends in your content from time to time. Show that you appreciate their input and attention.

Also, try to follow your clients on Twitter and befriend them on Facebook. Then, pay attention to what they say and do. Read what interests them and engage with their posts.

Even better, you can further the relationship by initiating dialogue on mutual interests. For example:

Oreo highlights members every week on Facebook, thereby creating cookie evangelists.

> **Client:** *Just came back from Paris. So romantic!*
>
> **You:** *Totally! I love it there. Did you get to try a Nutella crepe from a street vendor?*
>
> **Client:** *Yes! It was delicious! My husband was weird – he got an egg in his.*
>
> **You:** *Isn't that messy? The yoke could leak everywhere.*
>
> **Client:** *LOL what does it matter to a man…*
>
> **You:** *:)*

Just be genuine in conveying interest in people. It'll go a long, long way.

Cross Communicate

Amplify your messages by combining your tools. Don't confine yourself to one platform. For example, if you write a blog post about a client, then also write an update on your Facebook page that links to the blog post with a tag to your client's account. In addition, be sure to tweet a link to the Facebook update or blog post with an @mention of the client, if available. This will ensure that the client sees his/her coverage.

Also, encourage your blog readers to subscribe to your email list. Signing up for an email list is an act of intimacy these days. We're all drowned in spam, so giving up a private email address requires a certain level of trust.

Train your readers to open emails. Each email from you should be like a fortune cookie. There's always fortune upon clicking!

QR (Quick Response) codes are matrix barcodes that are readable by smart phones with QR code-reading applications. So rather than having users type information (such as long URLs), or mistyping information, QR codes can be scanned to reveal a corresponding website!

This is a sample QR code that links to my website. Create your own for free from various websites. I used http://qrcode.kaywa.com/.

Create Contests

Competitive participation and rewards are always fun. A contest for a free headshot is a neat way to engage clients in an intimate way. But make sure to add barriers to entry to create value. We'll cover value barriers in Chapter 8: The Social Luxury of Photography.

A clever way to host a contest is to make it themed (e.g., Spring in the Air). You could require people to submit photos or videos of themselves with something that epitomizes springtime. Then, pick three entries and post them online for people to vote. You can create polls on Facebook or on your blog. I like using http://polldaddy.com/.

Afterward, post the winning entry and the winner's headshot. Then, repeat the contest for summer. This form of engagement creates excitement and exposure. Throw in some behind-the-scenes video of how fun the experience was (even for shy subjects) and voilá! Great seasonal campaign.

Get Real

As fun as it may be to engage people online, it can never compare to a firm handshake, hug, or a discussion over drinks. So use Facebook as a way to maintain relationships when away, but remember to still engage in real life when you can.

Plus, going out is a great way to create new fans. There are lots of meet-ups happening

every day. But if you're not ready for a bridal event or an expo of that sort, try local gatherings. Take a peek at Meetup (http://www.meetup.com) to browse congregations of all sorts.

And remember to bring your business cards! Be sure your card shows your Facebook vanity link. You're welcome to add other social media information on your card, too, but try to avoid clutter. If your local area is tech savvy enough, QR codes are fun for trading information.

Timing

I've learned that many clients who have 9-5 jobs actually do most of their research for photographers during their work hours. This is why I don't add auto-playing music on my website. My readers could be at work!

So posts and email blasts sent Monday through Thursday during working hours seem to gain the most attention. But avoid sending emails at the crack of dawn. People tend to be less happy when they first get to work.

I stick with noon to 4pm EST for any important updates, but this really depends on your target audience. Depending on where you are in the world, you'll need to change the times accordingly.

Frequency

If you post too few updates, you will be forgotten. If you post too much, your content could become noise, and people will become desensitized. Ideally, you want everyone to eagerly wait for what you have to share as they scroll past many others.

As a rule of thumb, Twitter and Facebook updates can be as frequent as one to three times a day. That seems right for my network. But of course, your ideal frequency completely depends on your readers' interest and tolerance.

So that's the Big Three in social media: Facebook, Twitter, and YouTube. Ready now to dive into the blogosphere? Let's go! ✪✪✪✪✪

Socializing

An Interview with Catherine Hall

CATHERINE HALL STUDIOS: www.catherinehall.net
TWITTER: @catherine_hall
FACEBOOK: facebook.com/catherinehallstudios
GOOGLE+: gplus.to/catherinehall
YOUTUBE: youtube.com/catherinehallvideos

Why do you think content is so important in garnering a social media audience?
We live in an information age. With so much content being distributed at a breakneck pace, you need to seize the opportunity to be heard by producing good content. Content, whether it is on your blog or on social media platforms, tells an aggregate story about yourself and your brand. It's about creating continuous and exciting conversations, which in turn builds relationships with the people who are interested in you and your art. People tend to connect and engage with friends and familiar brands. Producing and distributing your own content allows you to influence how people see you ... rather than rely on what others say about you.

How did you determine which social media platforms to use to deliver your content?
Social media has provided a tremendous boost to my business. It's a common misnomer that it only takes 10-15 minutes a day to deliver and monitor your content on social media. In my experience, you need to spend a lot of time, at least initially, to create a sound editorial strategy that will allow you to achieve your business goals. Finding the right social networks can be a complex process of trial and error. You should find the ones that resonate best with you and your brand.

For me, Google+ has been an incredibly inspiring network for me to introduce my work and interact with a vibrant community. I am also very active on Facebook

and Twitter. I use these platforms to deliver messages and engage with different communities in different ways. Do not try to be on every social network unless you are able to hire a full-time social media manager. I suggest doing some research on social media dashboards, such as Hootsuite and Tweetdeck, and using analytics to determine which networks are most beneficial to your business.

What strategies do you use when fostering engagement habits with your viewers?

My main tip is to be responsive. Communication is a two-way street; if people take the time to comment on a post, you should (at the very least) spend some time each day to respond. You'll be surprised at how far a simple "Thank you" can go to foster relationships with your online communities.

You can also deliver your company announcements and brand images with an informal and personal touch, which may motivate your audience to start a conversation with you. Also, recognize important industry leaders and stakeholders in your business on the social media platform that they use. This builds an ongoing dialogue with them and gets you in front of their audience.

Many people are not familiar or not comfortable with being in front of a video camera. What is your experience with the video format? Has it been helpful?

Being in front of the camera can be very intimidating at first. You worry about how you look, how you speak, and/or how you may appear to other people. The good news is you can get better with practice.

Just remember to always prepare the content for the video. Think about your message and what you want to achieve for your brand. At minimum, have an outline for the message you'll deliver. And prior to being recorded for something important, do a test recording and watch your own video. You'll pick up on things that you can improve and boost confidence the next time you produce a video. Nothing engages your audience more than being able to see you live, so video is definitely a worthwhile undertaking for all photographers.

#chapter7

When I was very young, I would visit my cousin Joanne on the East Coast. She used to have a journal that I'd secretly read with her sister. And it was great entertainment, because Joanne would divulge her secrets about romantic infatuations, her insecurity about bad hair days, and her fascination with certain celebrity love affairs.

After reading a few entries, I always felt like I knew Joanne so much better. Her journal helped me understand her life, her views, her pains, and her growth as a person. Of course, she eventually discovered my trespass and thought I was an insensible jerk for reading her journal. But my rebuttal at the time was simple: Get a better security system. Duh. (For the record, we're friends again.)

Since blogs are online, it's become a convenient platform for many to journal thoughts … from and to anywhere in the world. Photo taken at Manly Beach, Australia, by Lawrence Chan at 16mm f/2.8 for 1/100 second.

Well, *blogs* (a term combining "web" and "log") are online journals—a new and improved type of website. In contrast to the relatively static sites of yesteryear, a blogger typically posts updates at least weekly and can write with no limit and no filter. (S)he can post images, embed videos, and much more. But, unlike journals with the little lock and key, blog entries are intended to be shared with others. And the good ones do get quite a bit of feedback from readers.

Aside from personal journaling, blogs can be used for many other purposes. For one, artists can use this platform to document the evolution of their art. Among the features that many photographers love about blogs are:

1. Blogs allow for people to comment on articles.
2. Blog posts can be shared with friends.
3. Good blogs are constantly updated, and this creates positive anticipation for readers.

4. Blogs are search-engine-friendly, which means that posts or photos might show up on a Google search, increasing a blogger's exposure.

The main thing though is that blogs allow you to write more elaborately about your images. They also provide great opportunity to convert prospects into clients ... through links to portfolio galleries, project-investment information, and a contact form.

To get some ideas for how your blog might look and feel, start studying other people's blogs. Notice what you like and don't like about the blogs you see. And be sure to look up your photography heroes. If they blog, what are they saying ... and not saying? Does their content make you want to check back for updates? What components are they using on their blog?

Obviously, don't mimic your heroes or other bloggers who are doing things you like. But be inspired by stuff that resonates with you and find your own style. Notice what strategies successful bloggers are using and repurpose them to reflect your own personality and business style.

Just be very clear about one important thing: Blogs require a lot of time to populate regularly with new content and to cultivate and retain readership. We'll talk more about possible content for your blog posts later in this chapter. First, let's take a look at how to select a blog program or host to get your blog started.

Blog Software and Hosting

Blog hosting services require a special kind of content management system (CMS), which occasionally needs to be updated with new versions. The CMS allows users to post and edit content online without requiring knowledge of HTML coding techniques.

Blogging software can run on any website host that offers database services and scripting language (e.g., Windows vs. Linux). Chances are, if you already have a website, you can just add this feature, perhaps as a sub-page (e.g., your-website.com/blog). But there are also services that make it possible for you to run your blog on a host's website. Don't be intimidated by the process. Most domain name servers (where you buy your domain name) offer free technical assistance.

When selecting a hosting service for your website or blog, consider using WordPress. It's a great service, and WordPress handles most of the SEO mechanics for users.

There's more on SEO later in this chapter, but this kind of support means that users are prompted to enter applicable keywords and integrate links to improve visibility on search engine results.

Of course, there are other great blog hosting providers, including Square Space, Blogger, Xanga, and Movable Type, but I use WordPress. These other companies also handle SEO mechanics automatically, to a certain extent; but they're not as customizable as WordPress, which allows users to change practically anything.

Plus, since WordPress is an open-source community, a lot of people develop tools for this product. And this means that the moment new social media tools are launched (such as +1 buttons, Facebook message, etc.) plugins for WordPress are available almost immediately.

If you're using your own URL and host, great! But if you decide to use a free blog hosting service, there are some serious drawbacks. For starters, you have to include the company's name in your URL (e.g., http://tofurious.wordpress.com/) rather than the cleaner http://tofurious.com/. This isn't a huge issue, but it can be annoying.

A bigger issue in my opinion is that you cannot make major changes to the overall design, or *theme*, when using a free hosting service, because these companies do not typically allow users to upload their own files to their servers. They fear the files might be infected. To avoid the risk of spreading virtual disease, external files are banned. This means no personal touches on your design. You get what you get.

And what happens if your hosting company decides to close its doors or sell the company to someone else who makes major changes? If this happens, then you're back on the market for a new hosting service. And you'll be changing your URL, which can get confusing for your audience groups.

Unfortunately, this happens rather frequently. Just last year, VideoEgg (a video ad network) announced that it would acquire TypePad and Movable Type. As part of this acquisition, some media outlets reported that these pioneer platforms in the blogosphere will focus less on blogging and more on advertising technology. It's likely that many users of these sites will soon move to WordPress.

Instead of risking such an outcome, after putting so much energy in building a website, I suggest that you seriously consider hosting your own blog and website.

Self-Hosted Blogs

As mentioned in the previous section, anyone can start a blog for free, but the no-cost hosts require you to retain their names in your URL, as in lawrencechan.wordpress.com. So if you're serious about blogging to promote your own business (and not help market a blogging site), I recommend that you install a blog system onto your own paid server.

This means you'll have your own domain name, which makes it easier for your clients, prospects, friends, family, and colleagues to find you. Full video tutorials on how to install your own WordPress blog are available on my website at http://www.tofurious.com. Just select *Blog Theme* to access these videos. Again, I recommend WordPress, because it's an easy program to install and maintain.

Self hosting your blog (and/or website) puts you in control in other important ways, too. No one else's IT problems are going to mess with your work. And, assuming your own IT challenges don't interfere, you retain a secure location on the web. That is, no matter what happens with any particular social media site or hosting service, your URL remains the same. People will be able to find you easily and access your content.

You also have the freedom to customize your own blog any way you want. Later in this chapter, we'll dive deeper into the sea of user experience as it relates to design and branding; but for now, this means that you can use plugins, place call-to-action buttons and social sharing controls, and mobilize your blog as you see fit—not based on your service provider's set of offerings. But, of course, there are disadvantages to self hosting, too. Among them, you'll need to:

- **Update the CMS on your own.** This isn't difficult. It's just a matter of pushing one button to update WordPress and plugins.
- **Backup your own database.** In other words, if your blog is infected or hacked, you'll need to be able to access all of your content to reload it.
- **Pay for your URL *and* hosting.** See, a domain name server and a hosting server are two different things. Most companies, like Bluehost or GoDaddy, allow you to purchase them together. At times, there are financial incentives if you bundle the two purchases. Bundling also helps users avoid needing to point a domain name server (DNS) to the host server IP address.

But all in all, I think the perks of self-hosting outweigh the extra work and expense it requires. Explore your options and decide what makes the most sense for your business.

It's cliché, but true; business traffic is all about location, location, location. Strategically positioning yourself in front of prospects is equally applicable online. HDR photo of Universal Studios City Walk Hollywood taken by Lawrence Chan at 24mm f/2.8.

Search Engine Optimization

As you begin conceptualizing your blog, determine what keywords you think clients might use to find you. Put yourself in the position of your client. What words would you use when looking for a photographer?

If you want to learn more about how keywords work, try a subscription to ScribeSEO Tool. This site analyzes your content for keywords and suggests ways to improve your use of them.

Here are some areas on your blog where keywords should be used.

- **Title:** When titling your site, consider using keywords that users might search. For example, event photographers might want to focus on a location as a keyword (e.g., Quinceañera Photos at Los Angeles Ritz Carlton). A pet photographer may post a video title on how to photograph dogs, such as How to Photograph Your Dog Indoors.

Just keep in mind that search engines read up to the first sixty (60) characters of a title, including spaces. Anything thereafter is dismissed. So keep it somewhat brief.

- **Description:** Use relevant keywords when describing your blog and specific articles. For example, an article on how to photograph dogs might be described as: *Easy tips and tricks on how to keep your dog entertained indoors, so photography is a dream.*

 Just be aware that overuse of keywords (also known as *keyword stuffing*) may lead to penalization, such as your site not showing up in search engines at all, because stuffing is a popular tactic for spammers. Write naturally and be sure your keywords are present. I think you'll know when you overdo it. Your content will be awkward.

 Also be aware that search engines read up to the first 160 characters of a block of content. Anything thereafter is dismissed.

- **Tags:** A tag is a word or phrase you assign to a post that relates to the topic of a post. It acts as a category button. So tags on a post for how to photograph dogs might include: *German shepherd* [or other breed], *dog food, dog tricks, indoors*, and/or *tips* and *tricks*. Or, let's assume that I tag five random posts with "vintage." Clicking on the "vintage" tag will pull up all five posts, even though they may be assigned to different categories.

 Capitalization for tags does not matter. However, I advise using all lowercase letters to maintain consistency with website URLs (e.g., http://www.tofurious.com/tag/starbucks/). Choosing the right words to tag is subjective. Personally, I pick words that search engines might want to see and that help better categorize different posts. Common words such as "photography" or "dog" could be avoided, because there will be so many hits on those words that they aren't likely to improve your search rankings.

- **Category:** Be sure to categorize your posts, so that others can easily find your work on a given topic. For example, a portrait photographer might use the following categories: *seniors, family, headshots*, and so forth.

- **Body Content:** When you identify some keywords that are likely to be used by your clients and prospects when searching for a photographer, be very sure to use these keywords in your blog posts. This is known as *targeted content*. Using it dramatically increases your chances of appearing near the top of search results. So avoid using jargon or industry slang. For example, don't refer to *engagement sessions* as "e-sessions" or words of that sort.

Microblogs

With no limit on length of posts, blogs can require quite a bit of time—for both readers and writers. The answer to this, for many people, is a *microblog*—a snappier form of blogging. Twitter and Tumblr are examples of microblogging programs.

We live in a fast-paced world, and not everyone has the time or patience for in-depth articles or long-winded posts. So microblogs operate as regular blogs but feature short posts instead of full articles. People who use microblogs appreciate brevity in a culture of information abundance.

Plus, with the ever-growing popularity of mobile devices, it's important to many people that articles are short and images limited. This quickens the loading time for posts being received on cellular data networks.

- **Hyperlinks:** The clickable characters in a hyperlink are known as *anchor text*. Search engines judge the content of the destination based on these characters, so make sure that your hyperlink text contains your important keywords to fortify your ranking for those particular terms.

To further enhance your SEO, I recommend installing a plugin called "All in One SEO." It can help you make changes to your blog that will make it even more SEO friendly. For starters, there are extra text fields where users can customize titles, descriptions, URL-structures, and so forth. But even without this plugin, WordPress is configured nicely already for search engines.

Yet, like most things related to the Internet, SEO is always changing. So it's pertinent to stay up-to-date on algorithm updates for Google and other major search engines.

Delivery Matters

I just can't say it enough. If there's one constant—a rule that applies to every social media program no matter what channel being used—it's this: Content is for your readers, not for yourself. No one likes a blowhard.

So no matter what platform you're using or where you're posting information, be very sure that you present information in a way that's accessible, pleasing, and convenient for your community. It can be tough though. Social technology is evolving quickly, and it's challenging to keep up with the various formats and special features of different devices. But you've got to know that people are receiving content, more than ever, on mobile devices. As a result, the design of social media sites is changing dramatically to satisfy the smaller screens.

This matters a lot when you're trying to build relationships through social media, because some sites load a different version when certain mobile browsers are recognized. Not everyone you're trying to reach will be using the same device to receive your posts.

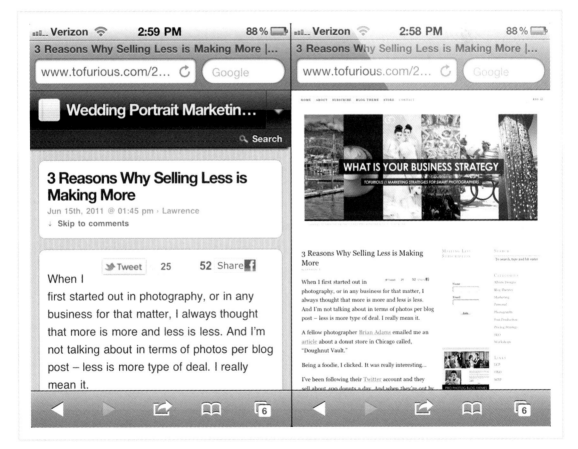

Compare a website viewed regularly (right) and one viewed with WPtouch (left). WPtouch is a WordPress plugin that makes the browsing experience mobile friendly.

RSS Readers

RSS, an acronym for *Really Simple Syndication*, usually refers to an XML-based news feed to which users can subscribe in order to receive updates to selected websites and blogs in one place. But not everyone uses RSS Readers. Like QR Codes, they can seem too advanced for some people. Yet even those who do may not read all of their updates. So offering this feature is nice, but it's not a reliable way to ensure your audience receives the content you're putting out there.

Another issue to consider with RSS Readers is that, like blog posts, updates are received in order of newest to oldest. So if you're trying to tell people about a new service or product, this may not be the best platform. Effective launches require some anticipation-building.

This is especially applicable to your website and blog. A phone browser is not a computer browser, so don't treat it like one when sharing photos and other kinds of content. That is, save images for the web on Photoshop to maintain clarity at a lower resolution. And limit the number of image files you post. (Don't exceed 15 photos on a single blog post, for example.) If you have more to share, split the content among different posts. On the bright side of this, there's a greater chance for optimization with multiple posts!

And remember that smart phone data speeds are slower than Wi-Fi broadband. But luckily, there are plugins, like WPtouch for WordPress, which automatically make blog posts mobile-friendly. These plugins do a variety of things, including:

- Remove "sidebars," which are columns that don't pertain to the content.
- Increase the size of text, so it's legible on mobile devices.
- Narrow the width of the text column, so it's not too long. This makes reading easier.
- Resize photos to fit on the mobile device screen.
- Remove all fancy CSS effects (designs), which makes the text generic black with blue hyperlinks.

One major issue to consider with deliverability is Apple's incompatibility with Adobe Flash. Steve Jobs of Apple does not permit Flash to be used on Apple devices. This includes the popular iPhone and iPad, so select your file formats accordingly.

> *"We see our customers as invited guests to a party, and we are the hosts. It's our job every day to make every important aspect of the customer experience a little better."*
>
> *Jeff Bezos (CEO of Amazon.com)*

Design

Similar to the issues related to deliverability, it's important to carefully consider how you present your content to your audience. Especially as a visual artist, you want to ensure that the visitor experience is pleasant. A big part of this is functional and appealing page design.

It's natural to lean toward your own tastes in terms of aesthetics, but remember that you are not necessarily your customer. What may be intuitive for you is not necessarily obvious to your audience. What matters to them may seem irrelevant to you.

Typography

One important and often overlooked element of web and blog design is text formatting and fonts. Even though typography can help define a brand—as whimsical, edgy, romantic, or whatever—be sure that the reading experience is comfortable for your audience. That means using a clean font and a size that is legible for all ages. Text that is too big or too small can be difficult to read. I suggest using a 14-point font size.

Also be aware that readers tend to scan and then read, so make sure your section breaks are clear—that your headlines are clearly headlines (and that they accurately describe the messages of the section being introduced). Use bullet points to highlight important lists, and bold or italicize words and phrases that need to be emphasized.

Another element of typography that will affect the overall look of your page(s) is the spacing between lines. Don't let the lines of text get too close to each other, because this will make it tough to read.

Column width is also important. Avoid columns that are too long or ridiculously short. Both extremes make reading cumbersome. Especially when columns are excessively wide, it can be very difficult to find the next line correctly. It's easy to lose your place when reading text that's formatted badly this way. And this is annoying. So watch the width of your columns of text and be sure it makes your pages approachable.

Sprawl

Along the same lines of design considerations, the length of paragraphs can make your content appear inviting or ominous. Brief, easily digestible paragraphs are much more approachable than thick blocks of text. I suggest keeping most website and blog paragraphs to about four lines in layout. And keep paragraph lengths consistent throughout any given page or article.

Content Strategy

Content strategy is a practice whereby you deliver content beneficial to your clients. Okay, good enough... So, how does one do it? And have enough content so that it's worthwhile for readers to return? I am not going to write about how to create content because there are infinite ways to approach it, but I will share an idea of how to promote your work while using content. For example, let's imagine that you wrote a blog post on "Learn How To Take a Photo of Your Baby Laughing" and listed instructions for capturing the right moments. Well, an example picture of a baby laughing would be ideal, right? Get where I'm going with this? By sharing your own photos for these content strategy posts is an indirect way of promoting your work while removing ulterior motives. While you educate your audience on how to improve their lives, you are hopefully keeping your brand on top of their minds. So that in the event that your professional services are required, you'll stand out compared to an ad they might have clicked on Facebook.

This is a block of text with a small font, no breaks, and a wide column.

Content Strategy

Content strategy is a practice whereby you deliver content beneficial to your clients. Okay, good enough... So, how does one do it? And have enough content so that it's worthwhile for readers to return?

I am not going to write about how to create content because there are infinite ways to approach it, but I will share an idea of how to promote your work while using content.

For example, let's imagine that you wrote a blog post on "Learn How To Take a Photo of Your Baby Laughing" and listed instructions for capturing the right moments. Well, an example picture of a baby laughing would be ideal, right? Get where I'm going with this?

By sharing your own photos for these content strategy posts is an indirect way of promoting your work while removing ulterior motives. While you educate your audience on how to improve their lives, you are hopefully keeping your brand on top of their minds. So that in the event that your professional services are required, you'll stand out compared to an ad they might have clicked on Facebook.

Make it easy for your audience to read what you're putting out there. Insert breakers. Use a legible font. Make the width of columns manageable—not too wide, not too narrow.

Overall, the ideal length of your online passages depends on the topic being covered and intended audience. But when considering the length of your website page or blog post, be sure that you say what's necessary and write concisely. Being too brief is just as frustrating for readers as text that rambles. Ultimately, your readers shouldn't notice how long or short your text is.

Color

Color choices can have a dramatic influence on our moods. A pleasant application and combination of colors can create a sense of order and balance a visual scene. Similar to sprawl, people will reject visuals that are under-stimulating or over-stimulating, so it's important to carefully consider how you apply color to your website or blog template.

Degraves Street in Melbourne, Australia, is rich in street art. The colorful graffiti adds character to the area. Photo taken by Lawrence Chan at 16mm f/2.8 for 1/50 second.

The two most basic schemes of color theory are *analogous* and *complementary*. Let's take a brief look at what these terms mean.

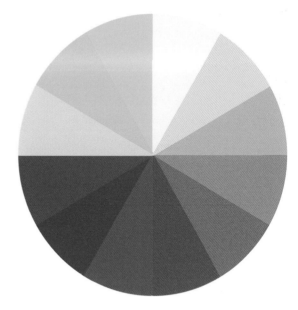

- **Analogous** combinations use colors that are next to each other on the color wheel, such as green and yellow. These colors tend to blend well and have little to no contrast. Use an analogous combination to convey serenity and put viewers at ease.

- **Complementary** combinations use colors that are opposite each other on the color wheel, such as blue and orange. This combination has strong contrast and a vibrant impact. Use complementary colors to make something pop.

There are also types of colors: warm, cool, and neutral.

- **Warm Colors** are intense and energizing. Examples of warm colors are red, yellow, and orange.
- **Cool Colors** are comforting and serene. Examples of cool colors are blue, green, and purple (violet).
- **Neutral Colors** are not shown on most versions of the color wheel, but they are important to color theory, because they accentuate or tone down other colors. Examples of neutral colors are beige, black, and white.

So instead of instinctively choosing your favorite color for your website or blog, think strategically about this important decision and select colors that are likely to portray a feeling that supports your market position and overall messaging. Use color theory as a guide.

Landing Page

So here we are. The entryway to your blog—your front door. Hopefully this will be a welcoming place for many, many other people, too, right?

Indeed, a well-integrated social media marketing program will guide your different audience groups to your blog. This is known as *funneling*, and it makes sense for your blog to be the end-point, because a blog is the platform that allows you the most creative freedom and space for meaningful content. It is the social media channel that's most likely to convert readers into clients, or at least referrals.

So your Facebook photos should have links to your blog (as in, "For a full gallery, please visit http://yourblog.com"), and your Twitter profile should link to your blog, too. Everything out there, all of your social media tools, including Google+, YouTube, and other channels, should be used to drive traffic to your blog.

I was trying to optimize for the term "Santa Monica" weddings. Traffic spiked when Google thought I had photos for "Monica's wedding." Once the search engine realized that I did not, it removed me from search listings related to this term.

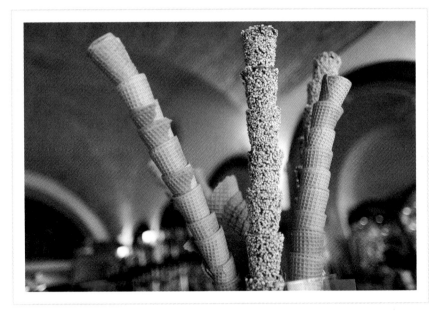
Upon entering a store in Pisa, Italy, towering cones made it obvious they served gelato. Photo taken by Lawrence Chan at 24mm f/1.4 for 1/640 second.

But then, the pressure's on. Your blog's landing page—the spot where visitors first hit your site—needs to carry the torch and continue to reflect the personality and value that you've established in your other social media efforts. So think about your communication goals when populating your landing page, and carefully consider your target audience. Who are they, and what are they looking for? Be sure that your content speaks to them, because—as we explained in Chapter 3: Audience Matters and Chapter 4: The Power of Content—if you don't, you'll lose them.

This is bad for a lot of reasons, but a big one is that a high bounce rate will negatively affect your search engine rankings. That is, if people land on your site using one of your keywords, but then quickly leave because they do not find what they want, you'll take a hit in your ranking. You won't be referenced for that term again.

Also decide what you want visitors to do when they arrive at your blog's landing page. Do you want them to move swiftly to a particular photo gallery or read a specific article? Or do you want them to check out your About page, answer a survey, or do something else?

Personally, I prefer to drive visitors to my About page. We'll get into developing your About page in the next section. For now, keep in mind that a key goal of business marketing is to differentiate yourself from others. There are lots of photographers out there. So it's pretty important for your audience to see the stuff that makes you stand out, that makes you unique. Just make sure that the attributes you highlight are unique to you. You're a dime a dozen if you're simply *passionate* and *creative*.

Also be sure to develop your content accordingly. A good term to know in this regard is *above the fold*—a reference to prominent placement in a newspaper. Since a typical newspaper folds horizontally in the middle, anything above the fold is going to grab more attention than content placed anywhere else in the issue.

You have very little time to capture a reader's attention, so make sure that you develop your visual real estate wisely. As explained earlier in this chapter:

- **Overall design** of the landing page needs to be professional and attractive.
- **Font size** needs to be legible.
- **Paragraphs** should be short (about four lines) for easy flow.
- **Images** must be optimized for your site (as explained in the previous section).

Plus, your messages and call to action must be enjoyable and easy-to-understand. Keep it simple. Don't ask for too many audience actions. Prioritize your information and guide folks through your messages to close deals. Think: About Page, View Portfolio, Pricing (or Investment) Page, Contact. Be clear about what you want people to do.

In other words, if your goal is to fortify your subscriber base, position the Subscribe button prominently on your landing page. And use an email marketing service to collect email addresses. Just be very careful to avoid confusing your messages. I'm saying, don't hide your Subscribe button on your pricing page. That's a different part of the sales funnel, and visitors may get distracted. Are they there to buy or sign up to receive emails?

Buying is an emotional experience. If your social media program is operating well, then you've built your relationship, established your credibility, and are now getting more serious. *So tell me about yourself ...*

About Page

When viewers see a post or an image that interests them, they'll often want to learn more about the author or artist. And although your About page is meant to describe you, the idea is to make clients say, "Yes! This is what I've been looking for!"

First impressions really count, and lots of bloggers are now using the About page as a landing page. So consider this, and use this page to set the tone of your work. But try not to make it a boring one. Honestly, how many times have you seen generic About pages that went something like this?

My name is [name]. I picked up my first [camera] at age [number].
I have been shooting [type of craft] photography for [number] years…

Fine. Fundamentally, it works; but it's boring. Make your About page light-hearted, comedic, a little self-deprecating, and personal. For starters, use a photo of yourself that shows your face, not you hidden behind a camera.

Shared interests and characteristics resonate, so talk about yourself. It really can make a difference. I remember talking to a photographer who changed her About page from "I graduated from this or that photography school…" to "I'm a Sagittarius! Cupcakes: I love them." As a result, some of her future inquiries were, "Hi there! I'm a Sagittarius, too! Are you available on such and such date to shoot my wedding?" You both like Starbucks, wear glasses, enjoy shopping, whatever. Connect with your audience.

My perennial advice: Stay humble and use humor. I love wedding photographer Jasmine Star's About page (http://jasminestarblog.com/). She writes:

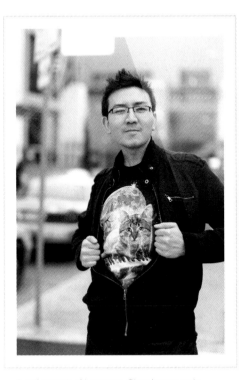

A self-portrait of Lawrence Chan humorously combining Superman's proverbial act of revelation, except replaced by kittens. Photo taken by Lawrence Chan at 50mm f/1.6 for 1/250 second.

> "Though I've garnered awards for my work and was voted Top 10 Wedding Photographer by *American Photo Magazine*, my crowning accomplishment was making meatloaf for the first time last year. I, however, still need to work on making the meatloaf edible."

Information-wise, be sure to include where you're located and how far you're willing to travel for a shoot. Also include a link to your Investment page (the spot for providing information about your starting rates and coverage) and your Contact form. These links usually work best at the bottom.

There's no real formula, except including who you are, what you do, when you're available to do what you do, and perhaps how you do it. If you want to explain why,

go ahead. Just don't forget to mention how all this information—your expertise, approach, and personality, etc.—benefits your clients. Refer back to the exercises in Chapter 3: Audience Matters to ensure that you understand the wants and needs of your target audience.

If you have specific goals for your About page, adjust your content to support this goal. For instance, if you want this page to convert visitors into clients, then link only to your Investment page and Contact form. Too many outbound links can get very distracting and may send readers away before they finish reading. Or, if you are more interested in connecting with them on other channels, highlight social media outlets on which they can follow you and include a clear call to action for subscribing to your email list.

Pricing and Contact Pages

When someone in your audience is ready to move beyond "liking" you—and learning about your favorite shooting locations and whatever else you communicate in your social media work—to seriously considering you for a job, be sure that your Investment page and your Contact page are well-designed and contain the details (s)he'll need to move forward.

Pricing

Your Investment page is one of the most important places you have online for conversion. So keep this page simple and straightforward and be sure that most of your sales-based strategies are present. That is, highlight your value messages. Include an FAQ document here to address any concerns or obstacles your visitors may have about hiring you. Since it can be difficult to proactively answer objectives directly, consider using testimonials to do it for you.

Post prices last. Because if your messaging is right and your social media program is operating in a way that resonates with your target market, by this point, buyers should be minimally concerned with cost. What matters is that you are the photographer that's best suited for their job.

Oh, and avoid including any outbound links here, except one linking visitors to your Contact page. A Contact form on the bottom of the Investment page is quite helpful.

Contact

Make it easy for folks to get in touch. Some photographers ask for 30 different things on a contact form. Seriously, in the case of some wedding photographers, I've seen contact forms that ask for the name of the event coordinator, details on catering, and other questions. But save all that for later. Your contact form really only needs five fields:

1. **One Line:** Name
2. **One Line:** Email
3. **One Line:** Phone
4. **One Line:** Event Date
5. **Body:** Extra Notes

Make it a one-click transaction. The more times a person needs to click, the more likely (s)he is to X out.

"The site looks pretty, but I swear they're intentionally trying to hide the contact button." –Julie

A simple contact form can be developed with plugins. A simple one for WordPress is *Contact Form 7*.

Blog Posts

Creating and maintaining a successful blog is no light task. It requires you to apply all the considerations we've covered so far in this book. You need to consider your goals and your strategy—why are you even doing this? And you must carefully consider your target audience and think about what they want and need to see from you to stay engaged.

That's where the advice from Chapter 4: The Power of Content comes into play. Use the suggestions there to actually populate your blog. But if you've slept since then, here's a refresher in a nutshell: be personable, don't fake it, and share information that interests your audience. We'll take a closer look at each of these concepts and figure out how they apply to your blog.

New blog entries appear at the top of your article list, in reverse-chronological order.

Be Personable

When putting pen to paper, so to speak, be personable and conversational. Your audience will likely consist of readers in all stages of photography knowledge; that's a good thing. So don't put off people by using too much industry jargon and talking above them. If you do, your content will come across as gibberish, and these folks will likely abandon you for clearer waters. Also, unless you're targeting photographers as your clientele, avoid talking about the technicalities of camera bodies and lenses.

Instead, focus on how your products and services benefit your clients. What do customers gain or experience by hiring you—uniquely you—for their photography needs? Think about Apple's campaign of *One Thousand Songs in Your Pocket*. That's much more enticing than an *8GB music player*, right? Same thing … totally different level of appeal.

Humans are social animals. We like to subscribe to traits and qualities of those we like. Therefore, to be successful, a brand must represent more than just a name or logo. It needs to represent an emotional relationship. So by sharing meaningful information about your interests and activities through your blog, your readers bond more closely with you.

Now, I'm not saying that you should divulge private information about your life. But talk openly and keep it simple. Limit the depth of information to what you'd share with a stranger at a cocktail party.

Consistency

Predictable, recurring themes encourage readers to return with anticipation. For example, a restaurant named Rubio's has Taco Tuesdays.

A wedding photographer could write a weekly article titled Wedding Wednesday. But your themes don't have to be industry-related. You could run with Mundane Mondays or Friday Fun. Just be sure to use these opportunities to convey your personality and interests.

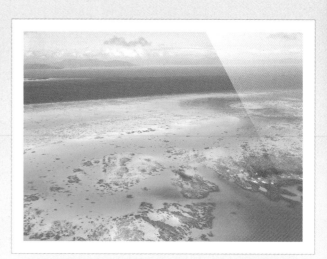

Photo of the Great Barrier Reef in Australia taken by Lawrence Chan at 25mm f/7.1 for 1/640 second.

The more you have in common, the more likely a person will book you. This is why after every Tofurious blog post, I add a postscript that mentions an interest I have or something cool I did over the weekend.

But don't be afraid of the crazy ole opinion piece either! This can be a slippery slope, but opinion articles will receive a lot of attention—both positive and negative—if you touch on a hot topic. I once wrote that photographers shouldn't watermark their images. That week, I felt like I opened Pandora's Box!

Don't Fake It

Being interesting and cool is great. But it's even more important to be authentic. Don't lie to yourself. Don't lie to other people. It's okay to be imperfect; in fact, it's preferable. In most cases, the more unpolished a person is, the less threatening (s)he is perceived to be. So go ahead and tell everyone that one of your life's biggest goals is to not burn white rice.

Asking for feedback is also nice. It enriches your knowledge of photography, and it shows humility and a willingness to learn. People are naturally repelled by cockiness. And most folks instinctively want to help. So open yourself to be critiqued.

But don't dwell in your imperfections, obviously. Use your blog to profile your strengths. Strength can be something that defines your character. For example, there are different types of delivery personas, such as inspirers, comedians, educators, and many others. I encourage you to combine different strengths to make a unique one for yourself.

Consider Perez Hilton. He's a prolific blogger known by many as a writer on celebrity news. He injects his humor and witty comments in all of his posts. What makes him unique is his transparent love or loathing for specific celebrities. And he uses his blog and Twitter account to communicate with his fans (or haters) and document his adventure as an online celebrity news author. No one thinks Perez Hilton is perfect, and that's why so many love him.

Share Interesting Information

Blogging is perfect for journaling your photography adventure. So feel free to use whatever tools can help you communicate that journey best. That is, if you're comfortable in front of video, produce small clips. If you're a prolific writer, articulate through text. Another fun tool is audio podcasting. You can record sound bites from your adventures with clients and share them online. Personally, I think sound bites are more fun if accompanied by photos, so a slideshow of photos with a voice narration is pretty cool.

> A "trash the dress" session is all about destroying a bride's dress. It symbolizes liberation from the countless hours spent in planning.

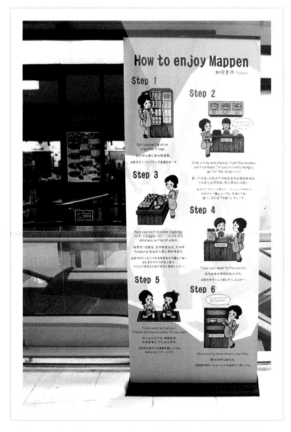

Mappen is a Japanese restaurant in Sydney, Australia, that uses cartoon illustrations to show a step-by-step ordering process. This makes it possible for even foreigners (like myself) to order like a pro. There is no confusion as to what to do next. Photo taken by Lawrence Chan at 16mm f/2.8 for 1/60 second.

Just remember to communicate casually, as if you're talking to someone in person at a coffee shop.

And be creative! Share work that's worth talking about. Be radical. Go experiment. Whether it's something personal (e.g., getting a tattoo) or public, try to do something different and worthy of attention. For example, a wedding photographer once burned a bride's dress and photographed it while the bride was still wearing it! The incident was called a "trash the dress" session.

Be selective about the work you share though. For the greatest positive impact, post only your best images. Especially for those who haven't worked with you directly, this will help to define your brand. Avoid mundane, generic photos that do not set you apart from your competition. And write content that knocks it out of the park. Each post should be worthy of print. If it's not, cultivate the idea until it's ready for a stronger debut.

After time, think about compiling your blog posts into a single document and publishing the publication as an e-book. Maybe this publication is a collection of answers you've developed for readers. Or perhaps it could be a collection of posts on a certain topic. In any case, combine your content, save the document as a PDF and create an e-book. This can bring awareness to your business and archive your blog content in a meaningful way.

Oh, and remember to give readers a clear call to action. Direct readers to the next step. This element usually resides at the bottom of posts. For example, after reading an entire blog post, a call to action might suggest that the reader hit the "View more articles" button. Or, for an image on Facebook, a call to action may be to hit the Like button. And when someone "likes" something on Facebook, it automatically pushes a notification to his or her network, thus creating a chain reaction of interest (hopefully).

My suggestion is to keep the call-to-action choices simple:

- **View Portfolio.**
- **View Pricing.**
- **Contact.**
- **Share.**

You could also swap one option out for your About Page.

Make sharing your content as easy of a task as possible for your readers. Be sure your posts load quickly. This means optimizing photos for the web and mobile browsers and limiting the number of images in a post. (As mentioned, I suggest no more than 15.) Also, make social media and other share buttons available under each post. Applications or plugins can be installed, like "Share This," so people can just click a button to Like on Facebook, tweet on Twitter, and share on StumbleUpon. Easy peasy.

Sincerely,

Lawrence Chan

P.S. I'm from Los Angeles. So, the first time I touched the ocean waters in Miami, I sort of freaked out! It's warm like a bath tub. So nice.

VIEW PORTFOLIO CONTACT ME BACK TO TOP

TAGS / CATEGORIES / COMMENTS

LAWRENCE CHAN PHOTOGRAPHY

My photography blog has three options programmed to appear at the end of every blog post: view portfolio, contact me, and back to top.

Turn the Love Around

Turn on the love light for those who interact with your posts and share your work. Recognize your audience and show your appreciation for their time and attention. Certainly when members of your blog audience take the time to offer a response to something you've posted, have the courtesy to show interest in what they've said by responding. This creates an online relationship that encourages people to comment again in the future.

This is the "Share This" plugin installed on a WordPress blog, where popular sharing applications are just one click away.

Yet you don't need to stop there. At the end of the year, I usually write a thank you note to my readers for their interest in my blog. I'm truly appreciative of their attention to my work, and I'm sure they appreciate this small effort on my part, too.

One thing I like to do from time to time is to dedicate a blog post to one of my readers. Making a reader "famous" is a powerful strategy in creating brand evangelists. (More on that in Chapter 9.) But it's not complicated. We all love attention, so put some limelight on a loyal reader or client by featuring something wonderful (s)he is doing. It does not necessarily have to relate to photography. It can be a charity they support, volunteer work, professional accomplishment, whatever.

Contests

Another way to acknowledge and thank your audience is to hold small competitions for prizes. We all love a good competition, right? Even if it's for a cheap stuffed animal at a Midway booth, most people revel in throwing down a little more coin to take another try. So offer something that doesn't take too much time to fulfill but motivates people to participate.

Make it fun and a bit challenging. For example, ask contestants to submit a photo of themselves with their favorite breakfast entrée to win a complimentary headshot session with you. Pick the top five photos and let the public vote for the winner.

Reach Out

Don't focus only on your clients and prospects. Remember, your audience likely includes other kinds of readers, including other bloggers and photographers. Whether you believe in karma or not, reaching out to other bloggers can help increase your traffic. If you're

afraid of competition, work with people in your industry who are not doing the same things. For example, a wedding photographer could blog about wedding planners and florists. Below are some ways to build connections with others.

Frequency

Creating consistent content for your blog in regular intervals sets up anticipation for return visitors. Since there is so much content on the Internet already, I recommend sharing about two times a week. Any more than two posts can become tiresome—for you and your readers.

However, your ideal frequency depends on your content focus and your readers. Scott Kelby has a blog (http://www.scottkelby.com/) that offers a new entry five days a week with a guest entry every Wednesday. Photographer Joe McNally's blog (http://www.joemcnally.com/blog/) is updated with a new entry once a week.

- **Promote:** By commenting on other people's blog posts or linking to them, something happens that's called a *pingback*. This is an online endorsement. Pingbacks rarely go unnoticed, because they appear as a comment, which usually needs to be approved by the author of the blog. So a tactic to garner attention with, say, a photo editor is to create pingbacks to his/her blog. One way to do this is to write a response for an article on a topic that was covered on the editor's blog.

- **Review:** Most people don't like to make wrong decisions. Heck! I don't know anyone who likes to make wrong decisions. It's probably why very few people are willing to make blind decisions. We rely on the opinions and reviews of others. Consider helping someone by writing a review of, say, how well a blogger covered a particular topic.

- **Stand Out:** When commenting on other people's blog posts, one way to stand out is to write a different kind of comment. That is, if everyone else wrote a short response, then you should write a ridiculously long one. If most other people show support, consider the value of a little criticism or an opposing point of view.

Titling Blog Posts

Titling your blog post is something you just have to get right. A title is your pitch to readers to pay attention to the content you're offering. And with online material, you have the added need to get picked up by a search engine.

For good ideas on blog titles, visit a magazine rack. Magazines have clever titles to compel readers to pick them. Below are some ideas that I picked up in a single visit to a news stand. Feel free to rework these templates to fit your own business needs.

- **[Number] Reasons to [something positive]**

Lists work because they're simple and they give readers a light at the end of the tunnel.

Examples:

5 Reasons Uncle Bob Should Sit Back and Enjoy the Wedding

8 Ways to Guarantee Cute Baby Pictures

This HDR photo of Juneau, Alaska, morning fog was taken by Lawrence Chan at 50mm f/5.6.

- **Learn How to [verb] [something]**

Whenever you start with "Learn how to," it means there are nuggets of information being offered in that post.

Examples:

Learn How to Rock Your Senior Photos

Learn How to Make Any Event Picturesque

- **[Positive adjective] [object] and How to Get It**

Finding out how to acquire something positive is always welcomed.

Examples:

Sexy Foods and How to Get Them

Adorable Dogs and How to Get Them to Behave

- **Is Your [object] Good for [someone or something]?**

We always want the best for those we love. Out of concern, posing a possibility of negative effects for a loved one will pique curiosity.

Examples:

Is Your Dog Food Good for Your Pet's Health?

Is the Use of Strobes Good for Your Baby's Eyes?

- **[Object(s)] You Won't Believe**

People like to be overwhelmed, so a title like this encourages a click.

Examples:

Landscape Photos You Won't Believe

Babies so Cute You Won't Believe They're Real

- **Win a(n) [object]**

People love to win contests especially if it's free to enter.

Examples:

Win a Free Headshot Session

Win a Free Canvas Print

- **[Something hard] Made Simple**

People love shortcuts. Who likes to be efficient and save time? I do.

Examples:

Honeymoon Planning Made Simple

Food Styling Made Simple

- **[Number] Free [object] for [object]**

Free is a magical word. In the first example, you could share links for templates while showcasing your engagement photos.

Examples:

8 Free Templates for Thank You Cards

12 Free Prints for Your Pet Calendar

- **Amazing [items] Under [low cost]**

People love good deals. In the second example, you could showcase all of the foods you photographed with links to certain restaurants. While sharing these good deals, you're also sharing what a great food photographer you are.

Examples:

Amazing Baby Bibs Under $20

Amazing Foods Under $12

- **Amazing [blank] Secrets**

Not only is your post about a secret, it's about an *amazing* secret. What's not to love?

Examples:

Amazing Arm Toning Secrets

Amazing Landscape Photo Secrets

- **Are You a [something positive] or [something negative]?**

This is subjective, so be careful of the words you choose.

Examples:

Are You a Stunning Bride or Bridezilla?

Are you a Loving Mom or Stressed-Out Caretaker?

- **Effective Ways to [blank]**

Learning how other people do things is always interesting, especially if they're "effective."

Examples:

Effective Ways to Relax on Your Wedding Day

Effective Ways to Capture Frozen Treats ... While They're Still Frozen

- **Master Basic [Craft] Skills**

Most clients just want to know the basics because they're curious. If you teach them, you're automatically deemed as a professional, because you know something that they don't. So, when these folks begin looking for professional work done, hopefully they'll think of you.

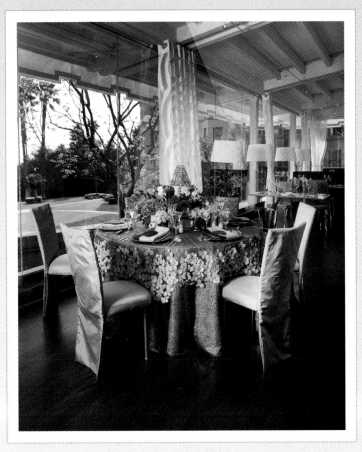

Photo of floral arrangements taken by Lawrence Chan for *Wedding Style Magazine* 2011 Fall Winter editorial at 24mm f/4 for 1/200 second.

Examples:

Master Basic Kids Photography Skills

Master Basic Food Photography Techniques

- **Discover [something desired] Options**

People like options, even if the options are different from the real thing (like a knock off).

Examples:

Discover European Style Floral Options

Discover Organic Baby Food Options

- **See the Magic of [blank]**

Did someone say magic? That got my attention already.

Examples:

See the Magic of Makeup on Food

See the Magic of the Right Lingerie

- **Secrets to [something desired]**

People love secrets.

Examples:

Secrets to Stunning Portraits

Secrets to Elegant Boudoir Photos

- **Challenge: [blank]**

Challenges, especially if they're somewhat consistent in theme or frequency, are fun ways to engage your audience.

Examples:

Challenge: Take a Photo of Your Baby Laughing

Challenge: Have Your Dog Sit Still for Five Minutes

- **The Fastest Way to [something desired]**

People love shortcuts.

Examples:

The Fastest Way to Pack a Healthy School Lunch

The Fastest Way to Photograph Family Portraits at a Wedding

- **The Art of [something desired]**

Learning the art of anything is enchanting.

Examples:

The Art of Photographing Sunsets

The Art of Capturing Your Baby's Growth

Remember that you're writing articles for your target audience. It does not always have to pitch your photography services. In fact, by teaching your readers simple tips or tricks about photography makes you a caring expert in their eyes. It also reinforces your expertise. You clearly know what you're doing if you're doling out advice for others, right?

That said, as much as possible, integrate your own photography in these posts. For example, if using "Challenge: Have Your Dog Sit Still for Five Minutes," show a photo that you took of a docile dog. These are all great ways to promote your work while offering value to your audience.

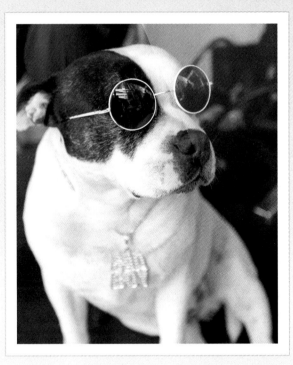

Bad Boy not only sat for five minutes straight, he sported sunglasses to show how docile he can be. Photo taken at a Sydney cafe by Lawrence Chan at 35mm f/2.8 for 1/200 second.

Metrics

So what's the point of having all of this fun blogging if you don't know whether or not people are reading your posts? Don't worry. Google's got you covered with Google Alerts and Google Analytics. But if the sheer volume of data available through these tools gets to be overwhelming, take a peek at WordPress' stat system plugin, called Jetpack. This program does a great job of consolidating your metrics into the most popular types of data for bloggers, including number of hits as well as where your readers come from and where they go when they leave your site. But I'm getting ahead of myself again. First things first.

When you begin blogging, one of the first things I suggest you do is to set up an alert system so that you know when people are talking about you. Google Alerts does a

phenomenal job at crawling the web and emailing you whenever your name pops up. You can register for a free account at http://www.google.com/alerts. Also consider setting up Google Alerts to notify you when people mention a competitor's name.

Next, install Google Analytics. You might need to find someone who is familiar with basic coding to install tracking codes on your website. But Google Analytics measures a lot of items. And it's the only service that's constantly adding new tracking devices. Register for a free account at http://www.google.com/analytics. As I mentioned above, Google Analytics offers so much information that you could spend hours studying the analytics. It can be pretty overwhelming. So I suggest that you focus on the following basic metrics:

- **Visits:** The number of visitors you have indicates whether or not your efforts are generating traffic.

- **Visitor Loyalty:** The number of returning visitors shows whether your content is encouraging people to return.

- **Bounce Rate:** This tells you how many people land on your blog and leave. A high bounce rate usually means that your blog does not have accurate or adequate content to maintain the attention span of your visitors, and this can adversely affect your search engine optimization efforts.

- **Pages per Visit:** This number tells you whether or not users are landing on your blog and perusing other pages. A high pages-per-visit number indicates that your site has content of value to your visitors.

- **Average Time on Site:** The length of time a user stays on your site is usually indicative of the value of your content. The longer they stay, the more helpful content they're finding!

- **Percent New Visits:** As important as it is to retain return visitors, it is also important to have a healthy increase of new visitors. You want this number to be relatively high— not zero!

- **Traffic Sources Overview:** This is a breakdown of where your traffic is coming from: referring websites, direct traffic, and search engines. Direct traffic means that someone typed in your URL in a browser, opened from a bookmark, or clicked from an email footer.

- **Keywords:** Keywords are the specific words people used on search engines, which led them to your website.

- **Referring Sites:** Aside from social media websites like Facebook.com or Twitter.com, I like to see if other bloggers or websites are linking to my site.

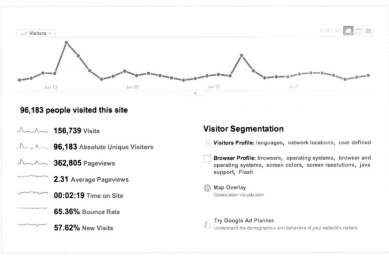

The line graph shows the amount of traffic, and this screen shows other useful information about visitors to my website.

- **Content Overview:** Some people view certain blog posts more than others. This section breaks down how much traffic each page is getting.

There are other valuable data (e.g., browsers used, screen sizes, etc.) that you could analyze, but the aforementioned should give you a pretty solid grasp of your traffic.

To simplify the amount of metrics data you receive, if you're self-hosting your blog, check out WordPress' Jetpack plugin (free). If you use WordPress for hosting, the features of this plugin are automatically available to you. But since this plugin runs on the WordPress server, it provides your metrics very quickly and won't take up space on your computer's system. New visits usually show up on your dashboard within about ten seconds. Pretty cool. ✪✪✪✪✪

Socializing

An Interview with Christopher Becker (aka [b]ecker)

TWITTER: @thebecker
BLOG: blog.thebecker.com
WEBSITE: thebecker.com
FACEBOOK: facebook.com/thebecker

How do you ensure a positive user experience on your blog?

My blog is my home base on the web. And while, of course, I want it to represent my brand and show off my photos, I know it's critical that viewers enjoy being on my blog. This is what will (hopefully) motivate them to come back often.

A main issue that visitors were having on my site was a long loading time. To make it quicker, we recently switched to loading summaries on the main page (instead of full posts), and we added a blog snapshot element to highlight my favorite and/or featured posts. The navigation is simple and there's a built-in mini portfolio at the top. Users seem to really appreciate these little efforts to make their experience more pleasant.

What are some primary goals that you considered when creating your blog?

The main goal of my blog is to encourage qualified prospects to contact me. I do that by showing off recent work in a simple and clean fashion, and then I try to be myself and showcase my personality. After that, if they like me and they like my photos, I try to make it easy for people to get in touch. I mean, that is the point of the effort to have a strong online presence, right?

Do you think it's important to integrate various social media channels with a blog?

Social media is just another way for people to find out about my work and share information about my business and images. So yes, I definitely believe that it's smart to integrate social media channels with a blog. I mean, Twitter and Facebook send more traffic to my blog than any other source. And when I post a few selected images on Facebook, tag the subjects, and then write the captions telling people to visit the blog to see more, it's always rewarding. I connect with so many people this way. Social media is absolutely a part of my online presence, but my blog is my primary locale—my home base on the web.

How does your blog convey your personality?

My blog is really all about me and my life, not just my photography work. You know, when I started blogging back in 2005, it was really just a way to let my parents and close friends know what I was up to. In fact, I actually get flack sometimes from other photographers who criticize me about some of my "non-professional" blog posts. They don't realize that I am all about selling my personality and life. And that's more than just my photography. I try to be myself when I post, and I'm not always thinking about work. So my advice to other photographers is to be yourself and to develop thick skin. Not everyone is going to like you or everything you post. That's okay.

What is your overall online message?

Hopefully my online communications convey my relaxed style of photography and a relaxed approach to life. I am a no-stress, laid-back guy who really loves life and loves taking photos. When prospective clients meet with me, the passion I have for being a photographer is obvious. I try to inject that same passion on the blog as well. What else can I do? That's me.

#chapter8

PHOTOGRAPHY AS A SOCIAL LUXURY

Most people cannot tell the difference between good and great. I usually can't anyway. Honestly. I wish I had a more refined level of taste, but the truth is: I don't. I rely on mental shortcuts and social proof. (Refer back to Chapter 4: The Power of Content for more on market validation.)

Take wine as an example. I drink a lot of wine, but I promise that I couldn't tell the difference between a $20 bottle and a $200 bottle, on taste alone, if my life depended on it. Instead, I look at other factors.

Luxury is a prized perception. Photo of champagne and other spirits taken in Vienna, Austria, by Lawrence Chan at 24mm f/1.6 for 1/100 second.

Obviously, $20 is less than $200, so the second bottle must be better, right? Then I look at the star or wine ratings if available. But this rating system is based on what someone else has said, and (s)he and I may not even share the same tastes! What to do?

It can be tough to convey and assess quality in esoteric markets that require refined tastes, such as art and food or wine and cognac. It's difficult for most people to tell the difference between good and great. But it's very easy to recognize terrible.

This is the situation for people in the photography business. Most clients have not looked through thousands of images or agonized over technical settings, like you and I have, to accurately discern the difference between good and great. So they naturally rely on their relationships, social proof and other mental shortcuts, such as a brand's level of exclusivity, social associations, and value of labels.

Exclusivity

While luxury is leveraged through scarcity and attainment barriers, social media is based on principles of accessibility. So if you have a question about Mercedes-Benz Fashion Week (http://www.mbfashionweek.com), you could easily contact the company via social media, and someone will respond.

Yet *value* is traditionally defined by the level of difficulty involved to acquire something. It's the concept of barriers to entry.

- We want what we cannot have.
- We want what we once had and then lost.

KristinClarkFSU Kristin Clark
@MBFashionWeek Absolutely! You have to enjoy those nice summer day when you can! What are the dates for #MBFWSwim?!
11 Jun

in reply to ↑

@MBFashionWeek
MB Fashion Week

@KristinClarkFSU July 14th-18th, almost there!!

12 Jun via Twitter for BlackBerry®

Twitter account @MBFashionWeek not only broadcasts event information, but also converses with people who have questions about the event.

In the case of Mercedes-Benz Fashion Week, I'm sure there are lots of people who would love to attend, including myself. But the exclusive event is reserved for only press and industry peers. No tickets are sold.

At first glance, it seems silly for the event organizers of Mercedes-Benz Fashion Week to use social media to promote and broadcast an event that most people cannot attend. But this peephole (like video streaming) actually enhances the event's exclusivity.

It's smart branding, no matter how frustrating it might be to some people. Establishing a high awareness of the exclusive event through social media, while blocking access, increases desire that cannot be satisfied among a large group of people. This reinforces Mercedes-Benz as a luxury brand.

The Almighty Label

Common perceptions of luxury businesses are those on Rodeo Drive with high glitz and glam. We associate luxury with companies like Mercedes-Benz, Louis Vuitton, and Tiffany & Co. What is it that they all have in common?

Julie happily reveals her new Furla bag. Photo taken in Bologna, Italy, at 24mm f/1.4 for 1/1250 second.

Well, they have great labels. They also carry a sense of high quality. A large amount of money is spent on marketing these brands; there are strong brand associations with celebrities; and the products are expensive. Ultimately though, is it price that sets products apart as a luxury brand?

I'm thinking yes, to a certain extent. But that's only a tactic. It's more important to realize that the strategy behind high cost is barrier to entry. This is the appeal of labels.

And labels are very important in consumerist cultures. It's a sign of difference. And as humans, we enjoy having something different. It signifies that we are unique. It's why we have so many different styles of clothing. People identify with the brands they use and wear. Think of the images you get when you consider J. Crew, Forever 21, Gap, Abercrombie & Fitch, Ann Taylor, Armani, and so on. You are who you are wearing, as they say on the red carpet.

To say that you live in Monaco is quite admirable. This photo of the country was taken by Lawrence Chan at 24mm f/5.6 for 1/400 second.

Labels add value. We all love added value. In fact, this reminds me of a tour I once took in Hollywood. The guide told us that the Hollywood sign was put up originally as a gimmick to raise the value of real estate surrounding it. The Hollywood sign defined the Hollywood Hills. Today, homes there cost several millions.

This concept of label association comes into play when choosing a university, too. Would you rather go to UCLA Law School or a small private university that's known only to a tiny percentage of the general public but has a slightly better law program? Tough call, but chances are that someone who wants well-rounded approval of his or her university might choose UCLA. It's because of the label; UCLA is well-known around the world.

I bring this up because few small photography studios consider themselves a luxury business. You might not have an opulent studio with marble flooring, but you could very well be a luxury brand ... if you choose to be.

Homework

Think of some clever ways to add labels to your own photography business. Something along the lines of "[Your Name] Brides," or "[Your Name] Collection" can solidify your position. A label gives your clients a defining factor of difference.

Here's a simple test. Which scenario best describes your business?

a. People hire you because they *need* a photographer for a special event, wedding, portrait, etc.

b. People hire you because they *want* your photography service for a special event, wedding, portrait, etc.

The former serves as a necessity or utility—sure, they'll take you—while the latter serves as a luxury—oh, if they can actually get you! Whoo. I know we talked a little about wants and needs in Chapter 3: Audience Matters, but here are some other ways to think about it in terms of need it/get it versus acquiring a luxury brand.

Need: I need a car to travel from home to work, so I'll get a used vehicle.

Want: I could rock the designated parking spot I just got with my promotion if I drive a Mercedes-Benz to the office.

Need: I need a bag to carry my things, so I'll pick up one in Chinatown.

Want: Oh man, I'd love to carry a Louis Vuitton purse when I lunch with the executives next week.

Need: I need a photographer to snap pictures at my wedding, so I'll remind Bob to bring his camera … and use it.

Want: Wouldn't it be awesome to have [name of a professional photographer] shoot images of our celebration?

Don't underestimate your value. And don't let others do it either. Rather, ensure that your market develops a perception of high quality related to your work by conveying a defining attribute, limiting attainability, and establishing a new standard for service in your niche. Let's take a closer look at these elements of value.

Defining Attribute

Especially if you and another photographer have the same or a similar message, you've got to find a way to gain an advantage. One is to overrule with trust, which we covered in Chapter 4: The Power of Content. Another is to dominate on customer service.

Well, a great tactic for winning with superior customer service is to remember names. It might seem silly and old fashioned nowadays, but it's proven to be quite the charming

thing among my clients. I do my best to remember names at weddings— from the wedding party folks to the names of uncles and aunts. I also try to remember at least a few details posted by clients on their social media updates or comments.

This personal touch is a basic courtesy that few find worthwhile anymore. It's the equivalent of handwriting a personal card for clients, even though email is more efficient. But it helps you stand apart. And by establishing a difference, you become unique. People want to be unique. People like unique.

This is all part of conveying the special treatment of social luxury. Beat your competition on courtesy by remembering details, sending small gifts, and saying thank you to those who trusted you to memorialize their special event or milestone.

Attainability

There is a fine balance between accessibility and attainability that's required to convey social luxury. It may seem paradoxical, but a strategy to be easily accessible, but not easily attainable is a proven formula for luxury brands. In other

What's the Difference?

Let's examine shoes as an example. If Store A and Store B carry the same shoe for the same price, how does a customer determine which store to buy from? The simplest way for a store to earn the business is to dominate on customer service. That's what Nordstrom has built its brand on.

Playing Hard to Get

I believe that the "playing hard to get" strategy is quite powerful and applicable to virtually all aspects of a business. But photographers can easily forget their value when offered a chance to shoot their "portfolio worthy" wedding or when starving for a job. Yet these are just the times when our guard should be highest. It's critical to maintain a "We want what we cannot have" model in order to protect our perceived value.

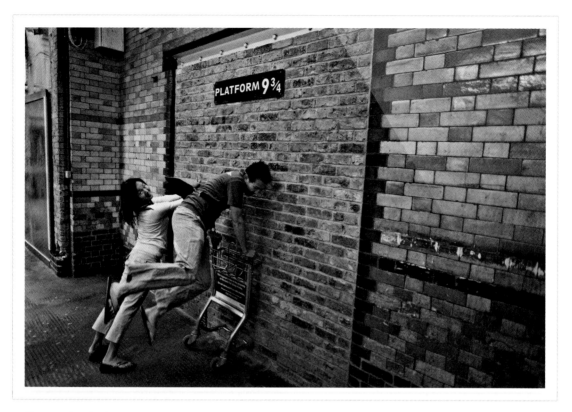

No matter how hard we try to be wizards and witches, Julie and I cannot get across to Harry Potter's magical world from King's Cross 9 ¾ station, thus increasing our desire. Photo taken in London, England, at 24mm f/1.8 for 1/160 second.

words, it should be extremely easy to contact you or to interact with you via social media, but it can't be too easy to hire you.

Of course, I'm not suggesting that you should be snooty or anything—even though some luxury brands are like that. The goal is to help clients understand the value of your services.

Here are some ways to apply this strategy—accessible, but not easily attainable—to all parts of your business.

Establish Scarcity

The more available something—or someone—is, the less value it is perceived to have. Doughnut Vault maintains its exclusivity by limiting its production. Every doughnut is sought and purchased. See sidebar on the next page.

Wedding photographers could limit themselves to 20 sessions a year—and then totally kick butt on those shoots. Pet photographers could limit themselves to two sessions per week.

To ensure that your limited availability is duly noted on your website, show the exact months that you're completely booked.

And when someone inquires about your availability, don't indicate that you're wide open all week, if that's the case. Rather, give options like, "Would Monday or Wednesday afternoon be better for you to meet?" This shows that your time is valuable and that you cannot be beckoned at a client's whim.

Location for Consultation

It's very easy to be coaxed into doing a house call for an initial consultation, especially if desperate for a job. Make sure to be stern and preemptive in choosing the location for this meeting, even if it's a Starbucks. Ideally, you should have prospects come to your studio for meetings. That gives you an opportunity to show off your space and your work to further underscore your value as a professional artist.

Consultation Meeting

A lot of times, potential clients ask why they should hire you. It's a good

Mmmm ... Doughnuts

There is a doughnut store in Chicago called Doughnut Vault. Every day, they tweet (from @doughnutvault) the number of doughnuts they have left and the moment they sell out, which is always sometime in the morning. And every day, there's a long line at Doughnut Vault. The business uses Twitter to constantly make people aware of their highly coveted products. It's a working system. But seriously, if their doughnuts taste so good, why not fry more dough?

And as for you, if you're free on a Saturday morning in December, why not squeeze in another photo session? Discuss.

question. But everyone's time is valuable, so be sure to use this meeting to interview your prospects as well. Be sure they give *you* good reason to work with *them*. It's not just about the money.

Look for a creative opportunity or a shoot that can help you profile a certain approach. Obviously don't force your portfolio needs onto your client's shoot, but if a match is there, go for it.

But don't be too eager. In my lectures, I describe a tactic called "The Ten-Foot Pole." Basically, even if prospects sound very excited during consultations and are ready to hire you on the spot, suggest that they go home, sleep on it, and call when they've had a chance to talk about what was discussed in the meeting. I figuratively push them away with a ten-foot pole. And honestly, more push tends to lead to more desire by the client.

Pricing

Pricing is a huge factor of perceived value. For example, which wedding photographer do you think is more skilled?

> Wedding Photographer A starting at $8,000
>
> Wedding Photographer B starting at $1,500

Hopefully, you chose the former. A normal thought process includes questions about why Photographer A is charging so much more. It must be because (s)he is really experienced. The question of whether one can afford Photographer A is irrelevant. So make sure to post your starting price on the Investment page of your blog.

Another pitfall is discounting. The moment you discount a luxury service, like premium photography, clients immediately become skeptics. They'll wonder what they're sacrificing to get the discount.

In *The King of Queens Season* 4, Episode 2 ("Sight Gag"), Carrie received laser eye surgery as a gift from her husband. After finding out that he used a coupon for her surgery, she was furious. Read more about the psychology of pricing at http://www.tofurious.com/category/pricing-strategy/.

Hours of Service

Just as how you should not discount, be firm on your hours of service during consultation. Agreeing to add extra hours to a session for free is the same as discounting. That said, on the day of a shoot, definitely be sure to over-deliver by staying longer if appropriate.

Under Promise and Over Deliver

Despite all of the barriers you develop to add perceived value to your service, remember that part of a luxury brand is to over-deliver on promises. You have to shower your clients with love. Make them feel special!

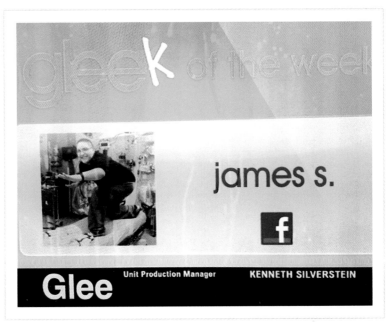

Go a step further by highlighting your customers' photos on your social media channels. Write stories about how wonderful the experiences were. And make everyone aware of how cool they are as people.

Glee used television broadcasts and Facebook to promote a gleek fan (a play on words combining *Glee* and *geek*) every week. The highlighted gleek, who represents this entertainment brand, is sure to become a loyal fan and tell friends about his/her "15 minutes" of fame ... er, make that seconds. This promotes the show and demonstrates how much this brand values its fans.

Summary of Attainability Paradigm

Think of this attainability structure as an hourglass. There are many ways to access you (top of hourglass where it's wide), but it's extremely difficult to acquire you (the skinny funnel in the middle of the hourglass). However, once a client passes through, it's important to overcompensate for the efforts (wide base of hourglass) to make them feel welcome. Excelling at service will ensure loyal customers.

Social media makes sharing easy. Barriers increase your perceived value. Combining mass top of mind awareness with a coveted service or product creates a luxury brand.

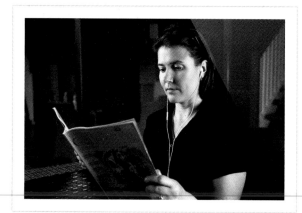

BURBERRY

Elizabeth,
thank you for shopping at store. It was a pleasure look forward to your next if you have any questo further assisted at 95285

vnaylon, burberry, noryana07, audreyxling, brandisimmons, v_vito_o, ngocnatalie, aferreira73, thecowsaysmoo

lizthompson Now that's customer service! #Burberry

♥ like 💬 comment •••

The iconic white Apple earplugs are recognizable by all. Photo taken by Lawrence Chan at 35mm f/2.8 for 1/200 second.

Burberry sent Elizabeth a hand-written note, thanking her for shopping at the store. This gratitude may convert Elizabeth from a one-time customer to a repeat customer, or even better, an evangelist who will advocate for this brand.

Additionally, Burberry used Instagram (a photo-sharing iPhone application) to repost this image from the user, thus making the sharer (presumably Elizabeth) temporarily famous.

We'll talk more about brand evangelism in the next chapter, but all of these attainment concepts resemble Apple's phenomenon. Apple products are ubiquitous; everyone has an iPod. But these devices are not cheap. In fact, they're quite expensive.

True confession: I lined up for the first generation iPad. Yes, I am one of those crazy ones. Upon buying it, the entire staff cheered and clapped for me as I exited the store. They showered me with love. I felt special.

I felt even more special when everyone I know seemed to perceive me as an innovator. For that first week, I had something that everyone else wanted. Remember, we want what we cannot have. I reinforced Apple's luxury label. And through brand association, I elevated my own social status just a tad by walking around with one of their newest devices.

From my understanding, one of the biggest torments for inmates at Alcatraz was being able to see the lights of San Francisco and hear the fun and laughter but not being able to join the festivities. HDR photo taken in San Francisco, California, by Lawrence Chan at 35mm f/5.6.

In photography, we can do the same with social media. The sharing of photos makes us ubiquitous. Our tweets at various shoots reinforce our valued services. Our high prices and limited availability (as noted on our blog) maintain exclusivity, making us worthy of value.

Delivering the Luxury Promise

Establishing a higher level of service than what's currently available, a luxury brand requires exceptional performance and outcomes. At minimum, you need to do what you say you can do.

As a luxury photographer, you need to also deliver on what you imply you can do. Through all of your social media work so far, we've established an audience and content that support our goals—remember the bit about being The Edgiest Photographer for Stylish Couples in Orange County?—and we've painstakingly selected the channels we use to convey our personality and brand messages.

Well, when it comes down to it, all that socializing is intended to elevate your status as a professional photographer and earn you the jobs you most desire. Ultimately, all that effort is made to build your dream business.

So here we are at a crossroad of approach. We now need to figure out how to bridge the gap between expectations in what Dan Ariely of Duke University refers to as *social norms* (our social media marketing approach) and *market norms* (our actual business transactions). Yet these two sets of norms, or behaviors, should not mix.

See, social norms consist of activities that relate to community, leisure, or society (e.g., topics related to vacations or hobbies). This is the authentic personal sharing that has dominated so much of our social media marketing program. Yet, market norms are important too. They are behaviors and attitudes that relate to money and work.

The Melting Pot separates the two norms by creating a server position and a restaurant cashier. The server is strictly to create an environment of comfort, while the cashier collects money.

Ariely's example was simple. Offering a tip at a restaurant is welcomed, even expected. This is a market norm. But offering a tip to the host of a Thanksgiving dinner is awkward. It's not in sync with social norms. We just don't expect to pay our friends for services. Instead, we offer flowers or a bottle of wine to a social host. In this situation, gifts of comfort represent appreciation for the host's efforts; they replace the element of sale from the transaction.

As photographers, we likely do not have the, ahem, luxury of hiring a person to strictly handle our market situations—the contracts, invoicing, collections, deposits. Yet we need to focus on the social aspects of our business, which is building relationships with clients.

Therefore, we absolutely have to know what role to play at which times. So here's my advice: Anything you do online with social media should remain social. Twitter, Facebook, and blogging should be casual conversations, like the ones you have at a golf course or dinner table. Focus on building relationships with these channels. Conversely, all business and client-vendor talks should be handled via email or in-person meeting rooms. No mixing and matching. For the husband-and-wife teams out there, consider assigning sovereign roles: one for market situations and one for social situations.

And when your client is in front of you and you're on location, give him or her the star treatment.

Think of it like having backstage access to a music concert. I can only imagine how cool it must be to see the craziness behind the curtains. That area is only accessible to people with special privileges—just like the Mercedes-Benz Fashion Week event is only for industry professionals and the press.

Given the focus of this book, I won't go too far into advising you on how to conduct a shoot, but be sure to extend the relationship you've built online. Make your clients feel really pampered during your work with them. Bring water and your humor. And continue any conversations you've recently had on Facebook, or laugh at a crazy image you both may have seen. This will put clients at ease and make them feel personally connected with you. Most importantly, this will definitely show in the images you capture.

Follow Up

With available technology, you can stream video live over the Internet. A great way to follow up with a client after a shoot is to send them (and perhaps the rest of your network,

People who Like Gucci on Facebook can access a live video stream of their 2011 Men's Spring/Summer fashion show.

burberry ◉ 9w

♥ **156 likes**

burberry Men's show finale rain from above.

view all 11 comments

jbiebsrox That's a cool picture. I like it! Everyone, please follow me and check out my pics!!!
drewtography Looks awesome!
ernzlim Where's this?
itshowlifeis This is a great view.
aomaomm Stunning! I love the show

♥ liked 💬 comment •••

Burberry shared a behind-the-scenes photo of rain falling from above the catwalk at their men's finale fashion show with those who follow them on Instagram.

or theirs) a glimpse into the backstage. This will remind your clients of the fun you had during the shoot, and it rewards your audience with exclusive digital content that shows behind-the-scenes clips and (hopefully) unintentional minor fiascos. Everyone loves a good bloopers trailer. It's humbling and reminds us that we all make mistakes. No one's perfect.

There's a show on the Food Network that I love called *Unwrapped* by Marc Summers. It details how certain American foods, like peanut butter or French fries, are created. I'm fascinated with this insight to how food is mass-produced.

Similarly, there are lots of people who are interested in how certain photographs are created. So take this opportunity to organize a catalogue of behind-the-scenes stills or video clips that you can share with your audience. And go all out if you want. Use photos and text to describe the making of a photo. Or video record your process of posing a subject.

The goal of all this after-shoot work is to add value to your relationship with clients. It also helps others, including prospective clients and those who might refer you to friends, to see the human, interpersonal you in action. And this can go far in diminishing doubts or anxiety about hiring you for an important occasion.

Also, when appropriate, feel free to add passwords or require logins for certain content. Gucci, along with many other companies, encourage folks to Like their Facebook page before granting entry to special content.

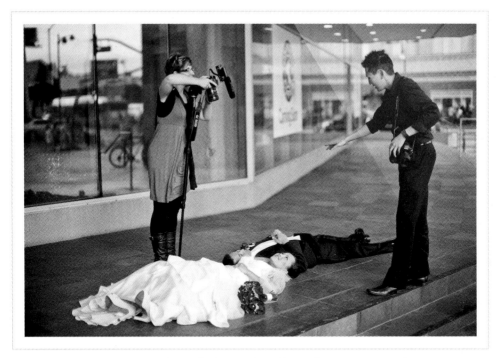

Here's me working with Jennie and Andy. The image adds a different dimension to the situation.

Photo of Jennie and Andy taken by Lawrence Chan at 35mm f/2 for 1/500 second.

If everyone owned a Ferrari, then the car brand would lose some consumer desire for it. Photo taken at Ferrari Factory in Bologna, Italy, by Lawrence Chan at 24mm f/2.5 for 1/60 second.

The Dream

Part of communicating a particular dream of a luxury brand is that the product or service must be desirable by all—past and current customers as well as future customers and those who will never be a customer. This means it should appeal to those who can afford it as well as those who cannot. Luxury brands must ensure that even those who cannot afford it know about the label, because it reinforces the elevated position of those who possess it.

We may not own specific luxury items—or any!—but we definitely recognize a designer label. The goal of a luxury brand is to reach an audience that one day may have the means to acquire said services or products. As a brand yourself, you need to make sure that when people are in a position to acquire luxuries, they come calling on you.

Gucci does this wonderfully by creating conversations and offering exclusive updates

on its Facebook page. The brand currently has roughly five million fans, but I doubt more than half of them can afford or currently owns a Gucci product. Nevertheless, the company removed access barriers to increase exposure and engagement while communicating the dream of this luxury from a position still out of reach for most.

Marketing to future generations—comprised of those who will come of age and will have the financial means to purchase luxury products or services, but cannot acquire them now—means identifying future customers and sending messages that resonate with them.

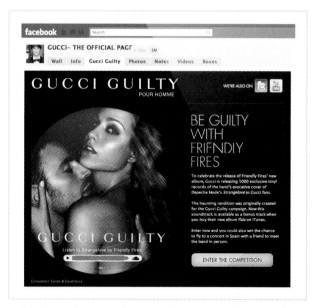

Gucci hosted a competition to launch a new men's fragrance. The company made the contest accessible to all rather than only those who could afford it. This effort prepares future generations to purchase this luxury merchandise.

For example, do you think it was coincidental that Emma Watson (Hermione in *Harry Potter*) was a spokesperson for Burberry? I don't.

Arbitrate Taste

In your role as artist, try to function as an arbiter of taste, recognizing and guiding consumers to cultural excellence. Doing so gives you the opportunity to stand out from other photographers. By making an effort to educate your audience, you draw their trust while also improving your craft through their feedback, insights, and perhaps even critiques. Every interaction is another opportunity for a stronger relationship.

Some key actions to influence *taste* in your niche are to recognize innovators, explore lifestyle enhancement, and solicit the opinions of others.

Recognize Innovators

In any specialty, there are many factors that go into the making of a photo. For instance, to set up a single shot during an editorial tabletop photo shoot I did for *Wedding Style*

Homework

We covered target audience in Chapter 3, so let's revisit that now. Looking beyond your current desired audience, can you use the exercises in Chapter 3 to describe your future clients? How can you engage with them now?

Here's an example. Let's say you're a pet photographer. You might conduct a co-promotion with pet stores. Every month, you could host a competition for a complimentary photo session. In this scenario, users would have to submit a photo of themselves with their pet.

Each month, the contest would have a different theme. One might be, "Do pets really look like their owners?" And people would take photos of pets dressed like their owners and post them to Facebook. When submitting their images, people will have time to look around your photo galleries and site to see your work. Of course!

It'd be important to make sure that everyone entering the contest knows the value of the prize. They'll need to understand your value as a premium photographer. So, even though they may not be able to afford your services today, they would have you in mind for a special occasion in the future, like the dog's first birthday. Or they may become a Fan that recognizes your brand and suggests your services to friends who are looking for professional pet photography.

What are some other ideas for engaging with your possible future clients?

Magazine, there was an event designer, a florist, a cake chef, linen designer, prop manager, and venue coordinator. Without everyone's collaboration, there would be no photo. Most people can't imagine the amount of detailed expertise that the shot took.

So I make an effort to not only mention them for this photo, but to highlight their expertise and services in my social media efforts, too, including Facebook tagging, Twitter mentions, blog posts, etc. Because it's important. Recognizing other innovators in your industry allows you to climb out of your own box and explore the work being pioneered so near to your own. And this ultimately helps you grow as an artist.

It doesn't really even matter if you've never worked directly with a person. If you like what you see from someone, check them out and encourage your audience to do so as well.

An Ed Libby tabletop editorial photo for *Wedding Style Magazine*, Fall/Winter 2011, taken by Lawrence Chan at 24mm f/6.3 for 1/200 second.

For example, children photographers might mention cool children's clothing designers or toy makers. Wedding photographers might recognize boutique wedding dress and veil designers. And a concert photographer might highlight a facility's new sound system that practically eliminates speaker feedback.

This expands your audience's awareness of the different types of expertise that goes into making your particular niche vibrant and, in some cases, even possible. Plus, if you recall from Chapter 6: Launch a Social Media Program, writing blog posts that link to other blog posts create pingbacks that will show up as comments needing approval. So your efforts won't go unnoticed. Pay it forward! If you're lucky, the good karma will be reciprocated.

Guide Lifestyle Enhancement

Another way to help your audience decipher between good and great is to provide deep and ongoing educational content that can help them with basic lifestyle considerations.

For example, demonstrate how photos in the home can enliven a room. Show examples with your own space and mention how certain colors work with others.

Be sure to also provide resources as to where readers may create their own, let's say, canvases. Don't try to use these kinds of situations to make a small commission for helping them print. Instead, it's probably more profitable if they simply hire you as a photographer or refer a friend. Be the helpful resource here.

And perhaps most importantly, encourage feedback and an open dialogue with this kind of content—with a clear call to action. Ask readers to join an email list for additional goodies. You can keep it comedic by saying every subscriber gets a free unicorn or something.

Just remember that email blasts are similar to social media. Don't make the mistake of trying to sell with this platform; the point is to begin or continue a conversation. And, again, through these relationships, people will associate you with high quality and hire you when they're ready.

Solicit Opinions

So far, we've focused pretty heavily on how to encourage your audience to engage with you on topics that you choose and put out there. And, I'm guessing, most of the topics you broadcast relate to photography or your community.

Well, I've found that being interested in your audience is what interests people the most. Therefore, create conversations on topics related to social norm. Instead of broadcasting, ask questions. Below are some simple examples.

> *Friday night! What are you doing?*
>
> *What are your plans for this [holiday]?*
>
> *What's your favorite restaurant in Savannah?*
>
> *What's your favorite kind of fabric?*
>
> *What's one thing you wish you knew a year ago?*
>
> *Who's ready for [upcoming television series]?*
>
> *Describe your perfect day!*
>
> *If you won the lottery, what would you do?*

Or you can also pose debatable questions, like *iPad* vs. *Kindle*?

Let's practice dialogue. What's your favorite soda pop? Feel free to holler on social media. Photo of empty bottles ready for recycling taken in Corfu, Greece, by Lawrence Chan at 50mm f/1.2 for 1/250 second.

By asking for other people's opinions, it shows that you value what they might say. So remember to respond to audience comments. They've taken the time to respond to you; show some gratitude. ✪✪✪✪✪

Socializing

An Interview with Grace Ormonde,
Editor-and-Chief of Grace Ormonde *Wedding Style Magazine*

TWITTER: @grace_ormonde
BLOG: graceormonde.com
WEBSITE: weddingstylemagazine.com
FACEBOOK: facebook.com/WeddingStyle

Being a print magazine, how did you integrate digital channels?

At first, it was a bit confusing. I've been in the print industry for over a decade and all of a sudden, everyone needs a Twitter and Facebook account. Naturally, I went and got one … to be abreast on the times, of course. But what to do with social media took some learning.

I was fortunate to have advisors to help with the transition and an editorial team to execute the plans seamlessly. The concept was simple: create content for our clients on the platforms that they like using.

That was about two years ago. Since then, we've set up multiple channels where we can engage with our target audience. This was something that a print format did not allow us to do. People can give feedback and share information immediately online.

Social media, or rather effective social engagement, is crucial to any company's success. But before that, it's important to understand your target audience. For us, we have two: brides and vendors. Therefore, balance is important; it's almost like walking on a tight rope. Our Spring/Summer 2011 issue had a 23.7% increase of newsstand copy sales, while the rest of the category fluctuated between a 2.4% gain and a 14.8% loss. I think our social media efforts contributed to that positive trend.

Speaking of balance, how did you manage your messaging, since luxury is all about exclusivity and social media is all about accessibility?

A wise young man [you] once summed it up this way: "Be easily accessible, but not easily attainable." Am I correct?

The whole idea of luxury is really about the *dream* of luxury. If I publish (whether in print or online) run-of-the-mill content, then the whole fantasy of luxury is gone.

Remember how I have two target audiences? For brides, we are a curator of style. *Wedding Style Magazine* writes about the most elegant gowns, the most exquisite foods, the most elaborate designs, the most stunning photography … and so forth. Mind you, nothing that we write about is easily affordable, and this is a way for us to maintain our cachet. For vendors, it's a matter of space in the magazine, so it works out nicely. As much as I'd love to print every beautiful wedding I see, I can only fit so many into our pages; it's a simple design barrier that works in our favor.

While there might be a high price tag for things we suggest to brides or that get printed in our magazine, our content is widespread. As examples, we have hundreds of thousands of magazines in circulation and more than 80,000 Likes on Facebook.

What's the most difficult part of maintaining a luxury brand?

For a magazine business, our main revenue comes from advertising. And when companies come with several hundred thousand dollar proposals, it's hard to say no. But there've been many instances when I simply must decline the business.

So, to answer your question, it's all about sacrifice. You can't be everything. The moment you dilute your brand, you might as well close the doors to your business. Brand clarity is everything. People should be able to pick up my magazine and immediately know whether or not it fits their profile.

Don't you remember the time when you and Yanni (Publisher) went to Barnes & Noble to check out the new magazine issue placement? Yanni asked a bride-to-be why she didn't want to read *Wedding Style Magazine*. Her response was, "Oh, I'd love to! Everything about it is so elegant, but clearly out of my budget."

So, as time goes on, and you become clearer about your brand, the process becomes easier. Eventually, your clients will attract other clients just like them—people with the same profile, same budgets, same clients, and so forth.

If someone asked you for a road map to becoming a luxury brand, what would you tell him or her?

Be clear. Be steadfast. And read everything you have to write!

BRAND EVANGELISM

To make evangelists out of your audience is every marketers dream, right? Truly, imagine having an entire tribe of supporters that believe so strongly in your service that they take it upon themselves to promote and encourage its use. I'd say this is the ultimate customer engagement.

The act of spreading the word, or *evangelism*, conjures a sense of religious fervor. And, in a lot of ways, brand evangelists are much like religious crusaders who preach their version of spiritual enlightenment. Both kinds of evangelists voluntarily campaign for a cause—bring good news—because they believe it's the right thing to do. They're not paid to pass along messaging by the larger group they're supporting. Rather, they tell people what they believe, because they're convinced that the lives and well-being of their friends and family will improve if they can "see the light" and adopt a similar way of thinking and living.

This strategy falls under Ariely's premise of *social norm*, which was explained in Chapter 8. For example, I spread Apple's good news happily and willingly without ever seeing compensation. But if you offer supporters a kickback to spread your name, this can cause confusion; because it switches your social-referral program to a market one. With financial incentives involved, your supporters become sales people, thus creating an ulterior motive. And with a market norm in place, supporters will only help you if there's a financial benefit. If their return is slim, don't expect them to apply much effort.

Fortunately, as social technology continues to cultivate user-generated content and attract new users, the phenomenon of brand evangelism has taken hold in entirely new ways and continues to flourish. Now, instead of your supporters reaching a few of their friends over dinner or a game of golf, they can broadcast your messages to a network of hundreds or thousands of people simultaneously with a Facebook post, tweet, or blog comment.

And it's happening every day. People are becoming so affiliated with products and services that it becomes a part of their identity. And living, breathing communities develop that center on things like Apple computers, Harley Davidson motorcycles, and Budweiser beer. Of course, groups have always formed on certain similarities and interests; the Internet has taken this to a whole new level.

More importantly, today's businesses rely on this kind of consumer activity. At a time when message control is but a sweet memory for corporate America, customer advocacy—or communal marketing—is a critical factor for capturing a competitive advantage in the marketplace.

Brand evangelism is the new iteration of the ever-coveted WOMM (word-of-mouth marketing)—credible social proof that make nice-to-have brands desirable to a group that will become somewhat cohesive. So how do you motivate clients and other audience groups to sing your praises?

Let's take a look.

Building Belief

Ben McConnell and Jackie Huba suggest in their book, *Creating Customer Evangelists: How Loyal Customers Become a Volunteer Sales Force*, that there are six steps to

making outspoken believers out of your satisfied consumers. Essentially they are:

1. **Gather** customer feedback continuously.
2. **Share** your knowledge freely.
3. **Create** intelligent word-of-mouth networks.
4. **Encourage** customer communities to interact.
5. **Offer** a specialized product or service.
6. **Focus** on improving the world or your industry.

Aha! Aren't these the things we've been trying to do with our social media marketing program anyway? Exactly. If you're engaging your audience—listening to them and putting out well-considered information that resonates … and they're sticking around—then you've got yourself a bona fide tribe of evangelists. So now you need to make sure that your audience knows what to be preaching about your business.

Philosophical Difference

Back in Chapter 2: Strategic Planning, we conducted a SWOT analysis to examine the strengths, weaknesses, opportunities, and threats of your business. And we used this analysis to develop your structural goals, including a unique market position. There, we used a position of *edgiest wedding photographer for stylish couples in Orange County*.

Well, this desired niche position helps your advocates define you. It helps them quickly determine what makes you different from other photographers. To clarify what we're getting at here, let's take a look at how some successful commercial brands apply this concept.

When someone buys a Pepsi, assuming a choice is available, there's more to the decision— consciously or not—than actual preference or difference. It's the cola choice for the Pepsi Generation. It's not "classic," like Coca-Cola. No, young people prefer Pepsi, right?

ladygaga
Monsters have 6 Grammy Nominations + Billboard Award "Artist of the Year." Thank you for fighting for artistic freedom + self-invention. ✖

1 hour ago via web

Lady Gaga thanks her Monsters (aka followers) for supporting artistic freedom and self-invention.

	Belief Statement	Approach	Product
Apple	Think different	Creates beautiful and sleek devices.	Computers, Music Players, TV devices
TOMS	Charity	Shares through a one-for-one program.	Shoes, Glasses
Lady Gaga	Self Expression	Preaches artistic freedom, self-invention.	Music, Performance

	Belief Statement	Approach	Product
Wedding	Edgy	Illuminates rebellion on a day of tradition.	Photographs that portray an unconventional bride
Boudoir	Beauty	Ignites/portrays alluring attributes of women.	Photographs that glorify a sexual female body
Photojournalist	Empathy	Reveals human hardship, fragility of life in war.	Photographs that reveal suffering, a need for help

Similarly, Apple Computers, as we mentioned in Chapter 3: Audience Matters, are for people who Think Different. If you want to create and make change, you choose Apple. The implication is that if you just want to compute generically, buy a PC.

A market position that establishes a belief statement like this often tips the scale for a consumer to select a brand—not necessarily because it's superior or offers a technical preference, but because it *feels* right to them on a personal level.

A *belief statement* is a one or two word definition of your company's philosophy. What you actually produce is not the distinguishing factor in this scenario. The important element is what you represent, or how you can define and unite the people who support you.

Of course, everything we covered in Chapter 2: Strategic Planning still applies; you need an actual position of difference and a well-defined niche. But the thing that will motivate your advocates to become evangelists is your philosophy.

For photographers, what is it that you want your clients to feel when being photographed by you or when purchasing your images? Use your market position for help. Here are some examples.

Let's examine the third example in the graph on the bottom left (empathy). Anyone with a camera, who's in the midst of a war zone, can shoot photojournalistic images of conflict, but only a talented photographer with a dedicated intent creates images that capture the human experience of the conflict and make viewers ache inside enough to help stop the suffering.

Relatable Face

Another important element to brand evangelism is ensuring that your audience recognizes themselves. Visual identity is quite powerful. People love to see a face that is like theirs.

For instance, think about some of the most popular campaigns in our consumerist culture right now:

- **Old Spice** is selling The Man Your Man Could Smell Like.
- **Dos Equis** is hoping you'll relate with The Most Interesting Man in the World.
- Even **Domino's** is getting personal with its Rate Nate's Chicken campaign.

As a boutique photographer, make sure that people identify with you and what you do. This has a lot to do with your content and general persona, but it's equally important to get your face out there to be recognized. Post your own picture on your Facebook and Twitter profiles, use a photo of yourself on your blog's banner, upload videos of yourself working on a photo shoot, and take advantage of other social media opportunities to portray yourself. You are a funny, approachable person, just like your clients, but you also happen to take excellent photographs.

So, yes, we build better human connections with a face than with a symbol or subject. Yet, nothing—and I mean *no thing*—connects people like a common enemy.

Identify Opposition

Just as we basically relate with what's familiar—truly or perceptually—we tend to reject and perhaps even fear people and ideas that are different.

But before we get started with all this talk about opposition and enemies, let's be clear: these terms should never reference an actual person, company, or entity. It's a *concept*. It's not okay to demonize an individual,

> *You have enemies? Good. That means you've stood up for something, sometime in your life.*
>
> 👍 *Winston Churchill*

brand, or an actual entity to get yourself ahead. That's not good at all—no matter what.

An example is George Lopez making fun of Mexicans. We laugh at his humor, because, well, he is a Mexican, so it's not as offensive. And he's making general references based on common stereotypes. If George Lopez made fun of a specific Mexican guy or girl in his audience, people would probably feel a little uncomfortable, and the targeted person would likely feel victimized and maybe even angry.

We cannot single out specific people (or companies) to further an agenda. That just ends up making you look bad.

Yet without some sort of opposing force or concept, your messaging is undefined; it's wobbly. Take a stand, and be firm. Raise a flag, define a cause, draw a line in the sand. And do this by explaining what you are *not*. You can give your audience a clear point of reference by identifying your opposition and amplifying your point of difference.

Consider the Audi 2011 Commercial for the company's "Release the Hounds" campaign (http://www.youtube.com/watch?v=3snyXTNmFm8). Riding in a chauffeured Mercedes-Benz represents "old" luxury, while new luxury is personified by driving away in a fast Audi to escape the shackles of society. It resonates, because who wants to be old and stuffy?

Chipotle's campaign takes on traditional fast food, presumably McDonald's, by mocking the uniformly shaped burgers and the lightning-fast food preparation. The Chipotle campaign emphasizes quality, as in "I'm a little particular about the way I prepare my carnitas. The right way takes six hours at a minimum!" This is a stark contrast to the waiting-for-you burgers at other fast food chains. Jack in the Box, in particular, has a timer at the drive-thru window to show customers how fast they can get food. This is *not* what Chipotle is promoting.

@ladygaga
Lady Gaga ✓

What a tremendous & beautiful day, DADT is officially repealed & the new order is in place. Sending all my love&gratitude to service members

20 Sep via web ☆ Favorite ↨ Retweet ↩ Reply

Retweeted by RihannaFanSpain and 100+ others

Lady Gaga is a defender of equal rights. Her public stance will earn her loyalty from her fans and further denouncement from those who oppose her beliefs.

Another example is Lady Gaga's steadfast position of support for individuality, which she demonstrates time and time again by opposing homophobic activity and groups. For example, when protesters rallied outside a Gaga concert in St. Louis, Missouri, to denounce LGBT, she told her fans that they are not the freaks, as protesters proclaimed. She announced that the freaks were locked outside!

Lady Gaga supporters were no longer just fans or people who like her music. The people inside at that concert became evangelists of sorts who were there protecting a cause—to stand against inequality through unity. She advised her

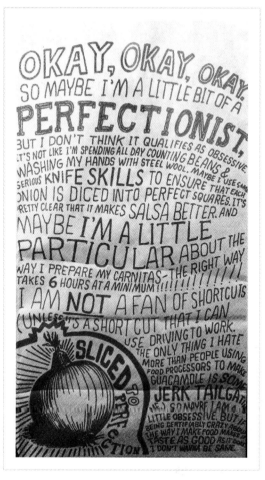

Chipotle's 2011 takeout bag indirectly pokes fun at fast food restaurants.

Pepsi Max's "Not all zeros are created equal" campaign is a clear opposition reference to Coke Zero.

supporters to avoid interacting with the protester groups. "Be inspired to ignore their ignorant message," she said, "and feel gratitude in your heart that you are not burdened or addicted to hate, as they are." This, among other pro-equality actions by Lady Gaga, solidifies her position as a leading supporter of unity among diversity.

Find more about this event at http://articles.nydailynews.com/2010-07-19/ entertainment/27070402_1_lady-gaga-gay-pride-westboro-baptist-church.

For a photographer though, it's probably enough to know what your opposition is. What are you *not*? That is your enemy, so to speak. It's not necessary to provoke your opposition or engage it publicly. Rather, if it comes to you, you can solidify your position as opposition.

For example, let's stick with the edgy wedding photographer gig. If this is your position, a conversation with a prospect might go something like this:

> **You:** *So what drew you to inquire about my services?*

> **Them:** *Um, I like your photos; they're …*

> **You:** *Would you say, they're edgy?*

> **Them:** *Yeah … edgy works.*

> **You:** *Cool. So if you want the traditional prom poses, I could refer you to a hundred other photographers.*

> **Them:** *Oh, no, we don't want prom poses.*

> **You:** *Well, I'll take a few traditional photos for the parents, but if you're looking for the most back-breaking, uncomfortable, borderline sexy, "Maxim"-like photos of your wedding, then please, have a seat. (Insert twinkle-in-the-tooth smile.)*

The Conceptual Enemy

As long as you stick with demonizing a concept, you should be okay. For example, Tofurious's position is *Marketing Strategies for Smart Photographers*. So any photographer who is not smart would steer clear from my content, right? No harm done.

Don't take yourself too seriously, of course. But opposition like this can be created online or in person. Using this strategy promotes your position and gives your supporters a point of comparison.

Create Community

So how did Guy Kawasaki create a community of evangelists for Apple Computers? After all, Kawasaki is credited with pioneering the phenomenon of evangelism marketing.

In an interview with Ben McConnell and Jackie Huba, Kawasaki explains that in his role as chief evangelist of Apple Computer in the late 1980s, he was responsible for "getting people to get more people." Yet the budget was tight. He didn't have unlimited money to place a bunch of advertising. So, he explains that one of the reasons he, like other people, took an evangelistic approach is because money was in short supply. Makes sense, right?

As part of Kawasaki's training to beget brand evangelists, he attended the Billy Graham evangelist school, which he describes as *fascinating*. Kawasaki reinforces that the similarity between religious missionaries and brand evangelism is profound, and he suggests that every car manufacturer should go to the Harley Davidson biker rally. Now there's a company with some real live evangelists!

And speaking of, Kawasaki cautions in his interview, a person can really only evangelize a concept or brand that (s)he truly loves and feels authentically and passionately about. "If it isn't exciting or doesn't excite you," he says, "[evangelism] cannot be done."

Indeed, the Apple evangelists— much like the bikers who attend an annual HOG (Harley Owners'

Despite owning an old PC to "test" things, Lawrence Chan is an Apple evangelist. Composite photo of pride in ownership taken by Lawrence Chan.

Group) rally feel about their motorcycle brand—are hard-core and fully, some might say *fanatically*, in love with Apple brands (e.g., the Macintosh computer, iPad, iPhone, and iPod). They wholeheartedly believe in the superiority of Apple products, especially in the context of the computer company's most notable competitor: Microsoft.

So Apple evangelists host user groups and blogs, attend conferences, develop apps, assist software developers and much, much more. They voluntarily promote the Apple brand purely because they believe it's better for the person or people they're advising.

Yet these voices have never had so much weight. Social media technology is an ideal platform for establishing customer communities and encouraging people to ask questions, make suggestions, and offer feedback on personal experiences with a brand. In fact, many social analysts describe an emerging culture in which communities are defined less by geography or even race and religion and more by the brands we consume—brand tribes.

Even in this sense, community remains an important part of human interaction as a place where people congregate and share their stories. This is fulfilled through blog posts and comments as well as via social networking channels, like Facebook, where clients can engage with photos that represent the community's visual identity.

Despite the power of branding online, do not forget to engage your supporters in person. A simple way to approach this strategy is to host a dinner with all of your previous clients. Chances are no one is going to know each other. So the only thing they all have in common is *you*. Let them share their stories of having you as their photographer. This is a wonderful way to energize your evangelists.

Ambassador Team

As in traditional communities, ambassadors are agents—officially or unofficially—that sustain a certain storyline and promote your point of view. The key is to properly engage with your would-be evangelists. As ambassadors, they will gladly invite their friends without you needing to ask for such a favor.

One way to engage your supporters is to notice them. We talked about this a little earlier in the book, but it's great to occasionally write about someone in your audience when posting updates to your social media channels. Something like, "I love how [this person] is [name something (s)he's doing that aligns with your cause]."

For example, if you're a "green" (eco-friendly) photographer, then make it a point to talk about clients who make an effort to improve our environment. Retweet their causes and write about their fundraisers.

This creates a top-down hierarchy. Because some members will be more active than others, let the active ones spread doctrine to those on the fence. Let these be the people who fight heretics. Keep your own hands squeaky clean.

In a religious context, the ambassadors are those who go to church/temple and talk about their beliefs. The most effective ones are not "in your face," forcing a philosophy. And this aligns with my first rule of trust: You can't sell directly to someone else. Instead, the ambassador speaks genuinely. Some will agree. It will move the dial for some others. And there will be those who do not agree.

Just be sure that you give followers a flag to wave, a clear message to send. They need to understand—and be reminded—what you are and what you believe. This line in the sand, so to speak, makes it much easier to sift prospects than if you're undefined with no opposition.

Nurture Relationships

People want to be unique. That's why we wear different clothes, drive different cars, frequent different kinds of places. Our possessions represent who we are; our whereabouts define us. You know this. A guy who wears a polo shirt and wraps a sweater around his waist at the tennis match is quite unlikely to wear a leather-studded jacket with a dog collar to go out at night. Those are two different beasts.

So you can't let just anyone become part of your club without mangling its identity, its exclusivity. This means you can't photograph anyone or anything just because the job pays. If you do,

Name It

Labeling your club gives members a sense of belonging. Lady Gaga has her "Little Monsters." She, of course, is "Mama Monster." As a photographer, be sure to print your name/company on each photo. It's the brand, and your clients should be proud of being part of your club—a Lawrence Chan Bride or, even better, photographed by Annie Leibovitz.

definitely don't publicize it. Your public (and private) appearance should be consistent with your brand.

It's the idea behind fraternity/sorority hazing rituals. It's supposed to be tough to get in. And that is supposed to make you more grateful to get there. Once you're a part of the group, the other members are typically warm and welcoming. But you have to be tested, and then you'll be part of the culture you'll represent and spread to others. The process is like tempering steel. The more hazing (barriers to entry for harder acquisition), the stronger the members will be.

To launch her new book, *Love Never Goes Out of Style*, Grace Ormonde of *Wedding Style Magazine* hosted a nationwide tour of luxurious soirees for her Platinum List Members. Photo of New York Plaza Hotel party taken by Lawrence Chan at 24mm f/3.5 for 1/100 second.

The group cohesiveness is also important to sustaining an evangelical momentum. Members need to meet with each other to talk and perpetuate the philosophies and doctrines that brought them together in the first place.

The Knot, Yelp, and other large companies regularly host regional parties for their "Elite Squad" (Yelp - http://www.yelp.com/elite). This gives the community a chance to communicate, respond, and otherwise interact with others like them. Take a look at Yelp Elite Squad: http://officialblog.yelp.com/2009/03/yelp-elite-events-whats-the-deal.html.

You can also nurture your relationships with clients and other ambassadors by remembering birthdays and sending holiday cards. Even think about hosting luncheons or dinners to gather your members and allow them to meet or reconnect with each other.

Just keep in mind that live events can be hard to arrange because of scheduling. Seriously, have you tried to get your three closest friends around the same table in awhile? Brutal. But, if executed correctly, a face-to-face get-together can be a powerful thing.

Here's an example: I know a photographer in one of my private Facebook groups who hosted a complimentary workshop for moms learning how to photograph their kids. And even though none of them ever hired this photographer for a shoot, the attendees told every mommy friend they had about the terrific workshop. And, to make a long story short, this photographer is now very busy. Voilà! An ambassador team was propelled into action.

Another way to show the love to your strongest supporters and clients is to give them a gift. For example, all clients should have a coffee table album or big canvas for their mantel. This is an easy way for them to promote your work. It's always in convenient view.

But at minimum, be sure to regularly engage your clients and supporters on social media channels. Make sure that they're subscribed to receive your newsletter, and ask them for feedback. In these ways and others, let them have some responsibility for the future of your work. And be responsive. If these people are going to be your brand ambassadors and evangelize your brand, make them feel special.

Truly, it takes a great deal of effort to gain people's trust and subscription. If you can cultivate this group of subscribers, they will help spread the word for you. They will help you find new clients.

But relax. Even if you don't see business results from your social media work immediately, don't worry. Not every reader is a potential client. Yet every reader could be a potential advocate.

Referring back to my Flay example from Chapter 4, I don't own a barbeque grill. So it's unlikely that I'll actually buy his cookbook anytime soon. But if I find myself talking to someone who loves to grill food, I would definitely encourage him or her to look into Flay's products. He's the grill guy that's always first to come to my mind.

So, if you are finding this book insightful, definitely pass it along to a friend! I'm confident that (s)he will be thankful ... as will I. ❏❏❏❏❏

#chapter 10

Conditions in the rough terrain of social media are unpredictable. The tools and technology change all of the time. To protect yourself and your business from this volatility—and ensure that you don't become virtually irrelevant—be sure that your online marketing survival kit is adequately packed with relevant tools that you know how to use well.

This chapter will explain why and how to use multiple channels for your social media work. For now, it's important to know that your messaging across platforms should be consistent and reflective of your brand. It's also smart to stay reasonably up to date on emerging social media channels and to carefully assess their appropriateness for your own campaigns.

Diversify

As mentioned in Chapter 5: Social Media Channels, each kind of social media platform, from social networking to bookmarking, has a certain purpose and can help you achieve different kinds of goals. Heck, each specific *channel* within the various categories comes with an entirely different set of pros and cons. And the different options work together in varying degrees of harmony. So surviving in the ultra-competitive marketplace of our plugged-in culture depends on choosing the right suite of gear. Don't make the mistake of relying exclusively on one tool to do it all. It won't work.

Think of stocking your online communications bag as you would select gear for an outdoor adventure. What you need depends on what you want to do. So whether you're setting out to climb a mountain, trek across a desert, kayak through a canyon, or launch some other kind of excursion, one tool is not likely to keep you alive. I'm thinking you'll probably need some kind of shelter as well as appropriate shoes, clothing, food, a compass, etc.—and, of course, a bag to hold it all together.

It's the same for a social media program. In most cases, basic provisions will include:

- **Facebook** Accounts (personal and business)
- **Twitter** Account
- **Website**
- **Blog**
- **Email** Marketing (newsletter) Program

> *It is not the strongest of the species that survive, nor the most intelligent, but the one most responsive to change.*
>
> *Author unknown, although quote is often erroneously attributed to Charles Darwin*

And while we surely know the stand-alone value of each of these starter essentials, the really, *really* remarkable aspect of online social tools is their potential interconnectivity. When used together, the seamless flow among the various channels makes it possible to achieve truly unified messaging that reaches a diverse yet targeted audience. Let's explore this a bit more.

Integrate

Before social media tools came along, marketers could broadcast similar messages across different platforms, but that's where it ended. It was nearly impossible to truly integrate the communications tools and tell a deeper story—the way we can do this today. I mean, a billboard, print ad and brochure could certainly all say the same thing, but there was no way to link these formats together. There was a single message—often a clever promotion—and many static platforms.

But now, the online tools of social media make it possible to truly integrate content and expand our stories. The gig is cross promotion.

When all of your online content is linked to everything else, your visibility grows and your messages become more shareable across platforms. So use tools like Twitter, Facebook, and Flickr to advertise your blog content or eBook with an end-game goal to move people to your website and convert them to email subscribers, buyers of your photography services, and/or advocates. The multi-pronged approach makes it easy for readers to share your content with their own networks, thereby widening your audience.

The strategy is to share. Tactics depend on platform. Ask yourself:

- Which platform works best for your content and audience?
- Is a particular broadcast appropriate for all social media platforms and worthy of such wide exposure?

The latter is something many don't consider, because if every post is simply repeated—and not customized for the platform—then perhaps the audience won't follow all profiles. Maybe one will suffice. So mix it up. And only repeat something if it's worthwhile for all to see.

For example, post different information and images on Twitter, your Facebook business page and Facebook personal page to gently force everyone to follow you everywhere. Of course, this requires you to produce three times the content, but it's something to consider.

Below are some easy ways to integrate your social media efforts:

- List all of your social networking profiles on your website's most frequented page (Home, About, Contact) and in the sidebar of your email template.

- When you write a blog post, post an update on your Facebook page that links to the blog post with all relevant tags.

- Tweet a link to your Facebook updates or blog posts with an @mention of any individuals or topics you're covering, if available.

- Include your Twitter handle, Facebook vanity page link, and website address on your business cards and online profiles as well as any print materials, including brochures, letterhead, portfolios, print photos, etc.

- Encourage your blog readers to subscribe to your email list by including an easy-to-find Subscribe button on blog posts.

- Write blog posts and e-newsletter articles based on threads from your social network sites.

Stay Current

Anyone who uses Facebook knows that it is always evolving. It can be tough to keep up with all the new features. What's here today may very well be gone tomorrow. Nothing's guaranteed.

In fact, entire channels appear and disappear on a moment's notice, if we're lucky enough to get any notice at all. Like MySpace and Friendster, it's likely that today's most popular social media channels will be replaced eventually—maybe even fairly soon. It's already starting to happen. Facebook was once the cool site, because of its exclusivity via .edu email address membership, but it's become ubiquitous. Slowly, niche social networking sites are already chipping at the Facebook empire.

So remember to stay reasonably current on what's happening in the topsy-turvy world of social media, and remain nimble enough to adjust your tactics as needed. Remember what you're trying to accomplish. Focus on your goals.

For many photographers, as we mentioned in Chapter 2: Strategic Planning, social media marketing is used to connect with key groups in the marketplace (e.g., clients, prospects,

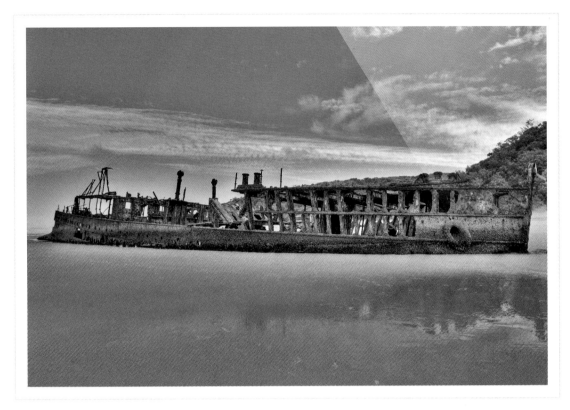

The SS Maheno was used as a hospital ship during World War I. After being declared outdated, it was sold for scrap metal. During her voyage to Japan (buyer), SS Maheno crashed at Fraser Island, Australia. HDR photo taken by Lawrence Chan at 16mm f/6.3.

industry thought-leaders, and potential advocates) and to build meaningful relationships with them in order to establish expert status, build clientele, and increase profits.

So if you're using social media to engage your audience and earn their loyalty, and your favorite social media channel turns into a ghost town, it's no longer serving its purpose. That's why it's important to keep up with the quick pace of change. That's also why it's a good idea to ground yourself in some of the more stable platforms, such as a blog, website, and email.

If a new social media platform comes along that is right for you (e.g., Google+), you can easily notify your audience with a blog post and email blast.

Back-Up Plan

While it's true that email doesn't have the group-interaction feature that makes social media so appealing and effective, it is a secure way to control your key online assets.

Reliable

Email lists are quite reliable in terms of direct access to your target audience. Given the near-universal hatred for spam, it's quite an act of intimacy for a person to share his/her email address. It's a big deal commitment, at least in my book, and it indicates sincere interest in engaging with you—over and far above liking you on Facebook or following you on Twitter.

Plus, email is a much more stable kind of medium than social media accounts. Honestly, I've changed my physical address more often than my email address.

Visible

Another benefit of email is that it's very likely that people will see what you broadcast to them via this medium, primarily because it doesn't have the expiration element of the more real-time-centered media. And people tend to access their email account multiple times each day. For me, checking email is the first thing I do when I wake up.

Sometimes people go for days without checking Facebook, and sometimes I do little more than skim over tweets. But we rarely leave an email unread. At minimum, I look carefully through subject lines and sender information.

For instance, my Twitter following is roughly 7,200 right now. I've tested it time and time again, and only about 100 people click through on links each time I tweet. I attribute this to three main things:

1. People are in different time zones from me.

2. People don't want to use Twitter as much anymore.

3. People go on vacations and don't check their Twitter feed.

Yet emails are opened much more frequently. With my list of about 12,000 email addresses, my email blasts get roughly 8,000 opens.

Management

To help manage your email subscriber lists, engagement metrics, and overall campaign activities, I recommend using a third-party system. Companies that provide this service will keep track of your subscriber names and contact information as well as track their engagement.

These services also provide campaign metrics, including the number of opens per email, number of click throughs, percent of clicks, percent of unsubscribes, and more. This will help you hone your email program and ensure that you're getting the results you want.

Testing ... Testing ...

To determine the most effective way to present your content via email, conduct a few A/B split tests to find out which version your subscribers respond to best. For example, you can test:

- Different subject lines
- Different intro paragraphs
- Different calls to action

"Do Not Reply"

For the most part, we use social media and email campaigns to engage with our audience groups. So do not use "do not reply" email addresses. And if a recipient responds to an email you send, be sure to reply!

In fact, encourage your email subscribers to respond to you. That's the name of the game, right? Ask questions. Here are some ideas:

- **Pet Photographers:** At the end of your general content, ask, What is the breed of your dog? Do you have a photo? Reply back!

- **Food Photographers:** Following your email message, ask, What is your favorite food? What is your least favorite food? Mine are tacos and broccoli. Reply back with a photo of your answers!

- **Wedding Photographers:** End your email message by asking, How did you meet your fiancé? I love stories. If you have a moment, reply back!

Make it your own, of course, but continue to interact. I know it can be a lot of work to maintain conversations with people this way—especially if everyone replies!—but dialogue leads to stronger relationships. And isn't it good for people to be so engaged that they reply to your emails? Think about all those brand evangelists you could be creating!

Commitment

As mentioned earlier, sharing an email address indicates intimacy with your brand. Subscribers trust that the content you'll send will be valuable. To further strengthen this carefully cultivated bond with subscribers, be sure to create and send out several follow-up messages for new subscribers. This will set up anticipation for them to receive future value.

At the one-week mark, consider sending new subscribers an email with a link to an old blog post that has good, relevant information. Refer back to the information on content strategy in Chapter 4 for a refresher on how to develop relevant content for your audience.

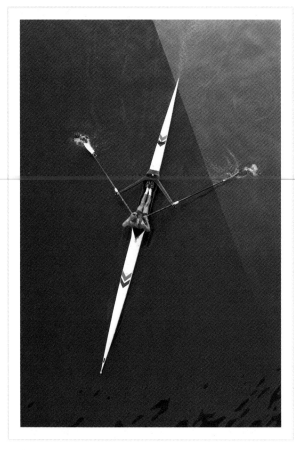

A rower must use consistent strength in both arms to maintain a straight path. Similarly, consistency in the frequency of emails is critical for reader expectations. Photo of rower on Yarra River, Melbourne, Australia, taken by Lawrence Chan at 35mm f/4.5 for 1/320 second.

At two weeks, or shorter depending on your frequency, send another. And at three weeks, send yet another. The point is to train your subscribers to open emails in predictable intervals. And this kind of commitment on the part of you and your subscribers establishes consistency, which builds trust. And trust leads to business.

You can easily send follow-up emails automatically by having them queued in your email management system.

Rewards

Be sure to give your audience a good reason to sign up for your emails. In fact, think about setting up a few different subscription forms based on the level of engagement you've established with different audience groups. For example, maybe you have a general subscription form for those who already find value in what you write on your blog or other communication platforms. Another form could be

used for those who may not yet be convinced. A reward subscription form would offer something of value in exchange for the subscription. This something could be any of the following ideas or something else meaningful to your target audience:

- **Special resources**, such as behind-the-scenes video footage or insider tips for a successful shoot
- **Free eBook** of your responses to photography questions or top blog posts
- **Recommendations** on industry-related products (e.g., children's clothes, doggie treats, wedding vows, etc.)

This tactic ends up being a win-win. Your subscribers gain helpful information and regular updates from you, and you earn their attention and, hopefully, their business and/or referrals.

Expectations

One of the most important (mental) survival tips for your social media program is to not get discouraged by your audience's level of activity. The intense competitiveness of business has allowed consumers to get a bit lazy, while they expect more than ever. Check out my parody on this: http://tofurious.com/parody.

For instance, email used to be a premium service; now it's free. We used to assume we'd pay shipping costs on all Internet orders, but this too is now free much of the time. Even typing used to be required to get to certain websites or perform certain functions on social media sites, but that too has been alleviated with QR codes and programs like FourSquare.

People want things to be easy and instant. Give me instant rice, instant coffee, instant weight loss shortcuts, instant photo sharing, whatever. So don't expect much from your customers. That is, don't expect anyone to type a long response to your posts and fill out long forms. Instead, make sure that your contact form and your subscription forms are short. Requiring anything more than a name and email address is likely to lead to lost opportunities and fewer subscribers.

Also consider the "Clicks of Death" concept. Don't expect anyone to click many times to find something on your website. Navigation needs to be obvious and quick. And be very sure that your call to action buttons—Like, Share, Contact—are easy to find and use.

Handling Criticism

Considering the potentially ginormous audience of your online content, it's inevitable that you will, at some point, receive harsh and possibly hurtful criticism of your work or opinions. And this kind of engagement can result in intense emotions.

Many people agree that the lack of visual and audible cues in online, text-based interaction results in what many refer to as the "disinhibition effect." Psychologist Dr. John Suler has written on this subject extensively. He explains it like this:

> It's well-known that people say and do things in cyberspace that they wouldn't ordinarily say or do in the face-to-face world. They loosen up, feel more uninhibited, express themselves more openly. ... It's a double-edged sword. Sometimes people share very personal things about themselves. They reveal secret emotions, fears, wishes. Or they show unusual acts of kindness and generosity. On the other hand, the disinhibition effect may not be so benign. Out spills rude language and harsh criticisms, anger, hatred, even threats. (Suler, 2002)

So what's the best way to handle these situations? Well, similar to any kind of conflict, here are some ideas:

1. **Calm down**. Log off and calm down before responding to a hurtful or otherwise aggressive response to something you've posted. It's usually best to sleep on it or wait about 24 hours before responding. Review the exchange again (maybe even trying out different tones) when your emotions are stable and figure out your next steps. A response is not necessary in every situation.

2. **Be rubber, not glue**. Try not to take things too personally. Sometimes people go online in a bad mood and take it out on you ... and probably others as well. Jerks are everywhere. You will almost certainly be judged and ridiculed at some point online, so you're probably better off letting this stuff roll off without much fanfare. In some cases, consider asking a colleague or friend to read the exchange and get another opinion on if/how to respond.

3. **Get acquainted**. If a stranger harshly criticizes you, go check out his/her website, blog, or other profiles to get a feel for who (s)he is and where (s)he's coming from. Not everyone will agree with you, so don't agonize over every divergent opinion. But

To calm down, some people meditate, jog, listen to music, or swim a few laps.
HDR photo of Bondi Beach, Australia, taken by Lawrence Chan at 16mm f/9.

if someone is truly out of line or if the person's intent is unclear, consider responding with a DM (Direct Message), email or other type of private message to gain more clarity on what (s)he meant or why you received such a response.

4. **Agree to disagree**. While it might be easy to dismiss, block, or delete a negative comment, genuine interaction is ultimately a good thing. So try to respond to people, even your attackers, in a positive way. It's possible for your biggest critics to end up being your greatest fans. But you need to work through the tough stuff to make this happen. Stay positive and give the person the benefit of the doubt. Assume sincerity.

5. **Apologize**. If an offensive post or harsh response was sparked by an error you broadcasted, then accept responsibility, apologize, and move on. ✪✪✪✪✪

#glossary

#: Symbol for hashtag, which is a clickable link in Twitter that represents common thoughts or topics.

Above the Fold: A reference to prominent placement in a newspaper.

Affinity: A Facebook term referencing the strength of the relationship between a user and a post's creator.

Ambassador: An official or unofficial agent who sustains a certain storyline and promotes a specific point of view.

Belief Statement: A one or two word definition of a company's philosophy.

Blog: A term combining "web" and "log," blogs are online journals, a type of website.

Call to Action: A request for a reader to do something.

CMS: An acronym for content management system, this online tool allows users to post and edit content online without requiring knowledge of Internet coding techniques.

Content Strategy: A plan for broadcasting content to reinforce a brand's market position.

Demographics: A common set of attributes that set a group of people apart from the general population.

If your goal is to sleep earlier, a strategy might be to avoid caffeinated beverages. Therefore, a tactic is to switch from coffee to chamomile (perhaps with with mango) herbal tea. Photo of steeped tea taken in Vienna, Austria, by Lawrence Chan at 24mm f/1.4 for 1/80 second.

DM: Acronym for Direct Message, which is a private message sent directly from a user to another user via Twitter and is out of view from the general audience.

EdgeRank: Facebook's system for ranking posts.

Feeds: A term that refers to the area that aggregates all announcements posted to a social media site.

Folksonomy: A term for social tagging or social indexing, which highlights individuals or groups shown or referenced in photos and text-based posts on social media sites.

Funneling: A marketing process aimed at guiding different audience groups to the point-of-sale.

Goal: Desired end point for a program or effort.

Inbound Marketing: An approach of audience recruitment that results in clients seeking information about goods and services instead of a company blasting out messages that an audience may or may not want to hear or see.

Landing Page: The place where visitors first hit your account or site.

Link Shortener: An online tool that consolidates URLs.

Market Norms: Actions and behaviors that relate to business transactions, including contracts, invoicing, collections, deposits.

A website landing page should be clear about what you represent. Viewers should be able to "get it" easily. Similarly, if you see the White Cliffs of Dover while crossing the English Channel, you will know that you have arrived in England. Photo taken by Lawrence Chan at 16mm f/6.3 for 1/250 second.

Market Position: A term that describes how the market perceives a business in terms of status and capability in its field of focus.

Media: In a traditional sense, this refers to static, one-way modes of communication that broadcast information to a large population of people.

Microblog: A site that operates as a regular blog but features short posts instead of full articles.

Mission: A definition of what a company does. A mission statement defines the purpose of a business or organization.

Noise: Useless information on a social media site that sometimes drowns out higher quality content.

Outbound Marketing: A method of communicating promotional messages based on a repeated pattern of interrupting an audience with a desired message.

Photo Galleries: Groups of images posted online.

Photo Strip: A series of five photos that run across the top of your Facebook or Google+ Wall.

Photostream: A collection of images.

Pingback: An online endorsement created by commenting on a person's blog posts or linking to them.

Profile: A summary of a social media account user that usually includes a photograph and basic information, like hometown, college attended, employer, and birthday.

QR Codes: Quick Response codes are matrix barcodes that are readable by smart phones with QR code-reading applications.

Real Proof: Physical, visible validation that the darn thing works.

RSS: An acronym that stands for Really Simple Syndication, which is a web format that's used to push information to a reader whenever updates are made.

SEO: An acronym for Search Engine Optimization, which is a combination of coding and keyword selection that strengthens online content, so it appears higher in search results by engines.

SMART Formula: SMART is an acronym for Specific, Measurable, Achievable, Relevant, and Time-Bound, and the SMART Formula is frequently used to establish meaningful action goals.

Social Bookmarking: An online tool that gives people a way to save access to and manage links to their favorite places on the Internet.

Social Currency: One's value to those in his/her network.

Social Media: A set of online tools that offers users a platform to interact in real time and on demand.

Social Networks: Online platforms that are designed primarily to offer users a way to connect with groups and people who share interests.

Social News: Online platforms designed to summarize news (by industry or topic) for users by aggregating based on user criteria.

Social Norms: Authentic personal sharing that typically focuses on topics related to community, leisure, or society.

Social Proof: A psychological phenomenon whereby trust is created based on the opinion and/or action of outside entities.

Social Sharing: A type of social media platform that makes it easy to circulate images, especially among those who are members of the site community.

With a line this long, the doughnuts have to be good. While this serves as perfect social proof, the real proof is when one actually eats it. But be wary that overwhelming social proof can influence how one thinks. Photo of American Doughnut Kitchen in West Melbourne, Australia, taken by Lawrence Chan at 16mm f/2.8 for 1/200 second.

Strategic Planning: The process of defining how a business will compete in its marketplace.

Strategy: A planned set of actions that function together to achieve a goal.

SWOT Analysis: SWOT is an acronym for Strengths, Weaknesses, Opportunities, and Threats, and a SWOT Analysis is a popular exercise for identifying where a business currently fits into the market in relation to competitors and in the minds of consumers.

Tactics: Specific decisions and actions that support a strategy.

Tag: A method for identifying specific individuals and places in text and images. A tag functions as a category button. On Facebook, a tag is a form of folksonomy to indicate people or brands in a particular photo or thought that's broadcast through the site.

Target Audience: The specific group(s) of people at which a particular message or campaign is intended to reach and influence.

Tweets: A social media slang term referencing posts to Twitter.

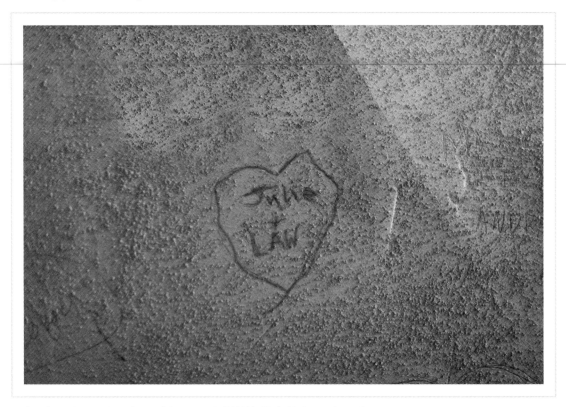

A Wall is a place to share. In today's Verona, Juliet's Wall is filled with declarations of love ... before it's repainted. Photo taken by Lawrence Chan at 24mm f/1.4 for 1/100 second.

Validation: Proof of your expertise. Validation can be in the form of social proof or real proof.

Vision: A long-range, potentially impossible aspiration that articulates a business' ultimate goal and thereby communicates its primary values.

Wall: This is where Facebook users post photos, links, and general updates.

Web 1.0: The original version of the World Wide Web, which served much like traditional communication platforms, but online. Information was projected to audiences without offering an opportunity to actively engage.

Web 2.0: A term that relates not to a technical upgrade, but to how developers and users approach and utilize the Internet.

WOMM: An acronym for word-of-mouth marketing. ▣▣▣▣▣

#index

★★★★★